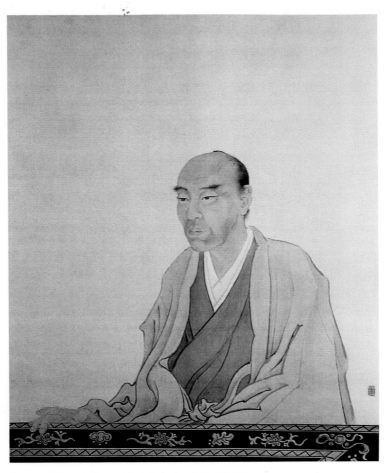

Portrait of Watanabe Kazan (1853), by his disciple Tsubaki Chinzan.
(By permission of the Tahara Municipal Museum)

Frog in the Well

Portraits of Japan by Watanabe Kazan, 1793–1841

DONALD KEENE

COLUMBIA UNIVERSITY PRESS NEW YORK

This volume is based on a series of presentations made by Donald Keene in November 2003 in London and Norwich as part of the Toshiba Lectures in Japanese Art, organized by the Sainsbury Institute for the Study of Japanese Arts and Cultures. The Sainsbury Institute would like to acknowledge the crucial support of Takashi Watanabe of the Toshiba International Foundation, in establishing this annual distinguished lecturer series. The Sainsbury Institute has also provided funding for the illustrations included herein and on the dust jacket.

Columbia University Press wishes to express its appreciation for assistance given by The Blakemore Foundation toward the costs of reproducing the color illustrations in this book.

Columbia University Press
Publishers Since 1893
New York Chichester, West Sussex

Copyright © 2006 Donald Keene

Library of Congress Cataloging-in-Publication Data
Keene, Donald.
 Frog in the well : portraits of Japan by
Watanabe Kazan, 1793–1841 / Donald Keene.
 p. cm. — (Asia perspectives)
 Includes bibliographical references and index.
 ISBN 0-231-13826-1 (cloth : alk. paper)
 1. Watanabe, Kazan, 1793–1841. 2. Painters—
Japan—Biography. 3. Japan—Intellectual life—
1600–1868.
 I. Watanabe, Kazan, 1793–1841. II. Title. III. Series.
 ND1059.W3K44 2006
 759.952—dc22

 2005034247

Columbia University Press books are printed on permanent and durable acid-free paper.
Printed in China

c 10 9 8 7 6 5 4 3 2 1

Chapter 7 has been published as "The Meeting of East and West," *Yale Review* 94, no. 1 (2006): 37–53.

For Jane and Richard Garnett

Contents

Illustrations

Acknowledgments

In preparing this book, my first about a painter, I had help from many friends. I must first thank the members of the Sainsbury Institute for the Study of the Japanese Arts and Culture, especially Nicole Coolidge Rousmaniere. Several chapters in the book originated as lectures given at the request of the institute, and the book has been greatly enhanced by its generous support for publication.

My thanks go next to Isabel van Daalen of the Japan-Netherlands Institute and Ria Koopmans-de Bruijn of the Starr East Asian Library at Columbia University for helping to discover materials in Dutch sources. I am grateful, too, to Professor Shimao Arata for the photographs of many of the paintings I have included, to Masatomo Kawai for locating the paintings, and to Hiromi Uchida of the Sainsbury Institute for obtaining necessary permissions.

Kakuchi Yukio, in making the Japanese translation of the book, uncovered errors that I had made. I thank him for his careful attention to every detail.

The manuscript benefited from the editorial assistance of Margaret Yamashita and Irene Pavitt of Columbia University Press.

To all the above, my heartfelt thanks.

Frog in the Well

Introduction

When I first informed Japanese friends that I was planning to write a book about Watanabe Kazan, nobody expressed surprise. Most Japanese, especially those over forty-five, are familiar with his name and remember, at least vaguely, his claims to the attention of modern readers. For many years he figured prominently in school textbooks, less as a painter than as a model of virtuous conduct, an exemplar of filial piety whom the young were enjoined to emulate. Novels have been based on Kazan's life, and his fame continues to grow, even though most other painters of his day are known only to specialists.

Kazan is much less well known outside Japan. I believe that the first time I saw his name was in George B. Sansom's *The Western World and Japan*. I was struck particularly by Kazan's harrowing sketches of prison life and tried to find out more about him, but at that time (about 1950) Sansom's five pages were the lengthiest description of Kazan published in any European language.

In Japan, in contrast, an astonishing number of books and articles about Kazan have continued to appear. Everyone admires

him—as far as I am aware, there are no exposés—but not always for the same reasons. Japanese of a conservative bent stress his loyalty to the daimyo of Tahara, despite the latter's extravagance and his seeming indifference to Kazan's fate. More liberal scholars voice admiration for his effective and compassionate handling of domain affairs in a time of famine. A writer of the left expressed his belief in 1973 that in certain respects there were "extremely close similarities" between Kazan and "present-day progressives."[1]

Regardless of the orientation of those who have written about Kazan, all praise his noble character. Even the shogunate officials who drew up the fraudulent bill of accusation used at Kazan's trial in 1839 had to admit that no one came into his presence without being attracted. The well-known portrait of Kazan by his favorite disciple, Tsubaki Chinzan, depicts him as a sensitive, thoughtful man, not as a stern-faced samurai. Miyake Tomonobu wrote that no matter how lazy or even contemptible a man might be, he would be inspired by conversing and laughing with Kazan and turn to the path of goodness. Kazan also encouraged younger men to study literature (by which he meant primarily the Confucian classics) as well as the martial arts.[2] He was known as a model of filial piety.

It is difficult to affix a political or philosophical label to Kazan. Although he not only studied but also revered the Confucian teachings until the end of his life, he wrote harshly about run-of-the-mill Confucianists who, shutting their eyes to Japan's precarious position in the world, refused to admit that anything worthwhile could be learned from the West. He declared, "Only the Confucian scholars have a conscience, but they are of shallow aspirations and choose the small, not the great."[3] He likened them to the frog in the well that knows nothing of the ocean. He was equally scornful of "people of lofty learning who revere only the classics," saying that they were like blind men who do not fear snakes or deaf men who do not flee the thunderbolt.[4] He was harshest on high-ranking officials: "They are flatterers who have obtained their positions with bribes."[5]

He contrasted his countrymen with people of the West who had a bold decisiveness in their nature: "This comes from their scientific spirit. That is why they often make revisions in the administration of their countries."[6] It is tempting to interpret this comment as an expression of Kazan's hope for "revisions" in the administration of Japan. In an ambiguously worded letter written the day before he killed himself, Kazan wondered whether people would be unhappy if a "great change" were to occur a few years later.[7] Some have interpreted the words as meaning that Kazan foresaw the end of rule by the shogun and the policy of seclusion.

The revisions that Kazan favored, and perhaps what he meant by "great change," were to be effected within the framework of the existing system. The ambiguity of his expression may have been dictated by his awareness that criticism of the government, however mild, was a serious crime; this may have inhibited him in whatever he wrote, even to trusted friends. The closest that Kazan came to openly criticizing governmental policy was his warning that the inadequate coastal defenses invited imminent danger of attack from foreign ships. But this criticism brought no unpleasant consequences to Kazan, probably because it was shared by members of the shogunate.

In studying Kazan's turbulent life and tragic death, one wishes he had managed to live another fifteen or twenty years, long enough to see the great changes brought about by the opening of the country. Japan's knowledge of the rest of the world, severely limited in Kazan's day by governmental policy, grew dramatically following the arrival of Commodore Matthew Perry's fleet in 1853, twelve years after Kazan's death. The trickle of mingled fact and fancy about the West, which was the most that the small band of scholars of foreign learning in Kazan's day could hope for, quickly broadened into a tide of information that swept over the country, enriching but also immensely complicating the lives of the Japanese.

If Kazan had decided not to commit suicide, choosing to remain alive so that he could participate in whatever changes would

come, he might well have played an important role in the Meiji Restoration.[8] But this is mere speculation: even if Kazan hoped that the new Japan would be an enlightened, modern state, his allegiance to the old, feudal Japan was profound. His final action—committing suicide to make amends for possibly having caused his lord distress—was certainly not in the modern mode.

We may regret Kazan's adherence to outdated samurai ideals, but we should not forget the obstacles he encountered in the path toward enlightenment. His education in the Confucian classics was likely to have made him (as it made many others of his class) reject outright "barbarian learning," but unlike most Confucian believers of his day, he was able to appreciate the magnitude of European civilization and became convinced that it was necessary for Japan to catch up with this new learning. But even if his eyes were directed toward the future, his responsibilities as a high-ranking samurai were much closer at hand, and he was obliged to spend many hours each day on domain business. This may be why he never had the time to become a *rangakusha* (scholar of Dutch learning), a slow process that took years; but he commissioned translations and seized every opportunity to widen his knowledge of the outside world.

Biographies of Kazan go back to a short account written in 1881 by Miyake Tomonobu. Although it is unsatisfactory as a biography, the anecdotes he relates provide sidelights on Kazan not found elsewhere.[9] More important biographical information is given by Kazan himself, notably in the petition he wrote in 1838 asking to be relieved of his domainal duties. As background for this request, he recorded events in his life from childhood, mainly unhappy or even tragic experiences. Perhaps he hoped that by writing in this vein, rather than giving a straightforward account of why he needed a leave at this time, he might move his superiors to grant his petition out of pity.

The petition, although used as factual evidence by most scholars who have written about Kazan, contains important errors, probably intentional, and should not be taken as simple truth.

It is nevertheless worth considering, if only because of the effectiveness of Kazan's moving presentation of his recollections.

The petition opens with a statement giving the one admissible excuse for asking to be relieved of office: his health. Kazan had been ill, although he appears to have recovered. Nonetheless, he insisted that he was by no means well. He had been urged to reconsider submitting the petition, but his nerves continued to be on edge and he felt he had no choice. His doctor informed him that unless he could get some relaxation, no medicine would do him any good. He told Kazan that his pulse was irregular and his muscles had become flabby; he compared Kazan's physical condition to that of a waterweed. Kazan expressed his gratitude for the kindness he had been shown by the daimyo but said that he was now like a clumsily made sword: "Even a sharp sword if used daily as a pocket knife or a kitchen knife will be of no use when needed on some important occasion. How much truer this is of myself, an unpolished sword that has been used to the limits of what his bones can take."

After this introduction, Kazan related events that had left an indelible imprint on his memory. He was born and grew up in the city of Edo. Although he belonged to Tahara Domain, he rarely visited the remote place where the castle was located. The earliest memory he recorded was of Edo:

> When I was twelve I happened to be walking in the neighborhood of Nihonbashi when something occurred that I cannot forget. I bumped into the vanguard of the procession of the lord of Bizen, and they hit me. Child though I was, I thought, "This lord of Bizen is about the same age as myself. He's escorted by a crowd of people, and he swaggers along with no thought to anyone else." I realized, of course, that human beings have different lots in life, but I could not restrain my anger. I made up my mind that henceforward if ever there was something I set my heart on doing, I would do it, and nothing would stop me.[10]

The boy went back to the domain office, where he consulted a man named Takahashi Bunpei, with whom he was on friendly terms. He asked Takahashi what profession would be suitable for him. Takahashi, no doubt aware of the boy's exceptional intelligence, suggested that he study to become a Confucian scholar. This was a logical profession for a scholarly boy of the samurai class, but it did not take Kazan long to realize that it would be impossible for him to pursue this profession. His father had been ill for twenty years, and as soon as he was able, the boy spent much of each day looking after him. The family lived in constant poverty. Although Watanabe Sadamichi, the father, was a high-ranking samurai, he belonged to an impoverished domain, and his income was small, by no means sufficient to support a household of eleven people: Sadamichi and his mother, wife, and eight children. Kazan continued,

> At the time, my younger brothers and sisters all were small, and there were seven of them. [Gorō had not yet been born.] My mother bore the burden of getting through each day, looking after my aged grandmother, my sick father, and the children. There simply wasn't the spare time for me to undertake studies of the kind I have mentioned. We were desperately poor. It would be impossible to convey in words just how poor we were. That was why two of my brothers, sent to temples, entered Buddhist orders. A sister was sent into service with a *hatamoto* [direct retainer of the shogun].
>
> Among all the painful experiences I have had, the worst was when I was fourteen. I had to escort a younger brother to Itabashi where we were to separate for life. Snow was lightly falling. My brother, who was eight or nine, was taken off by a rough-looking man I had never seen before. I can all but see before my eyes, even now, how my brother turned back again and again to say good-bye. This brother's name was Jōi. Later, he died among strangers at the Kumagaya station.

Another brother first was sent to a temple but later was adopted by a *hatamoto* family. Kazan commented, "I need hardly say that our primary thought was to reduce the number of mouths to feed." Kazan's family was happy to have found such a desirable place for the brother to be adopted, but "we were careless and sent him off without decent clothes on his back, as if he were an orphan of unknown parentage." The result was that the adopting family looked down on him, and he finally ran away. The boy died without ever returning to Edo. His sisters also were unfortunate: "We sent one in marriage to a distant place; the other went to a badly off family and died of poverty."

Kazan's mother was the most unfortunate of all:

> Until very recently I had never seen my mother sleep on bedding or have bedclothes to wear. She slept in her clothes on the tattered matting. In the winter she lay down by the *kotatsu.*[11] My father's serious illness made it necessary to buy expensive medicines and pay doctors' bills. We pawned almost everything except the tatami and the household fixtures, and we borrowed all we could from relatives. My mother has a relative, a mountain priest, who lives at Honjō Hitotsume. In order to borrow one silver coin from him, she set off in the snow with my little brother on her back. She returned home late that night. I thought I would heat some water for her to wash her feet but, in the process, singed my clothes, for which I was severely scolded.

Not even a thoughtful, filial gesture could excuse the waste of singed clothes. Probably these were the only clothes the boy had.

Kazan went back to Takahashi Bunpei for more advice. Takahashi said that he could not expect to make money even if he succeeded in becoming a Confucian scholar and that the essential thing now was to relieve the family's poverty. It was arranged for the boy, now sixteen, to become the pupil of a painter named Shirakawa Shizan. Kazan already had shown ability in his

drawings at school. In less than two years, however, he was dropped from the roll of Shizan's students because the presents he offered the teacher were deemed insufficient. "I broke down in tears, not knowing what else to do," he wrote.

Kazan's father then remembered that Kaneko Kinryō, a disciple of the celebrated painter Tani Bunchō, was distantly related to the daimyo of Tahara, and he was sure that Kinryō would take pity on Kazan. As expected, Kinryō accepted Kazan as his pupil and was kind to him. Kazan recalled, "Bit by bit I acquired some competence in painting, but I still had no way of buying any paper." He found a job painting pictures used for the *hatsuuma* festival,[12] which he sold at the rate of a hundred pictures for 1 *kan*.[13] The speed with which he turned out these paintings has often been cited as an explanation of the swiftness and the dexterity with which Kazan sketched scenes on his travels.[14] His pictures found customers, and "that winter I used the money to buy paper and brushes. I still wanted to study the classics, but I simply didn't have the time. In the winter I rose at four in the morning, cooked some rice, and read by the light of the hearth fire."

The autobiographical account then skips to an incident that took place some ten years later. At the time, discipline in the domain was lax. Kazan himself admits to having joined with other young men in singing and playing the samisen, inappropriate behavior for a samurai but the least of the offenses then rampant. On New Year's Day 1819 (when Kazan was twenty-six), a group of his friends assembled and swore that they would do what they could to help restore discipline. He composed this verse to commemorate the occasion:

miyo ya haru	Just look—spring has come
daichi mo tōsu	And even the earthworms
jimushi sae	Emerge from the ground.

On this occasion, he confided to a friend that he still wished to devote himself to scholarship. The friend arranged with the

celebrated Confucian scholar Satō Issai (1772–1859) for Kazan to have lessons with him. There was a problem: because Kazan worked during the day, he could have lessons only at night. The gate to the domain residence where Kazan lived was shut early every night. Kazan's father wrote a note to the official in charge of the gate asking that the gate be closed later to permit Kazan to study with Issai. The official refused, saying that Kazan was still a novice at Confucian studies and that the hour of closing could be delayed for only a recognized scholar. This was one more addition to Kazan's litany of misfortunes, but it made him resolve never to serve in any official capacity: "I decided that my immediate goal must be to relieve the poverty of my family, and my more distant objective would be to become the finest painter in Japan."

In order to satisfy the latter ambition, he felt that he should go to Nagasaki. This might suggest that he was thinking of the island of Deshima in Nagasaki Harbor, where ten or so Dutchmen resided at a trading station. Other Japanese had gone there to find out what they could about Europe, but Kazan's interest in Nagasaki was probably in the Chinese colony there rather than the Dutch. A few thousand Chinese were in Nagasaki, some domiciled there, and others for only business purposes. Sometimes the visitors included painters.[15] Kazan was particularly attracted to the art of Shen Nanpin (Chin Nan-pin in Japanese), which was bolder and more colorful than that of the Japanese painters with whose works Kazan was acquainted. Although Shen Nanpin had left Nagasaki in 1733 after two years of residence, some of his Japanese disciples carried on his traditions, and Kazan was eager to learn them. He composed a poem in Chinese (*kanshi*) anticipating his departure:

> Do not scorn the wren that tries to soar like a roc;
> Its efforts lift it only to an elm and it learns its limitations.
> The wanderer foresees the grief of the empty trees,
> But on mornings of blossoms, nights of moonlight can he
> forget them?

The poem says that no matter how hard a wren, a small bird, tries to emulate the huge roc that soars in the clouds, its strength can carry it only as high as an elm, and thus it discovers its limitations. (This is by way of disparaging his own ability.) The wanderer knows also that his parents will miss him during his absence, but he is sure that he will not forget them even when surrounded by beauty.

Kazan's father guessed his intention. One night, when Kazan returned home late, his father, despite his illness, went out to meet him. Kazan caught sight of him, but the father withdrew without a word, and when Kazan entered the house the father greeted him without any display of emotion. Kazan broke down and wept. He knew that he could not leave.

From this point on in the petition, Kazan moved quickly to his present predicament. His father had died, leaving him as head of the family, and he now was most concerned about his mother:

> If by any chance something should happen to me while my mother is still alive, my soul would not go to heaven. If I can be relieved of my duties, I would like to recuperate for even a year. Thinking of what might happen, I can only beg you in tears.

Scholars in Japan have pointed out the errors in the facts that Kazan presented in his petition. Of course, it is possible that he had forgotten some of the details, but not those of the most memorable experiences.

For example, the experience Kazan recorded of getting caught up in a daimyo's procession and being beaten by a guard supposedly took place in 1804, when he was in his twelfth year. He contrasted his poverty-ridden lot in life with the splendor surrounding the daimyo, a boy the same age as him. But the daimyo was not the same age. Did Kazan really forget that the daimyo was in fact twenty-four years older?[16] Surely this was a literary embellishment—the inequality in the fates of two boys of the

same age, one a pampered prince, the other a poor boy who gets pushed about by brutal guards.

Kazan's touching account of the unhappy lives of his younger brothers and sisters similarly exaggerates the pathetic destinies that they were forced to accept because of the family's poverty.[17] In 1814, when Kazan and Jōi parted at Itabashi, Jōi was eleven, not eight or nine as in Kazan's account, and Kazan was twenty-one, not fourteen. If Kazan had given the correct ages, the episode would surely have been less pathetic.

If, as seems likely, Kazan distorted the facts for literary effect, why did he do it? Obviously, he was impatient to be freed from administrative duties and to throw himself into the study of painting, but he may have been particularly desperate at this time. He had been informed that the daimyo intended to transfer him from Edo to Tahara, the domain's castle town. This would have been an even worse fate than being condemned to pass every other day in an Edo office. Kazan's whole life had been spent in a metropolis where he enjoyed an active social life in the company of many friends. Not even a promotion could make up for the loss of the stimulation this life provided. There would certainly be little to comfort him in the dreariness of Tahara, a village on a windswept peninsula. Not only would leaving his friends in the literary and artistic worlds of Edo be painful in itself, but he would have to abandon his hopes of becoming the best painter in Japan and to give up the possibility of consulting with the *rangakusha* who helped him in his studies. This prospect was so dismal that Kazan may have felt he had no choice but to use every means at his disposal to obtain leave from his duties and escape being sent to Tahara.[18]

Kazan's diaries also provide biographical information, but they are written mainly in an uningratiating classical Chinese and reveal surprisingly little of what he was attempting to achieve in his work. Although the diaries give the names of the paintings he was copying and the subjects of new works, most of the entries are disappointing because they do not tell us what we want most to know.

We therefore must turn elsewhere for personal details. Kazan naturally did not find it necessary to describe his own appearance, but fortunately there is a splendid portrait painted by his disciple Tsubaki Chinzan. In the picture, Kazan looks dignified but eminently human, although rather older than forty-five, the age at which this posthumous portrait supposedly depicts him. He sits leaning over a table with an inlaid border. (The table still exists.) His right hand seems disconcertingly disassociated from the rest of his body; indeed, his difficulty in depicting hands was a fault that Chinzan seems to have inherited from Kazan. We also have several of Chinzan's preparatory sketches for the portrait, which catch him in slightly different moods.

We are told by various other source materials that Kazan was taller than most men of his time and had a powerful voice and a ready laugh. He never lost his temper and never took a nap. There also is anecdotal material that brings out quite unexpected sides of his personality. The celebrated novelist Takizawa (Kyokutei) Bakin related that on one occasion Kazan stunned people by drinking saké out of a human skull, no doubt on a dare.[19]

Miyake Tomonobu told the strange story of how Kazan found an old suit of armor in an antique shop. He stopped to have a look and discovered that it was encrusted with dried blood. The merchant said that it had been worn at the battle of Sekigahara in 1600. Kazan, delighted to find an authentic relic of the great battle, bought the armor. According to Tomonobu, Kazan kept it by his bed and stroked it morning and night. Tomonobu's anecdote continues:

> One day his mother happened to look into his room and saw the armor covered with dried blood. Taken aback, she scolded him, "Did you actually buy that filthy thing? It's probably something taken from a corpse left exposed on the battlefield. Why do you keep anything so depressing?" She shook her sleeve as if to brush it away and left. That same day Sensei took the armor and sold it. His mother was

greatly pleased. This is an example of how he always obeyed her wishes.[20]

The conclusion of this anecdote is not surprising. Famed for his filial piety, Kazan of course obeyed his mother and got rid of the armor. But what made him keep the repulsive bloodstained armor in his room in the first place? Did he feel nostalgic for the days when samurai fought wars rather than spend their days attempting to balance the domain budget?

Other, more basic, mysteries surround Kazan's career as an artist. For example, we do not know how it happened that in 1821 Kazan painted the portrait of his teacher, Satō Issai. Was it at Issai's request? If so, does this mean that Issai had been impressed by the skill Kazan had demonstrated in earlier portraits? Or did Kazan ask Issai to sit for the portrait, so that future generations would know what his revered teacher looked like? What, if any, previous experience had he had of making portraits? And what dissatisfaction compelled him to make so many preparatory sketches of Issai's head, all almost identical in angle and expression? In Europe a painter who was dissatisfied with a picture could simply paint over the parts he wished to change, but because Japanese painters used ink and coloring on paper, rather than oils on canvas, if a painter was dissatisfied with even part of a work, he had to make an entirely new picture. It rarely happened that an experienced painter made more than one or two preparatory studies, but Kazan made eleven, of which seven survive. The finished portrait of Satō Issai is superb, superior to the studies and totally unlike any previous portrait made by a Japanese, a work that seems to have sprung into the world without parentage. What enabled Kazan to create this extraordinary work?

Another problem for anyone studying Kazan's life is his seeming lack of concern for his wife and children. At a loss to explain this disturbing feature of an otherwise admirable man, Japanese biographers have attempted to detect affection seeping through the impersonality of his farewell letters.[21] Perhaps Kazan was obeying a real or an imagined Confucian prescription: he felt no

hesitation about displaying deep affection for his mother (filial piety was a virtue), but he was embarrassed to admit that he loved his wife and children.

Although concern for his mother's welfare is almost obsessive in Kazan's writings, he painted her portrait only once. This work, which seldom appears in reproductions of his paintings, may disappoint Kazan's admirers: she is sitting ramrod straight, and nothing about her expression is in the least gentle or motherly; she is unmistakably a samurai wife and mother, a woman who has endured hardships and will not tolerate weakness in others.

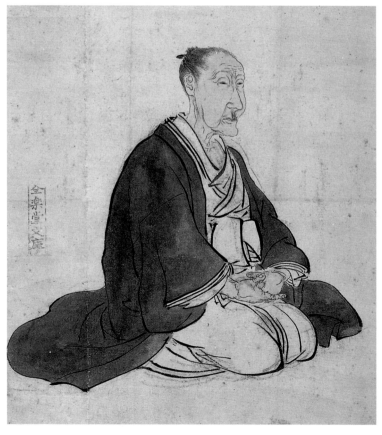

Portrait of Kazan's mother (1840), painted while he was under house arrest. (By permission of the Tahara Municipal Museum)

A final puzzle is the inscription Kazan wrote, to be placed over his grave in lieu of the customary tombstone.[22] It says simply: "Here lies the unfilial and disloyal Watanabe Noboru." It would be easy to interpret this as an example of "oriental" modesty, but surely the inscription is not simply an example of humility. Perhaps Kazan really believed that he had been unfilial to his parents and disloyal to the daimyo of Tahara, even though it is hard for an outsider to imagine anyone who behaved more in consonance with Confucian ideals. The profound filial piety that Kazan displayed toward his father was described by his first biographer, Miyake Tomonobu, and his filial piety toward his mother was beyond reproach. As for his disloyalty, it is now generally agreed that Kazan committed suicide in order to prevent repercussions from his crime—having painted and sold pictures while under house arrest—extending to the daimyo. The act of suicide, although a supreme proof of loyalty to the daimyo, might be interpreted as an act of unfiliality toward his mother, left without his support in old age.

But perhaps the inscription is a historical allusion rather than Kazan's confession of failure as a son and vassal. Yoshizawa Tadashi believed that it refers to Zheng Sixiao, a man of the late Song dynasty.[23] Zheng had word that Mongol troops were heading south and wrote a memorial reporting this. It was so blunt in expression, however, that it annoyed a high official, who failed to forward the message to higher echelons. The result was that the Song forces, not having been warned of the danger, were defeated by the invaders. Zheng, however, remained faithful to the fallen Song dynasty, refusing to serve the Mongols. To support himself, he became a painter and is remembered particularly for his painting of an orchid with its roots torn from the soil. When asked the meaning, he replied that the soil (his country) had been brutally snatched from the plant, an indirect reference to himself. Years later, when Zheng was on the point of death, he asked a friend to inscribe on his funeral tablet "The disloyal and unfilial Zheng Sixiao of the Great Song."

Kazan certainly knew the story of Zheng Sixiao and even wrote a poem about him. Perhaps he saw himself as a Japanese equivalent, a man of principle who did not compromise his beliefs. It was typical of Kazan, as a member of the samurai class, to turn to Chinese (rather than Japanese) precedents. But the parallel between the two men is not close, and only a person of Kazan's background would have understood the significance of the inscription.

These and other many other ambiguities make it difficult to write a biography of Kazan, but it is worth making the attempt. Just as I find his portraits the earliest in Japan to capture both the physical appearance and the personality of the sitter, I find an unmistakably individual and attractive quality in Kazan's life that has made me want to know him better.

Dutch Studies in Japan Before 1793

1

Watanabe Kazan was born in Edo in 1793. Although Edo ranked as one of the great cities of the world in both population and cultural amenities, it was hardly a familiar name to most Europeans. There were not even tales of the exotic pleasures of Edo to beguile armchair travelers. Europeans' almost total ignorance of Edo and even of Japan was mainly the result of the policy of seclusion enforced by the bakufu (government of the shogun) since the seventeenth century. A series of edicts issued between 1633 and 1637 forbade Japanese to leave and foreigners to enter the country, under penalty of death. An exception was tacitly made for a handful of Dutch merchants confined to the island of Deshima and for a small community of Chinese in the city of Nagasaki. Despite the strict enforcement of seclusion, from time to time a few Catholic priests secretly waded ashore, hoping to minister to Japanese converts; but without exception, they were captured and either put to death or forced to abjure their faith. The seclusion of the country was virtually complete.

The most important work written by a European about Japan during the 250 years of isolation is

undoubtedly *The History of Japan*[1] by Engelbert Kaempfer (1651–1716), a German physician[2] who spent two years, from 1690 to 1692, at the Dutch trading station on Deshima. His book, published first in English translation in 1727, describes what he observed while in Japan. It opens with a "prologue" in which he recounts the difficulties in obtaining information:

> With the eradication of the Roman Christians,[3] the imprisonment of our own merchants and the Chinese merchants,[4] and the closing of the borders to prevent entry by and communication with foreign nations, the Japanese also closed their mouths, hearts, and souls toward us, the foreign and imprisoned visitors. All those who are in contact with us especially are bound by an oath and sign with their blood not to talk or entrust to us information about the situation of their country, their religion, secrets of government, and various other specified subjects. They are all the more prevented from doing so since the above oath requires all to act as their neighbor's informer. To make an even deeper impression, this blood oath must be repeated and renewed annually. . . . The Dutch, who are here as traders, have been aware of this condition for a long time, and they believe that it is impossible for a foreigner to find out anything about this country, inasmuch as there exists neither the opportunity nor the freedom to do so.[5]

Apart from Kaempfer, very few of those who spent time on Deshima during the seventeenth and eighteenth centuries contributed to the Europeans' knowledge of Japan. Indeed, the Russian admiral Ivan Fyodorovich Krusenstern complained of Holland, "Europe owes nothing to this nation with respect to a knowledge of the Japanese empire."[6] It should not be forgotten, however, that employment on Deshima did not attract the cream of the Dutch nation. Only men who had failed in business elsewhere, perhaps many times, were likely to resign themselves, in return

for their salaries, to the unbearably tedious life they would spend at the end of the world. They felt no obligation to illuminate other Europeans about Japan, and their most memorable day on Deshima was probably the one on which they were released from bondage and boarded ship for home.

The Japanese did allow the Dutch merchants the privilege of having a physician of their own nationality to look after their health, probably because they supposed that Japanese doctors would be unable to treat the maladies of the Red Hairs (as the Dutch were called). Unlike the merchants, these physicians some-times were intellectuals who found learning about Japan more interesting than passing interminable hours in idle conversation with an unchanging set of uninteresting men. The Swedish bota-nist Carl Peter Thunberg, who served as physician in 1775/1776, described daily life on the island:

> Here, just as in Batavia, we pay a visit every evening to the chief, after having walked up and down the two streets. These evening visits generally last from six o'clock to ten, and some-times eleven or twelve at night, and constitute a very disagree-able way of life, fit only for such as have no other way of spending their time than droning over a pipe of tobacco.[7]

Despite the obstacles placed in the path of foreigners who at-tempted to acquire information, Thunberg not only learned a good deal about Japanese plants but also made friends with Japanese, presumably the interpreters. He wrote, "I had the good fortune to gain their love and friendship to such a degree, that they did not only set a high value on my knowledge, but they loved me from the bottom of their hearts, so as greatly to re-gret my departure."[8] No doubt these friends helped him under-stand something about the country in which he lived. Thunberg was particularly impressed by the bakufu and, after returning to Sweden, recommended to King Gustavus III that he reorganize the Swedish government along bakufu lines. The king, a brilliant

man, showed interest in changes that might bring greater stability to his troubled reign, but he was assassinated in 1792 before he could take any action.[9]

Kaempfer's and Thunberg's writings whetted the curiosity of some Europeans about Japan, but the general level of interest was low, as the inscription on a map of Japan published in Paris in 1748 suggests: "Je donne simplement une partie des positions, vu le peu d'interest qu'a le public de sçavoir les noms des Villages du Japon."[10] This map fails to identify such important "villages" as Nagasaki and Miyako (Kyōto), and the island of Hokkaidō is missing, but, perhaps by way of compensation, the Korean peninsula is immense. Probably purchasers were not disturbed by the map's failings, given the remoteness of the places depicted.

Japanese maps of the same period, of both Japan and the entire world, often are more accurate,[11] although the cartographers were not able to confirm what they had learned from European sources by making their own voyages of exploration. The Dutch maps and books they relied on were provided by the interpreters stationed on Deshima, who made money by serving as the channel through which articles from Holland reached those Japanese who could afford them.

The care with which the Japanese drew maps of countries they could never hope to visit was probably a reflection of their yearning for knowledge of the outside world. They treasured whatever scraps of information concerning the outside world came their way and seized every opportunity to learn more. When the Dutch mission arrived in Edo on its annual visit from Deshima, the members were resigned to being interrogated at length, often on matters of which they themselves had no knowledge and that were of no conceivable benefit to the Japanese.

Accounts of the interrogations to which foreign visitors were subjected go back as far as Kaempfer, who gave sample questions asked of the head of the Deshima trading station: "How far is Holland from Batavia? Batavia from Nagasaki? Who was mightier, the governor general of Batavia or the prince of Holland?"[12] After

many interrogations of earlier Dutchmen, the shogun should have known fairly well the distance from Holland to Batavia (modern Jakarta, Indonesia), but similar questions were likely to be asked each time a Dutch delegation was given an audience.

Sometimes questions were asked not so much to acquire new information as to display the questioner's knowledge. Kōdayū, the captain of a fishing boat wrecked in the northern Pacific in 1783, was rescued by Russians and taken to St. Petersburg, where he had an audience with Catherine II. When he returned to Japan in 1792 and appeared before the shogun, he was asked such questions as "There is a great clock in the tower of the castle of Moscow. Have you seen it?"[13]

Katsuragawa Hoshū (1751–1809), a physician and a scholar of foreign learning dissatisfied with the shogun's disorganized interrogation, then questioned Kōdayū about every detail of his experiences in Russia. He did a magnificent job of drawing out from Kōdayū's recollections the most comprehensive picture of a European nation yet obtained in Japan. But this did not put an end to useless questions whenever the Dutch were in Edo.

Watanabe Kazan may have been present when the "captain" of the Dutch trading station, Johannes Erdewin Niemann, was questioned in Edo in 1838. Niemann was asked (among many other questions) about the relative military power of various countries of Europe, whether Denmark had joined the German Confederation, about the status of Brabant, and about Dutch impressions of Japanese cities. One can sympathize with the Dutch, who were obliged to answer such questions. But behind the questions, however irrelevant to Japan, one senses the desperate eagerness of the Japanese to learn more about the mysterious world surrounding their islands.

One subject not brought up in such interrogations was religion. The Dutch, rather than the Portuguese or Spanish, had been allowed to do business in Japan because their variety of Christianity, unlike Catholicism, did not require believers to propagate it. The Dutch merchants on Deshima were forbidden to display any

outward observance of their Christian belief. Kaempfer related
the conditions to which the Dutch had assented in return for the
profits of trade:

> Submission to these proud heathens into such servitude and
> imprisonment, forgoing all celebrations of feast days and
> Sundays, all devotion with religious song and prayer, the use
> of the name of Christ, the symbol of the cross, and all out-
> ward proof or sign of being a Christian, and, added to that,
> good-natured acceptance of their despicable impudence, an
> affront to any high-minded soul, all that for the love of profit
> and to gain control of the veins of ore in their mountains.[14]

The government of the shogun was ruthless in carrying out
its prohibition on Christianity. The Dutch were not a problem; it
would not have been difficult to get rid of the ten or so foreigners
on Deshima in the unlikely case that they started to sing hymns.
But bakufu officials were convinced that there was a real danger
that belief in Christianity, a foreign religion, might cause Japanese
to divide their loyalties and eventually pave the way for coloniza-
tion by a European power. Such events had already occurred in
the Philippines and would take place in other parts of Asia dur-
ing the years that the Japanese were protected by their isolation.

The policy of seclusion has been deplored by most recent
Japanese scholars. They contend that Japan, deprived of contact
and stimulation from abroad, fell behind Europe, notably in the
sciences and the material progress brought about by the Indus-
trial Revolution. Seclusion over a period of many years, they
argue, gave rise to the insularism from which the Japanese still
suffer, and they tend to be dismissive of the artistic achievements
of the period.[15]

We might expect that Europeans would have been united
in their condemnation of seclusion, a policy that denied them
the God-given right to do business wherever they pleased, but
Kaempfer reached quite a different conclusion. His essay, with
the overpowering title "An Enquiry, whether it be conducive for

the good of the Japanese Empire, to keep it shut up, as it now is, and not to suffer its inhabitants to have any Commerce with foreign nations, either at home or abroad,"[16] opens with a statement of the argument that closing a country goes against the will of God, who created a world without boundaries. But in the end, Kaempfer concluded that even such an extreme measure as cutting off relations with the rest of the world was justifiable in terms of the preservation of peace.[17]

In Kaempfer's day, Japan was enjoying the peace brought about at the beginning of the seventeenth century by the Tokugawa shoguns. By contrast, during most of the seventeenth century, Europe was torn by the endless battles of the Thirty Years' War. Contemporary European scholars agreed that "the most fundamental and important right of the individual was to live in peace,"[18] but for many years this right had been denied. The Japanese, it is true, had forfeited the privilege of traveling abroad, but their country had been at peace. Kaempfer could not help but recognize the overriding importance of this benefit of seclusion.

Kaempfer and later foreigners who wrote about Japan also believed that because Japan was basically self-sufficient, it had no real need for trade or for intercourse with other countries.[19] The Japanese, it is true, were willing to pay high prices for the luxury goods brought by the Dutch, but as far as the country was concerned, these goods were a waste of valuable specie. As Kaempfer commented, "The Dutch spared no cost nor labor to seek out the world's rarest novelties to pay homage to the Japanese annually and to satisfy the ridiculous Japanese passion for various strange animals."[20] Strange animals, indeed, were one of the gifts that the Dutch offered to the shogun on their annual visits to Edo. Most of these animals and birds were relatively small, but the Dutch outdid themselves with the elephant they brought to Japan in 1824, at enormous trouble.

The Dutch not only offered strange and costly gifts to the shogun by way of expressing thanks for being allowed to remain in Japan, but also prostrated themselves before him in the manner expected of Japanese vassals. Unlike Japanese vassals,

however, they might also be asked, as exotic foreigners, to sing and dance in the manner of their native country, and they complied. Kaempfer's history includes a sketch of himself dancing before the shogun and the text of the long poem he sang on that occasion.

The Dutch were required to make one other offering each year to the shogun, an offering so valuable that it made their presence in Japan tolerable: the summaries prepared by the head of the Dutch trading station of events in the world outside Japan during the previous year. The *fūsetsugaki*, as they were called, were essential to the bakufu because they provided information it could not obtain in any other way about developments abroad that might threaten Japanese security. In return for this service, the Dutch were allowed to export quantities of copper containing gold that the Japanese themselves could not extract. The Dutch also took back porcelain, lacquerware, swords, and other products of Japanese craftsmen that may be seen today in the royal palaces and museums of Europe.

During the century or so before the country was closed—from the arrival in Japan of the first Portuguese sailors in 1543 until 1639, when the last of the seclusion edicts was promulgated—a considerable amount of European influence permeated Japan. Initially, many Japanese welcomed the visitors from Europe and were favorably impressed by Christianity and the firearms that the visitors carried. Along with Christianity came Western-style painting, both religious and secular, and the Gregorian chant. Glassware, velvet, and wine from Europe were eagerly acquired by the Japanese, and the Spanish and Portuguese brought tobacco, maize, and sweet potatoes from the New World.

They showed no hesitation in accepting such novelties, and some Japanese even came to enjoy European cuisine.[21] The favorite dish of Hideyoshi—the de facto ruler of Japan at the end of the sixteenth century—is said to have been beef stew. Within a few years of the introduction of bread (still known in Japan by the Spanish name *pan*), the Japanese were baking bread that, in

the opinion of Spanish priests, was superior in taste to the bread baked in Europe. For a time, Western clothes enjoyed a vogue, as we know from genre paintings. Most surprising, the origins of kabuki, the most typical form of Japanese theater, have been traced to the performances in Christian churches of plays about biblical subjects.[22]

If Western influence had been allowed to continue and grow, Japanese culture might have changed as decisively in the early seventeenth century as it did after the Meiji Restoration of 1868, when Japanese traditions were rejected wholesale in favor of Western techniques and institutions. Some scholars today regret that the natural development of Japan's knowledge of the West was aborted by the Tokugawa shoguns, but their decision to drive out the foreigners was perhaps necessary in order to forestall any danger of invasion, and the lasting peace they established brought prosperity and a flourishing of the arts. There was a marked rise in the standard of living, and in the cities people had the leisure and means to buy books, attend the theater, and decorate their houses with paintings, tea ceremony ceramics, and other luxuries.

Virtually the only foreign influence that affected Japanese culture during the period of seclusion emanated from China, not contemporary China but the China of the great eras of the past, when its poetry, history, and philosophy had been unrivaled in the world.[23] Respect for China verged on awe; most educated Japanese would have readily admitted that their country had produced nothing to compare with the grandeur that was China. Classical Chinese (*kanbun*) was the language preferred by members of the samurai class in their writings, and Confucianism was their religion. Even the eminent philosopher Ogyū Sorai termed himself an "eastern barbarian" and insisted that all the most characteristic elements of Japanese culture had originated in China.

China remained the model for Japan well into the eighteenth century. Although some Japanese had been surprised or even disillusioned by the Manchu conquest of China in 1644, and scholars of national learning reproached those who professed

exaggerated respect for China, the supremacy of Chinese antiquity remained largely unshaken. Painters more commonly depicted in their works the great heroes and sages of China than any Japanese equivalents, and (although they had never been to China) they more frequently drew the craggy mountains typical of Chinese landscapes than Mount Fuji. Indeed, Watanabe Kazan's last major painting is a depiction in traditional style of the Chinese tale of the magic pillow of Handan, even though by this time he was a master of the European-style portrait. Not until well after the Meiji Restoration did Chinese-style painting lose its commanding authority.

The first crack in the unfaltering belief in Chinese supremacy came not in the arts but in the study of anatomy. For centuries, ever since medicine first developed in Japan, the Japanese had turned to Chinese medical books for guidance. Physicians accepted the opinions of the Chinese doctors of the past as truth itself and did not question the assumption that the human body contained five viscera and six entrails. Their reverence for Chinese medicine made them hesitate to conduct experiments on their own, and, in any case, they were deterred by their extreme distaste for cutting open a human body.

The first original work of anatomy by a Japanese was based on the dissection carried out in 1754 under the supervision of a physician named Yamawaki Tōyō (1705–1762).[24] The dissected body was that of a criminal who had been executed in Kyōto. Tōyō's findings, which he published in book form five years later, were somewhat vitiated by lingering respect for the old Chinese textbooks; but his insistence on the importance of personal observation and maintaining an open mind when conducting experiments would strongly influence future developments in Japanese medicine:

When dogma is given the first consideration and observation comes second, it is impossible for the findings to be without errors. If the person making an experiment first conducts tests and only afterward puts into words what he

has observed, his findings can be of value even if he is a quite ordinary man.[25]

This rejection of preconceptions in favor of unbiased experimentation marked a first break with the hitherto uncritical acceptance of Chinese medicine.

A number of dissections were performed in accordance with the principles that Tōyō prescribed. The most important took place in 1771 under the supervision of the physician Sugita Genpaku (1733–1817). Sugita and another physician, Maeno Ryōtaku (1723–1803), both interested in finding out about medicine abroad, had asked a Nagasaki interpreter, Nishi Zenzaburō (1717?–1768), to teach them Dutch, but he informed them that it was virtually impossible for a Japanese to learn the language. Nishi, a third-generation interpreter of Dutch, may have made this unaccommodating reply because the knowledge of the Dutch language was a jealously guarded family secret.[26]

At first, Sugita was so discouraged that he abandoned his plan of learning Dutch, but his interest in Western medicine revived in 1771 when he was shown two Western books of anatomy. The owner was willing to sell them, and Sugita examined the books with great interest:

> I couldn't read a word, of course, but the drawings of the viscera, bones, and muscles were quite unlike anything I had seen before, and I realized that they must have been drawn from life. I wanted with all my heart somehow to buy the books, but at the time I was so poor this was quite beyond my means.

Sugita's domain came to the rescue and bought for him one of the books, a Dutch translation of *Tafel Anatomia*, written in 1731 by the German physician Johann Adam Kulmus.[27] Once he had the book in his possession, Sugita was eager to test the accuracy of the drawings by witnessing a dissection. At the time, the only persons who ever performed dissections were members of the

eta, or pariah, class, who normally worked as butchers, tanners, and furriers, occupations that were shunned by other members of Japanese society because of the Buddhist injunction on taking the lives of animals. In the rare event of a dissection of a human being, an *eta* would perform it.

Sugita was lucky. A friend wrote to him in April 1771 that a dissection was to be performed on the following day. The place was the execution ground at Kotsugahara, and the body was that of a woman who had been put to death. Sugita asked some of his friends, including Maeno Ryōtaku, to attend. When Maeno appeared the next day, he also was carrying a copy of *Tafel Anatomia*, which he had purchased in Nagasaki. Sugita's account includes this passage:

> The dissections that had taken place up to this time had been left to an *eta*, who would point to a certain part he had exposed and inform the spectators that it was the lungs or that another organ was the kidneys. Those who witnessed these performances would go away convinced that they had seen all there was to be seen. Since, of course, the name of the organ was not written on it, the spectator would have to content himself with whatever the *eta* told him. On this day, too, the old *eta* pointed at this and that, giving them names, but there were certain organs for which he had no names, although he had always found such things in the same place in every corpse he had ever dissected. He also remarked that none of the doctors who had previously witnessed his dissections had ever wondered what these organs might be.
>
> When Ryōtaku and I compared what we saw with the illustrations in the Dutch book, we discovered that everything was exactly as depicted. The six lobes and two ears of the lungs, and the three lobes on the right and four lobes on the left of the kidneys, always mentioned in Chinese books of medicine, were not to be found. The positions and shapes of the intestines and the stomach were also quite unlike the old descriptions.[28]

Years before, when two court physicians had witnessed dissections and discovered discrepancies between what they saw and the illustrations in Chinese medical books, they concluded that there must be physiological differences between Chinese and Japanese;[29] but Sugita and Maeno did not doubt the universal validity of the Dutch book. Convinced of its superiority to all they had learned about medicine, they decided that they must translate it. This was, in prospect, a staggering task. There was no proper dictionary of the Dutch language, only a crude word-list that Maeno had obtained in Nagasaki. The two men enlisted the help of another physician, Nakagawa Junnan (1739–1786), and all three men spent almost the next four years working on the translation. Quite apart from learning a difficult language, they had been trained in traditional Chinese medicine, and it often was difficult for them to follow the reasoning in the Dutch text. Above all, the basic linguistic problems were enormous. Not only was it hard to discover what a particular Dutch word meant, but even when the definition was at last determined, it was often a struggle to find a suitable Japanese equivalent for use in the translation. Sometimes they borrowed old terms inherited from Chinese medical books; at other times, they had no choice but to invent words. Despite all the problems, the translation (entitled *Kaitai shinsho* [*A New Book of Anatomy*] in Japanese) was a landmark in the history of Japanese medicine.

After the translation had been completed,[30] a new problem arose: the fear that the government might prohibit its publication because it violated the censorship. In order to avert opposition, one copy of the translation was sent to the shogun's castle in Edo and another to the imperial palace in Kyōto. Sugita was subsequently informed that there was no objection from either quarter. The book was published without any problems in 1774, the first work to be translated from Dutch into Japanese.

The translation itself was a monumental achievement that enabled the Japanese to obtain an accurate understanding of human anatomy, but its effects were not confined to the world of medicine. In his old age, Sugita wrote a memoir known

as *Rangaku kotohajime* (*The Beginnings of Dutch Studies*, 1815),[31] in which he recounted his experiences in making the transla-tion. The title itself is revelatory: with this translation, *rangaku* (Dutch studies) was initiated. The *ran* in *rangaku* was an abbre-viation of O*ran*da for "Holland," and it was written with the character for "orchid," a flower traditionally associated with scholars. Up until this time, the usual term for foreign stud-ies had been *bangaku* (barbarian learning), and although this word did not disappear, *rangaku* indicated new respect for learning from abroad.

Conversely, *rangaku* meant less respect for China. Young men of the samurai class continued to study Confucian texts and to lard their Japanese with references to Chinese history, but for the first time the importance of Chinese examples and of Japanese followers of Confucius were questioned. In 1783 Ōtsuki Gentaku (1757–1827), a disciple of Maeno Ryōtaku, published a textbook of Dutch entitled *Rangaku kaitei* (*A Ladder to Dutch Studies*), in which he not only described Dutch grammar and pronunciation but also defended *rangaku* in this manner:

> In recent years, ever since Dutch learning became prominent, there has been a tendency for Confucian scholars to reject it, declaring that barbarian theories should not be adopted. What is the meaning of this criticism? Dutch learning is not perfect, but if we choose the good points and follow them, what harm can come of that? What is more ridiculous than to refuse to discuss its merits and to cling to what one knows best without thought of changing?[32]

From this defense of the value of Dutch studies, Ōtsuki moved on to an attack on admirers of China:

> Hidebound Confucianists and run-of-the-mill doctors have no conception of the immensity of the world. They allow themselves to be dazzled by Chinese ideas, and, in imitation of Chinese practice, laud the Middle Kingdom, or speak of

the Way of the Middle Kingdom. . . . But what excuse is there for us to adopt the proud usage of China and speak of the Middle Flowery Land or of Flowery People, Flowery Ships, Flowery Things, and so on? For long years we have been imitating them, senselessly delighting in their ways without thinking of anything else. This has led to our excessive stupidity with respect to geography and to a limitation to the knowledge we have gained with our eyes and ears.[33]

Ōtsuki was challenging the authority of believers in Confucian tradition, and it was only natural that the Confucianists responded acrimoniously. Toward the end of the eighteenth century, the bakufu discouraged the teaching of any but the Zhuxi school of Confucian philosophy, even though the importance of learning more about the West should have been self-evident by this time. In their anxiety to preserve orthodox thought, the Japanese Confucianists seem to have forgotten the emphasis that Confucius himself had given to *ge wu*, the investigation of things as the work of the educated man.[34]

In the late eighteenth century, the number of students of *rangaku* was modest, perhaps no more than a hundred men, apart from the Nagasaki interpreters. A delightful painting by Ichikawa Gakuzan (1760–1847) shows a group of *rangakusha* sitting around a table and celebrating the Dutch New Year on January 1, 1795.[35] The host was Ōtsuki Gentaku, and the place was the Shirandō Academy, founded by Ōtsuki in 1789 after his return from Nagasaki, where he had perfected his knowledge of Dutch. Twenty-nine people attended the party, mainly friends and students of Ōtsuki. Kōdayū, the former castaway, not only was invited to this gala occasion but was seated in a place of honor. An unidentified Japanese, dressed in Dutch clothes, sits on a chair, rather dominating the people seated in Japanese style around the table. The table is sparsely covered with bottles of wine, glasses, a couple of forks, and some unidentifiable food in bowls. It does not look like much of a banquet, but we know from other sources that there was plenty of exotic European food for the guests to consume.[36]

The painting on the wall resembles the portraits of Hippocrates made by *rangaku* scholars (many of them physicians), but it may in fact be of Lorenz Heister (1683–1758), whose textbook of medicine was translated by Ōtsuki.[37] The guests, ranging from a daimyo down to the low-born Kōdayū, seem to be having a good time together, although differences in social position would normally have kept them apart. Katsuragawa Hoshū, a member of the most distinguished family of *rangaku* scholars, sits by Kōdayū's side, sharing the place of honor.

Although it was unlikely that anything controversial would be discussed at such a party, there was always a danger that the government might suddenly crack down on the group on the grounds that it had displayed undue partiality to foreign countries. Criticism of the government, whether direct or in the form of praise for the government of some other country, was an offense punishable by death. Years later, the Bansha (Barbarian Society), to which Watanabe Kazan belonged, would be subjected to intense questioning, and Kazan was very nearly executed. This painting, however, was a gesture in the direction of cosmopolitanism. Kōdayū writes the date in Russian; another guest holds a Dutch book; still another half-conceals his face with a fan inscribed with a Chinese poem; and, presiding over the gathering, the bearded face of Hippocrates (or Heister) gazes down benevolently from the wall at the twenty-nine Japanese.

Japan in 1793

Kazan's Early Years

2

Watanabe Kazan's life falls within the period of Japanese history known as *bakumatsu* (end of the bakufu). Like *fin-de-siècle*, this term suggests not only the waning of an age but also its decay and, possibly, corruption. There is certainly much evidence that the years between 1772 and 1786, when the *rōjū*[1] Tanuma Okitsugu (1719–1788) was the chief power in the government, were marked by bribery, sale of offices, and other forms of vice in high places. Making money became more important to the samurai class than Confucian ideals or martial skill. Samurai who failed in their attempts to become rich often ran up huge debts instead, and there are stories of samurai who were forced to grovel before rich merchants, begging to be rescued from financial disaster. Even though they had long been schooled to revere and obey the samurai, members of the lower classes now openly sneered at their orders.[2]

Kabuki, by far the most popular theater at the time, was blamed for the corruption in the morals of a decadent age. It was claimed that the theater no longer imitated life; instead, life imitated the highly immoral scenes acted on the kabuki stage.[3] The plays of Tsuruya

Nanboku (1755–1829), which often include blackmailers and murderers in their cast of characters, aimed at startling and even shocking the audiences. Humor, often crude, enlivened the scenes, and there was a generous helping of sex. A critic writing somewhat later (in 1816) described the decline of morals in terms of audience reactions to kabuki:

> Up to seventy or eighty years ago the amorous play of men and women was suggested by an exchange of glances; if the man ever took the woman's hand, she would cover her face in embarrassment. That was all there was to it, but even so, old people in the audience are said to have been shocked by what they deemed to be unsightly exhibition. . . . Nowadays sexual intercourse is plainly shown on the stage, and women in the audience watch on, unblushing, taking it in their stride.[4]

Even if such documents, presented as evidence for the great decline in morality, are literally true, it is likely that they represented only a part of Japanese society. In Edo, idle samurai might turn to vicious pleasures, but elsewhere in the country there was a conspicuous increase in the number of domain schools where samurai boys were taught the principles of Confucianism. Even at the height of Tanuma's rule, most samurai did not forget their métier, and by no means did every merchant delight in tormenting his betters. Indeed, the quickness with which reforms were soon effected afterward indicates that for all the wayward and sometimes disgraceful behavior of some samurai, the class as a whole did not forget its special responsibilities.

The agent of the badly needed reform was a samurai of impeccable qualifications, Matsudaira Sadanobu (1759–1829),[5] one of the most brilliant men of his time. He was the grandson of Tokugawa Yoshimune, the outstanding shogun of the eighteenth century, from whom he may have inherited his exceptional talents. His ability was recognized early: in 1774, when Sadanobu was fifteen, he was appointed by command of the tenth shogun, Tokugawa Ieharu, to be the adopted son and heir of the

Matsudaira family of Shirakawa, a major domain with an income of 110,000 *koku*. Nine years later, upon the death of the daimyo, Sadanobu became his successor and soon established so outstanding a reputation as an administrator that when Ieharu died in 1786, Sadanobu seemed likely to be chosen as the next shogun. However, a political maneuver by Tanuma Okitsugu, who feared Sadanobu's exceptional ability, caused the election to go instead to the incompetent Ienari, a boy of fifteen.[6]

Sadanobu never forgave Tanuma, and eventually he had the pleasure of seeing him dismissed from office when a series of riots and acts of destruction by commoners—starving men and women demanding famine relief—erupted in the cities. The senior officials were at last stirred into taking action against a regime that was detested for its open bribery and corruption. This was probably the first time in Japanese history that a government had been overthrown by pressure from below.[7]

Sadanobu's hatred of Tanuma was not simply the result of frustrated ambition. As a believer in Confucianism, he could not tolerate Tanuma's insistence on making money the highest purpose of the state. Tanuma resigned his post as *rōjū* in 1786, but even though Sadanobu was favored to succeed him, the *rōjū* still loyal to Tanuma opposed his appointment. Sadanobu finally was able to force the resignations of his opponents, and in 1787 he not only became a *rōjū* but was chosen as chief *rōjū* (*rōjūshu*), an unprecedented honor for someone who had never held an office in the bakufu.[8]

Sadanobu must have long considered what he would do if he came to power, for hardly a month passed after he became a *rōjū* than he proclaimed the Kansei Reforms.[9] The reforms were aimed at restoring morality and honesty to the government and the samurai class as a whole. In the oath he offered at the Honjo Kichijōin, Sadanobu swore not only on his own life but also on the lives of his wife and children that he would carry out a renewal.[10]

Sadanobu believed that the most urgent need was to revive samurai traditions in the martial and literary arts. Competitions

in the martial arts soon were initiated, with prizes for the victors, and samurai who seemed to have lost interest in the use of their swords responded eagerly.

The literary arts—meaning, in the case of samurai, Confucianism—also enjoyed new respect, although not everyone was content. During the Tanuma years, Ōta Nanpo (1749–1823) had led a rather happy-go-lucky life, known for his *kyōka*, or comic *waka* (thirty-one-syllable verse). After Tanuma's fall, one of Nanpo's patrons was executed for his outrages as a member of the discredited regime. Nanpo thereby decided to give up composing *kyōka*, an avocation not in keeping with stern samurai ideals, and prepared himself instead for the examinations in the Confucian classics required of officials. He passed with highest honors and was rewarded with government posts of some importance. He was believed, however, to have composed a *kyōka* that circulated widely at this time, satirizing Sadanobu's emphasis on the importance of *bun* (literature) and *bu* (martial arts):

yo no naka ni	In all the wide world
kahodo urusaki	There is nothing quite so
mono wa nashi	Exasperating:
bunbu to iute	Thanks to the awful buzzing
yoru mo nerarezu	I can't sleep even at night.[11]

The point of this comic verse is the pun on the word *bunbu*. On the surface, *bunbu* seems to be onomatopoetic, the buzzing sound of a mosquito that keeps the poet from sleep; but it is used also to express irritation with the government's insistence on "letters and arms" (*bun* and *bu*), which keeps him awake at night. It would not have been surprising if someone like Nanpo, recalling the easygoing days under Tanuma, had composed a poem deriding the new puritanism, but he vigorously denied authorship, no doubt fearing that the poem might be taken as criticism of the regime.

Sadanobu's program of cultivating arms and letters was successful. An edict was issued in 1790 reaffirming the government's

support for the orthodox Zhuxi school of Confucianism and stigmatizing (although not actually banning) other schools as heterodox. Many who had been devoted to baser pleasures became officials in the Confucian mode. Sadanobu's method of government was firm but not dictatorial; no decision of consequence was taken without conferring with the Three Families (major daimyos of the Tokugawa family)[12] as well as with the other *rōjū*.

In principle, there was an even higher authority, the emperor, but Sadanobu never felt the necessity to consult him. The emperor participated extremely little in the administration of the state. He lived behind the walls of the Gosho (Imperial Palace) in Kyōto, where he was expected to spend his time in study and the composition of *waka* poetry, in keeping with the Regulations for the Palace and the Nobility (1615), the first set of regulations ever issued by a Japanese government prescribing the activities suitable to the emperor. His duties were mainly ritual: the performance on certain days of the year of ceremonies that were believed to have divine significance for the Land of the Gods, as Japan was sometimes called. The rare exchanges of messages between the emperor and the shogun (or his delegates) were never direct but passed through the hands of officials in Kyōto and Edo appointed for this task. As a result, the lives of the late-Tokugawa-period emperors tended to be repetitious and dull, and their lives often went by without a single event worth recording. But not long after Sadanobu became a *rōjū*, relations between the imperial court and the bakufu suddenly became tense.[13]

Emperor Kōkaku (1771–1840), the reigning emperor when Sadanobu became a *rōjū*, had been crowned at the age of eight after Emperor Go-Momozono died without an heir in 1779. The closest person eligible to succeed him was Kōkaku,[14] the son of a high-ranking nobleman, who was officially adopted as the late emperor's son; it was in that capacity that he ascended the throne. There was no problem about the succession of a child or about the somewhat irregular connection of the new emperor to the vaunted imperial lineage of ten thousand generations. But about

ten years after Kōkaku became emperor, he began to worry about the position of his real father, Prince Kan'in, and decided that he should be given the title of retired emperor (*daijō tennō*). This was not simply a matter of honoring the prince. Filial piety dictated that he show the proper reverence to his father, and this was possible for Kōkaku only if his father had the status of a retired emperor. An imperial command was sent through the proper channels to Edo, where, after examining the contents, Matsudaira Sadanobu decided to refuse to sanction the emperor's command. All the same, he hesitated to issue an open rejection, no doubt intimidated by the aura that surrounded the emperor. He asked for more time to consider.

The difficulty of giving Prince Kan'in the title of retired emperor was that he had never been emperor. However, scholars in Kyōto managed to dig up two precedents, the first going back to 1221 and the second to 1447, when a prince who had not been emperor was named a retired emperor. Precedents of this kind were needed to justify present actions; they also had the force of commands from the past and were not to be dismissed lightly. But Sadanobu rejected the two precedents, saying that both had occurred during a time of war and were appropriate only under similar emergencies.[15] He, in turn, invoked precedents from Chinese and Japanese history to demonstrate the inadvisability of establishing dangerous precedents.

Sadanobu eventually worked out a compromise based on an eleventh-century precedent: Prince Kan'in would not receive the title of retired emperor but would rank immediately below a retired emperor and, in that capacity, would receive an augmented stipend from the bakufu. Emperor Kōkaku accepted the proposal, and it seemed as though the matter had been settled, only for it to flare up again in 1791. The *kanpaku*, Takatsukasa Sukehira, the highest officer of the emperor's court, had been on friendly terms with Sadanobu and favored the compromise, but when he resigned, he was succeeded by Ichijō Teruyoshi (1756–1795), an outspoken opponent of the bakufu. The court nobles possessed little

power outside the tiny world of the Gosho, but they never forgot their past glories and resented the bakufu upstarts, although not so strongly as to refuse salaries or gifts. Teruyoshi again opened up the matter of the honorific title, and the emperor had the high-ranking nobles polled: thirty-five out of forty supported his command to bestow the title on the emperor's father.[16] On learning of this development, Sadanobu decided that he would have to be blunter.

He prepared a response in which he took up the crucial issue of the emperor's filial piety toward his father. Sadanobu declared that even though bestowing the title of former emperor on his father would be filial, Kōkaku would be lacking in filiality toward his ancestors if he established a bad precedent. The court replied that it nevertheless intended to award the title to Prince Kan'in. Angered by the court's obstinacy, Sadanobu warned of the danger to the succession, perhaps meaning that the emperor might lose his throne.[17]

The court depended on the bakufu for its economic survival and was in a poor position to continue resisting, but some nobles, ignoring their real weakness, tried to persuade the emperor not to withdraw his command. The emperor, however, was intimidated and backed down. Two high-ranking nobles were arrested and, after an investigation, were placed under house arrest. One of them, Nakayama Naruchika (1741–1814), was the great-great-grandfather on his mother's side of Emperor Meiji. Naruchika had to wait until 1884 to be absolved of his crime and to be posthumously promoted to the junior first rank. In the same year, Kōkaku's father received the long-awaited honorific title of former emperor, much to Meiji's satisfaction.[18]

Watanabe Kazan was born in 1793, during the reign of Emperor Kōkaku, and lived much of his life during the reign of Kōkaku's successor, Emperor Ninkō (1800–1846), but as far as I am aware, he never referred even indirectly to either sovereign in his writings. Kazan knew, of course, that there was an emperor who lived in Kyōto, but although he recorded whatever

information came his way about the policies of foreign monarchs, he never had occasion to mention the man who arguably was the supreme ruler of Japan.

Kōkaku's reign was unusually long, and he has been credited with restoring many ceremonies that had fallen into desuetude, but he seldom figures in histories of the late Tokugawa period. Early in his reign, when the country was suffering through the terrible famine of 1787, Kōkaku made the unprecedented gesture of appealing directly to the shogun to give help to the victims, but even this gesture did not secure him a place in history.[19] He is remembered, if at all, for his inability to achieve what concerned him most: to obtain for his father the title of retired emperor.[20] In the end, the emperor had no choice but to obey Sadanobu, a clear indication of where the superior authority resided.

Kazan's failure to mention the emperor even in relation, say, to the vulnerability of Kyōto to the danger of foreign invasion may have reflected his belief that the emperor did not belong to the world of ordinary mortals. This was true of Sadanobu, who, in a letter written in 1792, described the emperor as a god, lord of the divine people, father to his million, trillion subjects: "When His Majesty makes even one move, it affects the prosperity or decline, the danger or safety of the state and the people; it is indeed of utmost significance."[21] Sadanobu declared that the emperor's actions reverberated not only within Japan but in foreign lands as well.

Sadanobu did not attempt to reconcile his harsh refusal to consent to the emperor's wishes with this declaration of the divine essence of the emperor's being. He seems to have been convinced that Kōkaku, a particular man who happened to be the emperor, must be blocked in his plan to violate the wisdom and precedents of China and Japan but that the institution of the emperor transcended limitations that applied to human beings.

The shogun was a more this-worldly figure, but Tokugawa Ienari (1773–1841), the occupant of the office during most of Kazan's lifetime, was even less conspicuous than the emperor. His greatest achievement was probably having been the father of fifty-five children. Although his long reign as shogun began promisingly,

corruption and open nepotism became its most conspicuous characteristics. Kazan could not have admired Ienari, but, unlike the emperor, the shogun did not belong to a different world. High-ranking daimyos had access to the shogun, and also unlike the emperor, who never in his lifetime was subjected to the horror of seeing a foreigner, the shogun gave audiences each year to members of the Dutch trading station.

For most Japanese of the time, the emperor, to whom they owed highest allegiance as the descendant of the gods who had created the Japanese islands and founded the country, was a remote presence whose existence rarely crossed their minds. There were exceptions. From the early eighteenth century, the *kokugakusha*, or scholars of national learning, had insisted in their writings on the supreme importance of pure Japanese traditions that antedated the introduction of Chinese thought. They rejected both Buddhism and Confucianism as foreign and unsuited to the Japanese people and looked to the *Kojiki* (*Record of Ancient Matters*, 712), the oldest work of Japanese literature, for guidance in their lives. The *kokugakusha* included some brilliant men, but in Kazan's time their influence was limited, and they did not succeed in persuading the mass of the Japanese to follow their special traditions, notably the worship of the emperor. People were more aware of the shogun, but even he was too august to be considered either good or bad. Rather, the primary allegiance of most people was to the daimyo of their domain, even if the domain was small and poverty-stricken like Tahara.

The Tokugawa shoguns required daimyos to spend alternate years in Edo. This was a way to keep an eye on their activities and to weaken the daimyos' finances by forcing them to maintain a residence in the expensive capital. Tahara Domain, to which Kazan belonged, was exceptionally poor. Its income of 12,000 *koku* was only a small fraction of the income enjoyed by major domains, and with this meager sum the domain had to pay the stipends of the daimyo and the more than 350 samurai.[22] It regularly had a serious deficit, and whenever there was a crisis, the samurai stipends, already inadequate, were cut to the bone.

Kazan's father, Watanabe Sadamichi (1765–1824), was officially entitled to a stipend of 100 *koku* a year, but for most of his life he received less than half this amount, and despite being a member of the upper samurai class, he lived his whole life in poverty. Even after he had risen to a position of eminence within Tahara Domain, his stipend was never more than 80 *koku*.

As was true of several generations of his ancestors, Sadamichi served not at the castle of the domain in Tahara but at its residence in Edo. His eldest son, Kazan, born and reared in Edo, naturally considered this city, rather than Tahara, as his home. Before being sent into exile in Tahara, Kazan's official residence as a member of the domain, he had visited the dusty peninsula only four times, usually for no more than a few days each time.[23]

The poverty of Kazan's family lasted throughout his childhood and youth. Even as a child, he helped support his family. In 1800, when he was seven, he was chosen to serve as the playmate of the daimyo's son and four years later began to receive a small monthly salary. Despite the increases in stipend that came with his father's promotions, the family never had enough money to meet their needs.

Until this time, Kazan's education seems to have been typical of that of samurai boys. He studied the Four Books of Confucianism and calligraphy and, for pleasure, read books of Japanese poetry and prose.[24] One account has it that his first induction into painting came from a great-uncle who many years before had studied under the same teacher as the celebrated painter Tani Bunchō (1763–1840).[25]

At the age of sixteen, after having been dismissed by his first teacher, Shirakawa Shizan, Kazan became a pupil of Kaneko Kinryō, who introduced him to Bunchō. Although officially Kinryō's student, Kazan also studied with Bunchō, who not only fostered Kazan's burgeoning artistic skills but set the young man an example by rising at dawn each morning. Kazan recorded in a notebook written when he was seventeen that sometimes he rose at 4:00 A.M. and did not go to bed again until 2:00 A.M. Possibly he exaggerated, but he undoubtedly slept very little.

Kazan's paintings became an important source of income for his family. Most either were copies of old masterpieces of both China and Japan or were realistically drawn pictures of dragonflies, butterflies, and seasonal flowers. The choice of subjects was presumably dictated by prospective customers, and he probably turned out as many paintings as he could, relying on his exceptional facility. Kazan, however, was not at liberty to devote himself solely to painting. He had duties to perform each day at the domain office in Edo, and even during his free time, because he believed (as a good samurai) that his life would be poorly spent if he failed to gain a genuine understanding of Confucianism, he spent considerable time reading the classics.

The "lantern pictures" of the young Kazan seem to have disappeared, but some paintings survive from his early twenties. Although they show that he was painting in several styles, most of his works would fit into the category of *bunjinga* (paintings by scholar-artists). A work dated 1814 depicting wild ducks huddled together under a plant by the shore has a somewhat ominous atmosphere. Hibino Hideo wrote that at first glance one might suppose that it was painted under the influence of Kōrin, but the minute detail with which Kazan painted the wings of the ducks and his use of shades of blue and green suggest instead the influence of Shen Nanpin. A painting of 1815 of a Chinese scholar and his docile pet tiger confirms Kazan's allegiance to *bunjinga* traditions and bears an inscription in the hand of Ōta Nanpo, proof that even at the age of twenty-two, Kazan had attracted the attention of the literary world. Other paintings of this period are devoted to Chinese mythical or historical themes. Every aspect of Chinese civilization was of interest to Kazan, as both a painter and a member of the samurai class.

Kazan's earliest surviving writings are diaries and travel accounts. Some were written entirely or partly in *kanbun* (classical Chinese), the language preferred by the samurai as a mark of class distinction. The style of Kazan's *kanbun* tends to be impersonal and is seldom relieved by a lighter touch. He may have chosen this severe style as a means of avoiding sentimentality or

精一非私狩岸
如驯
郎俾不兹婴兒
不親

李元圃

文化乙亥秋此倣馮参仙
圃英山寿寫

Chinese scholar
with his pet tiger
(1815). The in-
scription on the
painting states
that if a human
being treats a tiger
without selfish
intent, the tiger
will be tamed.
(By permission of
the Seikadō Bunko
Art Museum)

"unmanliness," a fault detested by samurai. Kazan had studied
kanbun from childhood days, and he could write without trouble
a factual account and even a conventional poem in that language.
But he seems to have found *kanbun* constricting when writing
about deeply felt experiences; at such times, whatever he was writ-
ing in *kanbun* was apt to break down into Japanese. His letters
were composed in still another language, *sōrōbun*, the epistolary
style, a curious mixture of *kanbun* and Japanese.

Kazan's *kanbun* diaries are not of literary interest, but they pro-
vide valuable information about how Kazan spent his days and
what new acquaintances he made. The oldest surviving document
in Kazan's hand is *Gūgadō nikki*, a diary written mainly in *kanbun*
during the year 1815, when he was twenty-two. Kazan left six such
diaries as well as travel accounts that take the form of diaries.[26]
Gūgadō nikki opens with an account of what Kazan did on New
Year's Day. It was a quite ordinary day. He rose at 6:00 A.M. and
that morning drew "auspicious pictures" and copied a painting
by Shen Nanpin. That afternoon, he copied a work by another
painter. At night he read. He went to bed at midnight.[27] The
entries in the diary are laconic, with no indication of personal
feelings. This is disappointing if one thinks of the long tradition
of diary literature in Japan, but each fact jotted down seems to
reveal an aspect of Kazan's life.

For example, the auspicious pictures (*banji kitchō zu*) he men-
tions were probably painted on commission for the new year;
Kazan painted whatever subject a client requested. If several
clients wanted pictures on a similar theme, he would paint
them regardless of whether or not the theme was congenial,
although he did try to space out works on the same subject.[28]
Thirteen years later, in his diary for 1828, after noting that he
had just painted a picture that someone had ordered, he wrote
as a kind of comment,

> I always think that if I were able now to devote my time to
> copying wonderful paintings and tracing models of calligra-
> phy, my techniques would certainly improve, but my pictures

are all that barely save me from poverty and hunger. Any day on which I fail to make a painting is a day that increases my poverty. And I am not the only one to suffer. Above me, I have two mothers [mother and grandmother] to nourish, below me, a younger brother and a wife to whom I owe my affection. My paintings are like his fields to a farmer or his grounds to a fisherman. How can I not bewail this situation?[29]

The entries in the 1815 diary always mention the paintings he was copying. Although copying paintings was a basic and in-dispensable part of an artist's training, there were no museums where a young painter might examine masterpieces he wished to copy, and he was unlikely to possess masterpieces of his own. Part of the attraction of becoming the disciple of a well-known and successful painter, therefore, was the disciple's access to the master's collection.

Kazan's 1815 diary indicates that he went to Tani Bunchō's studio eighteen times that year and usually spent the whole day copying paintings. He may also have borrowed paintings from Bunchō that he copied at home or in the domain office. No doubt, Bunchō's praise or criticism considerably influenced Kazan and helped form his distinctive art.[30]

The diary is invaluable for what it tells us about Kazan's daily life. He was obliged to serve night duty almost every other night at the domain headquarters in Edo. He gives no details of the work he performed, but it cannot have been very demanding, judging from the number of books he read and paintings he made while on duty. In the first month of that year, he turned out *hatsuuma* (the first horse day in the second month) pictures as well as pic-tures for fans and, somewhat surprisingly, pornographic pictures. Eighteen entries in the diary mention borrowing and copying *shunga* (spring pictures) and several more mention *gōkanzu*, which were probably the same thing. The editors of the 1999 standard edition of Kazan's works replaced the two characters for *shunga* with blanks, perhaps in order not to disillusion readers who be-lieved that Kazan was a model of decorum.[31] Another surprise is

that among the painters he copied that year were Moronobu and
Kōrin, artists who, although not usually associated with Kazan,
seem to have influenced his early development.

Kazan cites many names of acquaintances, but only occasion-
ally does he mention anyone in his family, as when he describes
the sudden death of his maternal grandfather in the penultimate
entry of the diary. This passage is in Japanese, as though the
experience of death was too deeply felt to be narrated in an
artificial language:

> At night a message came saying that my grandfather Hiko-
> zaemon was in critical condition. I was not only stunned but
> had to look after my mother. I then went to my grandfather's
> place, but he had already died. He left the world only a few
> days before the spring of his ninetieth year, so it couldn't be
> helped, but I did not succeed during the course of the day
> in comforting my mother. A steady stream of people, both
> officials and civilians, came to offer condolences. This was
> kind of them, but all I could say was how much I regretted
> it. I went home about eight, submitted an official report, then
> went into mourning.[32]

In the final entry of the diary, Kazan states that he accompanied
his grandfather's body to the Sōgenji, a temple in the Yotsuya
district. The last words of the diary (in *kanbun*) are "At night a
bout of my usual complaint," referring to the stomach cramps
that would trouble him for the rest of his life.

Kazan's diary for the thirteenth year of Bunka (1816) is en-
titled *Kazan sensei manroku*.[33] The text contains a greater propor-
tion of Japanese writings (including a number of *haiku*) than the
earlier diary does, but the tone is similar. On a typical day he
arose about 6:00 A.M., had a bath in the morning, and painted in
the afternoon. At night he performed his customary duties at the
domain office. He did not get to bed until after 2:00 A.M. Some-
times he was so absorbed in copying works of the old masters
that he did not sleep the entire night.

Kazan frequently met other painters, visited shows of their works, and borrowed their copies of famous paintings. By this time, he had become so accomplished at judging paintings that after attending an exhibition he did not hesitate to declare that both a landscape attributed to Sesson and a portrait attributed to Kanō Motonobu were fakes.[34] He often visited the studio of his master, Tani Bunchō, not only to study and copy works in his collection but also to obtain advice on such specific problems as which pigments to combine in order to obtain a desired color. Kazan and his friends organized a society of painters called the Kōotsu-kai, which included a few senior men like Tani Bunchō and Kaneko Kinryō, although most of its members were still in their twenties.[35] They seem to have been about equally interested in Japanese and Chinese art. Not much is known about the society's activities, but according to the rules drafted by Kazan, the members were expected to bring to meetings a maximum of three unsigned paintings each, and, while eating a simple meal, they were to judge one another's work.[36] Probably the chief attraction of the society was the pleasure of the company of fellow painters. The most important event in the diary, even though it is mentioned casually, was Kazan's meeting with Tsubaki Chinzan (1801–1854), who would become his most accomplished disciple. Kazan's letters on art, written while in exile, were addressed to Chinzan.

The phrase *kokorozashi ni motorite* (contrary to my wishes) occurs several times in the diary, generally just before mentioning the time wasted in worldly gossip or in "mistaken actions," whatever they might have been. It is easy to obtain the impression from this self-condemnation that Kazan was a straitlaced young man, but we also can gather from his writings that this was not always so. His well-known portrait of a geisha, reproduced in most books that discuss Kazan, has a long inscription in Chinese that begins

Wangyan of Chin disliked copper coins; Ouyang Xiu hated flies; Su Dongpo disliked *go*. Every human being has his likes and dislikes. In my case, what I like is women. For me to

sleep with a geisha, she must be pretty. That's what I like best. A person without desire for food and drink and for sex is not a human being.[37]

All the same, Kazan was basically not a playboy, and he devoted himself to painting in every minute of available time. In 1818 he produced his first major work, *Issō hyakutai* (*A Clean Sweep: A Hundred Aspects*). It was completed, he said, in barely a day and two nights, an extraordinary achievement.

Genre Paintings and Early Portraits

3

Issō hyakutai (*A Clean Sweep: A Hundred Aspects*)[1] consists of thirty-one double pages filled with sketches of life in Edo. Kazan wrote that he completed the little book in a day and two nights, but it does not seem to have been completed so much as abandoned. Brief notations on the sketches indicate changes that Kazan planned to make, and the last pages of the booklet lack the coloring applied to earlier ones. In addition to the paintings, the work contains three short essays, each a page or two long, placed at the beginning, middle, and end of the whole. The main theme of all three essays is Kazan's contention that *fūzokuga* (genre paintings) serve a legitimate and serious purpose.[2]

The inclusion of the three essays, composed in classical Chinese as though to lend them dignity in a booklet otherwise devoted to seemingly lighthearted sketches, indicates that Kazan intended to publish the work, but although it was more or less ready in 1818, it did not actually appear for another sixty years, when a facsimile edition of the unique copy was published in Tahara, the site of his exile.[3] Since then, the artistic value of *Issō hyakutai* has gradually been recognized, and it

is now classed as an Important Cultural Property. A page or two of the work is often reproduced in books devoted to Kazan's art, but it has attracted comparatively little scholarly attention, perhaps because specialists find it difficult to deal with a work of disarming humor.

Unlike the sketches, the essays are seriousness itself. The first opens with a rather ponderous defense of genre painting in China and Japan.[4] Kazan declares that paintings in this style should not be dismissed as mere trivialities, even though they usually depict humble people performing their mundane occupations or diverting themselves in plebeian pleasures. Like any worthy art, genre painting possesses moral importance because it encourages virtue and chastises vice. As applied to literature, this Confucian ideal was associated especially with the didactic novels of Takizawa Bakin (1767–1848). Although Kazan was acquainted with Bakin,[5] long before the two men met he probably had acquired the conviction from his study of Confucianism that art must possess moral value.

Bakin may have influenced Kazan in a different respect: for all his Confucian moralization, Bakin also wrote distinctly light-hearted works, and Kazan may have been encouraged by this example to decide that even seemingly frivolous sketches can convey Confucian doctrine, although in a palatable manner. It is difficult, however, to discover moral teachings in the pictures that make up *Issō hyakutai.*

In the first essay, Kazan praises three Japanese artists of genre painting[6] for their surpassing skill but regrets that as the result of catering to the preferences of the people of their time, they at times produced works of deplorable taste. He is even more critical of Yosa Buson (1716–1783) and Maruyama Ōkyo (1733–1795), who depended on technical facility when painting genre scenes to cover their lack of mastery of painterly traditions. He blames these men for the coarseness to which their followers stooped, so extreme at times as to make people nauseated. It is hard to imagine what in the works of these men would have produced such an effect, but perhaps their manner offended those who

shared Kazan's Confucian conception of the necessity of moral significance in art. Some artists, he adds, were so afraid of becoming contaminated by the vulgarity of Buson's and Ōkyo's followers that they no longer painted genre scenes. Others, deciding that genre painting was no more than the work of mere artisans, haughtily refused to depict the life of their own time, preferring to evoke, in the Chinese manner, the loneliness of tiny figures in landscapes dominated by towering mountains.

Kazan felt such confidence in his own knowledge of the techniques of painting that, although still in his twenties, he felt qualified to criticize masters of genre painting like Buson and Ōkyo. Despite his criticism, harsh or gentle, of all the men he cites in his essay, Kazan believed that genre painting is the variety of art

Goldfish seller and
other Edo street people.
From *Issō hyakutai* (1818).
(By permission of the Tahara
Municipal Museum)

that, more than any other, is capable of capturing daily life, in this way enabling people of the future to know what life was like in the artist's time. Kazan realized this possibility brilliantly in *Issō hyakutai*. It is hard to think of another work that so effectively depicts the lives of the people of Edo during the waning years of the Tokugawa shogunate.

Following the first essay are ten sketches of Japanese mores from the fourteenth to the mid-eighteenth century. The sketches are presented in chronological order and are dated by the name of the reigning emperor and the reign-name (*nengō*). The detailed attention that Kazan gave to changing fashions in clothes and hair styles during the successive periods indicates how carefully he had studied genre paintings of the past. The pictures in this first part of *Issō hyakutai* are lively, skill-fully composed, and marked by touches of humor, but perhaps because they are re-creations of the past rather than scenes that Kazan had personally observed, they are less exciting than the depictions of contemporary life that follow them.

Each page of the main body of *Issō hyakutai* is filled with people, some busy at their work and others merely onlookers of life on the streets and inside the buildings of Edo. Almost any page is typi-cal of the whole booklet, but one particularly effective page has at the top a goldfish seller of distinctly plebeian features. He sits cross-legged on the ground before his tub of fish,

a pipe in his mouth and a net in his hand. A little boy, his father bending affectionately over him, holds out a bowl for the goldfish man to fill. To the right, a nursemaid and an infant are watching two turtles, tied with strings to a box, as they struggle to escape. In the middle of the page, a man walks by carrying a wicker basket filled with chunks of *kamaboko* (fish paste). A dog, attracted by the smell, pokes his head into the basket. At the bottom of the page, two men pass, going in opposite directions. One, a samurai, is dressed in stiffly starched clothes; the other, a harried-looking commoner, carries a bundle slung over one arm. The S-shaped construction of the page draws the viewer from one figure to the next, each different in appearance and expression.

There is generally no sharp break dividing two facing pages in *Issō hyakutai,* but turning a page may shift the scene from the bustle of an Edo street to the interior of a theater where a cluster of men sit on the floor and listen to a *rakugo* raconteur or to a room where a woman accompanies on her samisen the lessons in singing that she is giving to a man whose woeful expression reveals that he is fully aware of the ineptness of his performance.

Each page catches people in attitudes that reveal something of their way of life. Outdoors, people carry the tools or appurtenances of their profession: baskets on carrying poles, umbrellas, lanterns, trays. They range downward in social class from samurai to a man who squats on the ground and repairs footwear. In the street, a dentist pulls teeth; two high-ranking courtesans with elaborate headdresses go by; some people play musical instruments while others lean over a chessboard. Indoors, men and women sit around a charcoal brazier and exchange gossip. We see them as they pour themselves cups of tea or saké, eat from pots that boil on the hearth, or simply doze. Each page is a marvel of variety and animation.

Kazan's unerring choice of details makes us feel certain that he had witnessed each of the sights he depicted. No doubt his skill at drawing quickly, the product of years of dashing off *hatsuuma* lantern paintings, accounted for his ability to catch gestures or actions that lasted for only a moment but typified the people

portrayed. Kazan was never without a notebook in which he made sketches. Miyake Tomonobu, a friend and patron, wrote in a brief biographical account,

> Sensei always carried a notebook of *ganpi* paper tucked into his kimono. Even when he visited a government building, he never put the notebook aside. If anything struck his attention, he would invariably make a sketch, even if he was walking along the street or traveling in a palanquin on official business. If piled one on top of the other, these little notebooks would have been as tall as he.[7]

Kazan painted the people of *Issō hyakutai* with affection but did not try to make them quaint or otherwise endearing. One feature that sets off this booklet from *ukiyoe* art is that not all the women portrayed belong to the demimonde. They include housewives who sew and wash kimonos as well as a woman, obviously poverty-stricken, who leads a small child with one hand, holds a baby at her breast, and carries a wooden tub on her head.

The two most often chosen representative scenes of *Issō hyakutai* are both double pages that make up a single composition. The first depicts a *terakoya* (temple school) where three pupils sit in front of their teacher and intone something from the Chinese classics while all the other boys are fighting, screaming, and doing everything but practicing the calligraphy lesson on the desks before them. The next best-known sketch shows a daimyo's procession. Far from stately, it is a scene of tumultuous confusion, crammed with figures going off in different directions. The daimyo is all but blotted out by the unruly samurai surrounding him. It is tempting to attribute the disorderliness of the scene to Kazan's remembrances of his experience as a boy, when he was swept into just such a procession and was beaten by a samurai for having had the audacity to intrude on the pandemonium.

Another crowded scene shows people swarming into a gallery where there is a vernissage of an artist's work. Pages are also devoted to depictions of samurai at martial sports. Although

this enchanting book contains a bit of everything that made up the city of Edo, it is relatively little known, no doubt because of the overwhelming popularity of the series of *manga* (cartoon) books published by Hokusai, the first of which appeared in 1814, four years before *Issō hyakutai*. In Jack Hillier's words, Hokusai's book "immediately achieved almost universal popularity, greater probably than any other Japanese picture book up to that time. And what is more extraordinary, as soon as it became known in the West, it rapidly became equally widely acclaimed there."[8]

Hokusai may have initially inspired Kazan to make this little book of genre scenes, but the enormous success of Hokusai's series of *manga* books, eight of which had appeared by 1818, may also have made Kazan abandon hope of publishing *Issō hyakutai*.

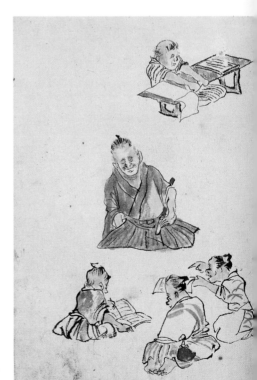

Classroom in disorder.
From *Issō hyakutai* (1818).
(By permission of the Tahara
Municipal Museum)

If Kazan's book had appeared at the same time, Hokusai's great reputation might have led people to suppose that Kazan had merely imitated him, but *Issō hyakutai* in fact does not much resemble Hokusai's *manga* collections. Whereas Kazan's book is devoted entirely to life in Edo, as Hillier has pointed out, Hokusai's first *manga* collection contains pages of

> animals, birds, insects, flowers and fish until, at last, two double-page prints are devoted to a mountainous landscape and a seascape with many ships and a raft. Then follow pages of trees, grasses, cottages, villages, bridges, rivers and waterfalls—it is almost as if there was an intention to provide a comprehensive range of models for a would-be painter, on the same lines as an explicit instructional manual.[9]

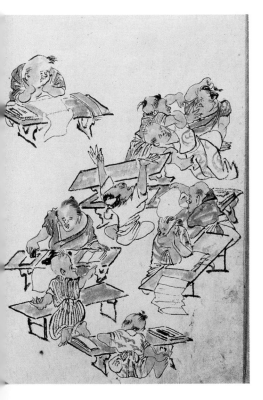

Hokusai's *manga* seem to have been created for the benefit of students of painting. This feature is most apparent on such pages as those devoted to "sparrow dances," on which little figures, seen from behind, gyrate arms, legs, and torso in a frenetic dance, presumably to teach apprentice painters how to depict the human body in every form of movement. *Issō hyakutai* had no such pedagogic intent. Kazan sought instead to depict Edo life in all its variety in the hopes of delighting present viewers and arousing nostalgia for the Edo of

his day in people who would look at the sketches in centuries to come.

The third of the three essays in the book (although it probably was composed first) contains a tantalizing clue to the inspiration of the work. Kazan opens by stating his reason for having chosen to depict ordinary citizens of Edo rather than members of the aristocracy or peasants: it is equally true of both those who live in palaces and those who live in farming villages that they experience little or no change in their lives from generation to generation. Only in the capital (by which Kazan means Edo) does a love for novelty give rise to incessant change. Perhaps Kazan felt the desire to capture a day in the ever-changing life of Edo, preserving it for all time.

Kazan pays tribute in the third essay to one Hayashi as the first to succeed in using urban life as the subject of painting. But even Hayashi unfortunately followed at times in the footsteps of Ganku[10] and Buson, falling into exaggeration and distortion that destroyed the realism in his works. Kazan admits that he was no match for Hayashi and recognizes that his own paintings could stand improvement because of the haste with which they had been executed. But he believed that at least some were of value, and he asks the indulgence of those who would view them.[11]

The first question that arises is: Who was Hayashi? Although Kazan otherwise names only well-known painters in the three essays, Hayashi does not appear in any work about Japanese art and nothing is known about his life. A Hayashi, possibly the same man, is mentioned in Kazan's diaries for 1815 and 1816, but almost none of Hayashi's paintings has survived. Yoshizawa Tadashi, a specialist in Kazan's art, has suggested that Kazan may have used Hayashi as a kind of pseudonym for Hokusai,[12] not wishing to use the real name lest it call attention to his indebtedness to Hokusai's *manga*.

Kurahara Korehito, however, believed that despite his obscurity, Hayashi really did exist. Kurahara discovered in Tahara a painting by Hayashi Hansui (a portrait of Duanmu, one of Confucius's "ten disciples"), along with a note stating that it had

been painted for Tahara Domain in 1816 on commission from Watanabe Kazan.[13] This discovery may have cleared up Hayashi's identity, but if it did, it also created another mystery: Why should Kazan have credited Hayashi with having been the first to paint urban life successfully while ignoring Hokusai, the great master of genre painting? Nor is it clear what Kazan admired in Hayashi. If the mediocre portrait of Duanmu was typical of Hayashi's style in 1816, two years before the completion of *Issō hyakutai*, he could not have exerted much influence on Kazan.

Kazan probably did intend to publish *Issō hyakutai*, but it was never printed during his lifetime, perhaps because he had not quite completed the work, as we can infer from the unfinished state of the last pages and the corrections. If Kazan hoped that the booklet would bring in income, he must have been disappointed. Today it still is in the shadows, but each of the pages, crammed with people, is worthy of examination, and the whole is a delight.[14]

Three years later, in 1821, Kazan produced a work in a totally different vein, the first and, in the opinion of some, the best of the portraits for which he is remembered today. His portrait of the Confucian scholar Satō Issai[15] is a powerful creation, with a three-dimensional quality not encountered in earlier Japanese portraits. Unlike *Issō hyakutai*, dashed off with incredible speed, this portrait was achieved only after numerous preliminary studies. In the second version, for example, Issai's face looks almost forbiddingly intense, but in the third the expression is softened by the suggestion of a smile. By the eleventh version, Issai's expression has become pensive and even withdrawn. The expression of the final version (the only one on silk rather than paper) is resolute, and Issai's eyes are penetrating. In some instances, Kazan's preliminary sketches for a painting were more vivid and produce a more powerful effect than the finished work, but here the final version is the most successful in communicating not only what Satō Issai looked like but the strength of his Confucian beliefs as well.

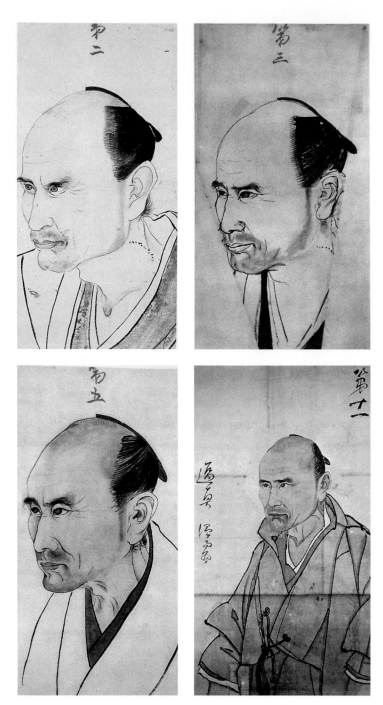

Four of eleven studies for the portrait of Satō Issai (1821): (*above left*) version 2, (*right*) version 3, (*below left*) version 5, (*right*) version 11. (Private collection)

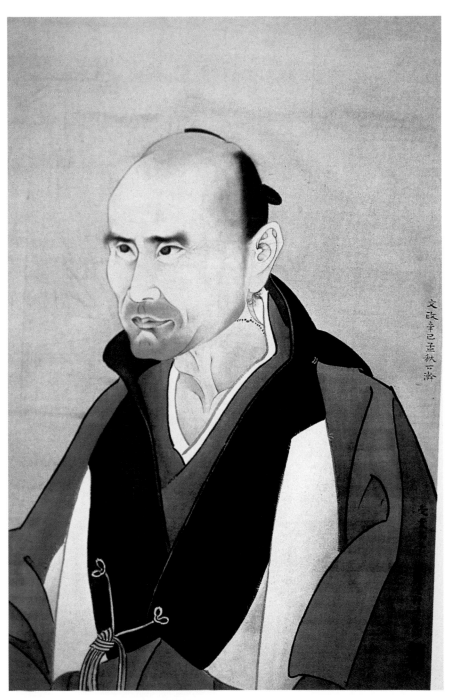

文政辛巳盃秋□澥

Finished portrait of Satō Issai (1821). (Private collection)

This portrait is without precedent in Japanese art. In the centuries following the painting of Prince Shōtoku, Japanese portraits were most often of high-ranking Buddhist priests and nuns, as well as many of emperors, members of the aristocracy, and military men. There even were some portraits of poets, going back in time as far as Kakinomoto Hitomaro (active late seventh century). These paintings occasionally succeeded in capturing the sitter's individuality. No one who has seen the fifteenth-century portrait of Ikkyū by Bokusai is likely to forget the face of this extraordinary man. But most often the portraits of emperors and statesmen show small, decorative heads emerging from sharply angled, bulky layers of clothes. With his round face and tiny display of whiskers, Emperor Toba could easily be mistaken for the Shining Prince Genji as depicted in celebrated scrolls. A few men (like Oda Nobunaga and Toyotomi Hideyoshi) were painted so often that it is not difficult to recognize them, regardless of the artist, whereas others, like Ashikaga Yoshimasa, look different in each portrait.

The portrait statues were more realistic than the paintings. They were generally of priests and nuns (including priests who had only recently "abandoned the world"). Moreover, some of the portrait sculptures are not only startlingly realistic but are more beautiful than the painted portraits. Not until Watanabe Kazan borrowed from Europe the techniques of shading did portrait paintings acquire the depth and solidity of the features' contours long since characteristic of the sculptures.

Close resemblance to the subject's features was not, however, considered to be essential.[16] The most extreme examples of indifference to achieving facial resemblance are found in such scrolls as the *Satake sanjūrokkasen shō*, in which some lady poets are portrayed from the back, the cascade of black hair falling over their kimonos taking the place of a face. Portraits of emperors were commonly made after their death, by painters who had never had so much as a glimpse of their subjects. In that case, it was quite sufficient to convey the impassive majesty of the late emperor; realistic detail was unnecessary and unwanted.

Kazan clearly wished his portraits to be both a realistic depiction of the subject's features and an evocation of the personality. In his letters to his disciple Tsubaki Chinzan on the techniques and objectives of art, Kazan repeatedly insisted that a picture must look like the object portrayed. An anonymous mountain somewhere in China, the kind frequently portrayed in traditional Japanese landscapes, was of no interest to Kazan. Rather, a mountain, like a face, must be individual and unmistakable.

The series of at least eleven numbered preliminary sketches that Kazan made for the portrait of Satō Issai was unprecedented. His teachers, like Tani Bunchō, were highly accomplished artists who easily painted in a variety of styles. Kazan was no doubt influenced by Bunchō in many of his works, but not in his portraits. Having no teachers or predecessors to guide him in his quest for realism in portraiture,[17] he had no choice but to experiment. Even the second version of the portrait of Satō Issai[18] is impressive, but Kazan was not satisfied. Of the surviving versions, it was not until he reached the eleventh that Kazan showed more of Issai than the head and neck, and this expanded view was retained in the definitive work. The successive stages of Kazan's attempts to achieve a portrait that truly represented his teacher Satō Issai indicate how difficult he found it to attain his goal of reality.

It is a commonplace of art criticism to say that Kazan's portraits reveal his indebtedness to European painting. Undoubtedly there was European influence, especially in the use of shading, but the portrait of Issai preceded Kazan's serious interest in the West. Even if he had seen engraved portraits in Dutch books, they would have been stiff, formal likenesses of princes and eminent men that could not have inspired his intensely human portrait of Issai.[19]

Although Kazan probably never saw an oil painting, he may have seen reproductions. We know about his interest in oils from the formula he jotted down for making oil for use in painting. It is inscribed in a notebook next to a drawing of Jeanne d'Arc that was no doubt traced from an engraving in a Dutch book.[20] Kazan also made copies of a few European portrait sketches, including

one of Edward Bright, whose chief distinction, as described in the accompanying Dutch inscription, was as "an extremely fat Englishman."[21] Kazan, like many other scholars of the time, drew a portrait of Hippocrates,[22] probably based at least indirectly on a Dutch original, but no European example can be shown to have directly influenced the techniques he employed in his portraits of Japanese contemporaries.

Kazan did not learn much about portrait painting from Japanese predecessors either. He was certainly not inspired by the traditional portraits of emperors and monks, painted with cavalier indifference to resemblance. Even portraits of recent times that incorporated European elements, like the famous portrait of a European woman by Hiraga Gennai, could not have helped Kazan when he set about making Issai's portrait. Other Japanese painters in the "Dutch" style, like Shiba Kōkan and the artists of the Akita school, despite their skillful use of perspective in their landscapes, did not attempt to create European-style portraits. Kazan may have seen the portraits of Dutch merchants on Deshima painted by Kawahara Keiga (1786?–1860?), but these totally lack the dramatic intensity of Kazan's portraits, beginning with that of Satō Issai. Perhaps the most noticeable Japanese influence in Issai's portrait is the absence of a background; a European portrait of that period would have had a landscape, a building, or at least ornamental drapes behind the sitter.[23]

Kazan also painted in 1821 a portrait of his younger brother Gorō. The plump, innocent features of this boy of five are endearing, but the portrait is more in the traditional Japanese manner of a quick sketch than in Kazan's newly created style of portraiture.

Kazan's difficulties mounted in 1822 when several members of his mother's family moved in with the Watanabes. To pay for the additional burden on the family's finances, Kazan threw himself into painting, but the money he received from sales of his works could not keep up with the additional expenses and he went heavily into debt. The next year saw no improvement in his finances, but several of his paintings, presumably works that he

really wanted to paint and were not commissioned by a customer, are of special interest.

Kazan's portrait of the Confucian scholar Tachihara Sui-ken (1744–1823) is of a man of about eighty, unshaven, eyes penetrating, thin lips tightly drawn—a forbidding rather than a benevolent face.[24] Suiken died in the third month of 1823. The original painting was probably made shortly after Suiken's death, even though this did not accord with Kazan's preference for repeated observations and sketches of his subjects. Kazan

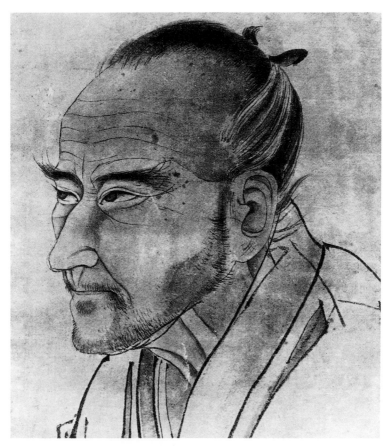

Portrait of Tachihara Suiken (1823). (Private collection)

had at least met Suiken, whose son Kyōsho was a friend, but when he painted in the same year a portrait of the Confucian scholar Fujiwara Seika (1561–1619), he depended for the features on an old portrait by Kanō Einō (1631–1697). This portrait of Japan's first major Confucian scholar was a gift to his teacher Satō Issai, who thirty years later would add an inscription to the painting.[25] Although skillfully painted, it is not one of Kazan's memorable portraits; rather, it seems like a throwback to more traditional Japanese portraiture.

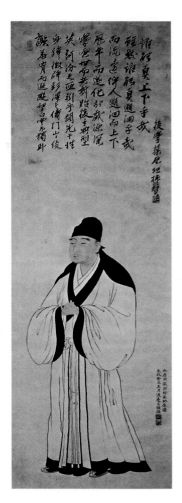

Portrait of Fujiwara Seika (1821).
(By permission of the Tokyo National Museum)

In the following year, 1824, soon after his father's death, Kazan painted his portrait. Kazan always evinced the highest respect for his father, a model of samurai probity and culture, but for years the father had been confined to his bed, and Kazan probably had fewer occasions to confide in him than in his mother, who became the most important person in his life.

We can see from the preliminary sketches the difficulty Kazan had putting down on paper his father's likeness. Even though the father's face was wasted by the long years of illness, Kazan wanted to portray him not as an invalid but as a samurai. He therefore drew his dead father's head from different angles, perhaps trying to discover a characteristic pose, but the father looked sadly unlike the samurai Kazan wished to paint. It is said that Kazan was so carried away by grief that he wept and sobbed even as he painted. Evidently not satisfied with the portrait, he left it unfinished. The sketches of the dead father are almost unbearably moving, but the unfinished portrait was not a success. In this portrait, as in some others, Kazan devoted almost his entire attention to the face, leaving the hands, like the clothes, perfunctorily drawn. Least successful of all is the sword by his side, the symbol of the father's status as a samurai.[26]

One other painting of about the same time compels attention, the portrait of the giant Ōzora Buzaemon. An inscription gives details of his measurements (he was more than seven feet tall). The date 1827 and Kazan's seal are at the lower right corner. Inside the mounting is pasted a text written in Satō Issai's hand:

On the eleventh day of the sixth month of 1827, Ōzora Buzaemon visited me. Watanabe Noboru, a retainer of Miyake Bizen-no-kami, happened to be present. He made a perfect copy of Buzaemon's features, using a *shashinkyō* [camera obscura] which he held up to Buzaemon's face. The portrait was exactly the same as the one I own. When this Buzaemon sat down, his hand extended to the lintel. The ceiling was three feet above the lintel, but when Buzaemon stood and stretched out his hand, it touched the ceiling.[27]

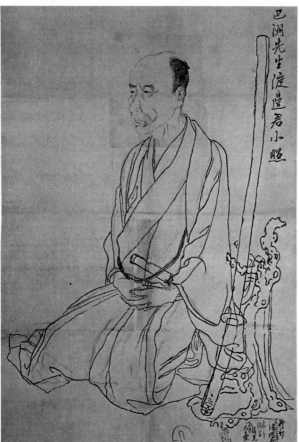

邑
洲
先
生
渡
邊
君
小
照

Sketches for the portrait of Watanabe Sadamichi, Kazan's father
(1823). (By permission of the Tahara Municipal Museum)

Portrait of the giant Ōzora Buzaemon (1827). (By permission of the
Cleveland Museum of Art)

Buzaemon arrived in Edo in the fifth month of 1827, when he was twenty-four. Despite his frightening size, he was mild-mannered and even timid. Rumors of the giant excited the curiosity of the people of Edo, and dozens of woodblock prints were published to meet the demand. But when some pornographic examples appeared, the authorities stepped in, and no more prints were permitted.

Buzaemon hated being stared at, and while he was in Edo, he tried never to go outdoors. His only desire was to leave as quickly as possible. During his stay, Buzaemon frequently visited persons of distinction in the company of his master, the daimyo of Kumamoto. One month after his arrival in Edo, Buzaemon and the daimyo visited Satō Issai. On this occasion, Watanabe Kazan used a camera obscura to paint Buzaemon's portrait.

Buzaemon was later invited to the residence of Hayashi Jussai, the head of the Shōheikō, a Confucian academy. Kazan also was invited; no doubt Jussai thought that if Kazan painted another portrait, it would add to the festive nature of the party. Trying to comfort Buzaemon, Jussai told him that being so tall was nothing of which to be ashamed. He should henceforth appear before others with a proud expression on his face. After these words, Jussai gave a great laugh that threw his words of comfort into doubt.

Bakin described the occasion: "Hayashi Jussai invited Buzaemon to his residence so as to get a good look at him. My friend Watanabe Kazan also was present. Sitting in the back of the room, he shone Dutch mirrors and drew a portrait of Buzaemon's entire body." Bakin stated that using two crystal mirrors made it possible for Kazan to paint a picture that looked exactly like Buzaemon.[28] The resulting portrait impressed people by its close resemblance to Buzaemon's face and body. Buzaemon's handprints also confirmed the precision with which Kazan had made his portrait. Although Kazan's passion for realism been satisfied, this is not one of his most appealing works.

Okado Kazuyuki, who wrote a detailed study of the portrait of Ōzora Buzaemon, claimed that it was not a true portrait,

achieved by the use of perspective and shadowing, as in Kazan's major works, that it was nothing more than the representation of a freak.[29] This criticism seems to miss the sadness in Buzaemon's face. This is not the portrait of a "freak" but of a man doomed to lead a tragic life. It would be surprising if Kazan did not feel this.

Travels
and Career

4

Kazan's accounts of his travels are among the most enjoyable parts of his work, thanks to the enchanting illustrations. Travel accounts, often written in a poetic manner, had a long history in Japan, going back to *The Tosa Diary*, written by Ki no Tsurayuki in the tenth century. Although travel in Tsurayuki's day and even much later was slow and sometimes dangerous, this did not daunt the Japanese, who loved nothing more than making journeys to sacred places and to the sites that had inspired the poets of the past.

These accounts circulated in manuscript and, over the centuries, induced many readers to follow in the footsteps of the authors. Unlike typical Western travelers, the Japanese did not aspire to be the first to set foot on a certain mountaintop or the first to spoil a hitherto unspoiled village. Rather, they preferred sights that earlier visitors had many times described, and even if they were aware, for instance, that the Eight Bridges and the irises, mentioned by Ariwara no Narihira in the tenth-century anthology *Kokinshū*, had rotted away centuries earlier, they were determined to visit the site, if only to compose a poem on the ravages of time.

A different kind of travel account began to be written during the Tokugawa period. The authors described their experiences in a resolutely prosaic style, showed little interest in religious matters, and, skeptical of old legends, were at pains to debunk them. Kaibara Ekiken (1630–1714) was typical of this new breed of diarists. His inquiries into the true nature of things led him to investigate the waves at Wakanoura, a bay celebrated in poetry because there were said to be "male waves" (*onami*) but no "female waves" (*menami*). Ekiken explained, "By 'male waves' is meant big waves, and by 'female waves' is meant small waves. I have never believed this story." Accordingly, he spent time at the bay carefully observing the waves and reached the conclusion that just as at every other beach, Wakanoura had both male and female waves.[1]

Kazan's early travel accounts, written in *kanbun*, were at first in much the same prosaic mode as Ekiken's, but after he shifted to writing in Japanese, they became more literary and even at times deeply moving. Although Kazan enjoyed sightseeing, he traveled surprisingly little. Apart from four journeys to and from Tahara, he did not go beyond the bounds of the Kantō region. In part, this was because as a samurai on active duty, Kazan was not at liberty to leave his post at the domain residence in Edo whenever it pleased him. His journeys almost always had some justification (at least nominal) involving domain business; but this did not prevent him from describing the people he met or the scenery he admired on his journey.

Kazan's *Tōkaidō kago nikki* (*Diary of a Journey by Palanquin Along the Tōkaidō*) describes a trip he made in 1818 from Edo to Tahara in the company of his master, Miyake Yasukazu, the daimyo of Tahara. Although as a member of Tahara Domain, Kazan was officially domiciled in Tahara, he went there as little as possible. This was only his second trip to Tahara. The journey took six days, with stops at various places of interest along the way. After spending about a week in Tahara, Kazan headed back to Edo without his master. The diary, in a mixture of *kanbun* and Japanese, contains the names of every place Kazan visited, but he rarely had anything to say about them. He evidently was still feeling his way as

a diarist, but the illustrations of the return journey from Tahara to Edo make up for the lackluster prose.[2] By this time, he was clearly an accomplished artist. In the following year (1819) Kazan staged a well-attended exhibition of his paintings at a gallery in the Nihonbashi section of Edo.[3]

In 1821 Kazan wrote *Yūsōki* (*Visit to Sagami*),[4] his earliest travel account.[5] Unlike the matter-of-fact diaries that preceded them, the travel accounts have literary interest and are enhanced by Kazan's illustrations.[6] *Yūsōki* describes the journey Kazan made with Miyake Yasuteru, the younger brother of the daimyo of Tahara, who was traveling with several companions from Tahara to Edo. Kazan went part of the way to meet them and then guided the party by the scenic route—Kamakura, Kanazawa, and Enoshima—before reaching Edo. The purpose of the journey seems to have been to give Yasuteru, who was likely to succeed his ailing brother as daimyo of Tahara, an education in the basics of Japanese history.

Kazan had no special knowledge of the temples and other buildings in Kamakura, but he made good use of guidebooks and occasionally asked locals about places they passed. In Kamakura they visited the main Zen temples, the Tsurugaoka Hachiman Shrine, and other celebrated religious sites, and Kazan recalled (or found in his guidebook) historical events related to each. He noted without explanation that they were refused admittance to the convent Tōkei-ji. We know that it was because men were not permitted inside the precincts of this temple, to which unhappy wives fled in order to be protected from abusive husbands.

The high point of the short account occurs after the party had crossed to the island of Enoshima. Kazan, gazing over the sea, gave a great shout, "How wonderful! How marvelous! From here to the southeast is what the Westerners call the Pacific Ocean and the American states! They must be very close! That's why Uraga and Miura are so vital."[7] Although Kazan lived fairly near the sea in Edo, and at Tahara the sea was distressingly close, this may have been his first vivid realization that on the other side of the Pacific, not so very far away, was America.

In later years, Kazan continued to travel occasionally, even after becoming more deeply involved in the domain's administration. *Shishū shinkei* (*True Views of Four Provinces*),[8] written in 1825 in a mixture of *kanbun* and Japanese, consists mainly of the names of people he met and the features of places passed on the journey. The most interesting moment of the narration is the bare account of what Kazan heard about some Japanese castaways who had been rescued by a foreign ship in the spring of that year. The return of castaways, picked up on some lonely island in the Pacific, had served since the eighteenth century as a pretext for foreign countries to ask the Japanese to permit trade, and these futile attempts would continue well into the nineteenth century. It is disappointing that Kazan had no comments to make about the castaways' fate, although a few years later he would show great concern on learning that shore batteries had fired on a foreign ship with rescued Japanese castaways aboard.

The main reason for looking at *True Views* is the thirty landscapes with which Kazan illustrated the work. Although the pictures are relatively small,[9] they superbly display Kazan's many-faceted talents as a painter. They probably were drawn quickly, perhaps sketched from the deck of a riverboat, but with absolute surety of line. Many have a poignance that may suggest to a modern reader that Kazan, foreseeing the great changes ahead, wished to preserve for people of the future the appearance of Japan in his own day. If this was in fact his intent, we must be grateful to him, as none of the places he magically evoked retains its charm today. These sites were not of especially poetic or religious significance, but as his sketches demonstrate, even ordinary villages and landscapes were worth remembering.

The first sketch shows a guardhouse on the bank of the Naka River where ships heading for Edo were inspected for possible weapons or suspicious passengers. The guardhouse is not imposing. Far from it: the two little buildings are crudely constructed, and their chief armament seems to be some piles haphazardly driven into the riverbank. In each building is a figure, a man in the guardhouse and a woman in the smaller building behind, both

Guardhouse on the Naka River. From *True Views of Four Provinces* (1825). (Private collection)

exceedingly unintimidating. The douanier Henri Rousseau may have cut a figure similar to the man in the guardhouse. The man and the woman in the painting serve, like others in the *True Views* series, to give a specifically human dimension to the scene. Unlike the tiny figures in Chinese landscapes who communicate the smallness of man amid the grandeur of nature, these people make us see instead how small and unthreatening a guardhouse was in peaceful Tokugawa Japan.

Kazan and his companions continued their journey by river, observing the landscapes. The sketch of the grassy plain of Kamahara is one of the most affecting, conveying (despite its small size) the vastness of a still plain where horses safely graze. The sky, seldom of importance in Japanese paintings because moun-

tains usually dominate, is as prominent here as in a Dutch landscape. The picture is given particular appeal by two figures who trudge a path through the fields, most likely a man and his small son. The colors used for this utterly peaceful scene are a pale green for the fields, shades of brown for the horses, and one small patch of blue for the boy.

Kazan used only four colors—brown, green, blue, and red—in the sketches, perhaps because carrying a full range of pigments would have been an encumbrance on a journey.[10] But the quality of the paper is exceptionally good, an indication that Kazan anticipated that his depictions of the journey would turn out well.

Other sketches take us into the towns. The best known shows the pleasure quarter in Itako, a town famous for its six brothels.

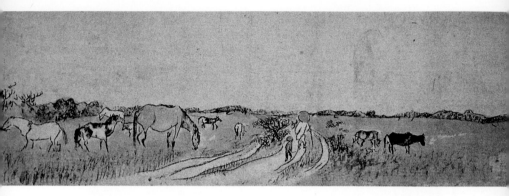

Grassy Plain of Kamahara. From *True Views of Four Provinces* (1825). (Private collection)

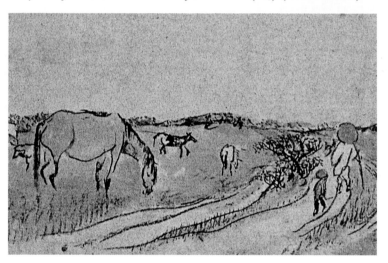

Detail of *Grassy Plain of Kamahara*.

As a man of the world, Kazan was not repelled by the immorality. The picture is almost entirely in shades of brown—the gate to the quarter, the fence around the houses, and the brothels all are shades of brown. Here and there are spots of red—for the lanterns outside the houses, the kimonos of women looking out from upstairs windows in the brothels, and a woman with two children[11] on the main street of the quarter. The street itself is drawn with perspective, a technique Kazan may have learned from

Dutch books.[12] There is nothing remarkable about the scene.
Similar pleasure quarters were found all over Japan in Kazan's
time. But because they do not exist any longer, the sketch gives
the quarter in Itako a nostalgic-making appeal it probably never
originally possessed.

Another town scene bears the title *The Residence of the Magistrate
at Shinmachi Ōte*. This sketch is dominated by houses with tiled
or thatched roofs. The buildings are crowded together, but they
have a solid dignity that would be hard to find anywhere in
Japan today. Two shops are visible: on one side is a pharmacy
(the shop sign says "ginseng"), and on the other is a liquor
store. Two travelers pass, one with a walking stick in hand, and
the other carrying a burden over his shoulders. The scene is
by no means dramatic, but Kazan's evocation of a disappeared
world may bring tears.

A group of sketches depicts towering rock formations along
the coast. In the most striking, *Uranaka*, menacing rocks are drawn
in shades of brown and dark green with geometric simplifica-
tion—harsh angles, perpendicular sides, dagger-point crests—
and crashing waves between the rocks. This might be mistaken
for a Cézanne if there were not two small, telltale Kazan travelers
at the foot of the rocks. It is an unforgettable scene, without
prototypes or successors.

These sketches and the rest of the thirty in *True Views* display
Kazan's extraordinary versatility. They are far more alive and ex-
citing than even the best of his *bunjinga* of the same period,[13] but
Kazan had to paint what his patrons desired, and the prevailing
preference was for birds and flowers, not Japanese landscapes.

In the fifth month of 1827, Miyake Yasuteru died in his twen-
ty-eighth year. He had succeeded his brother as daimyo only four
years earlier, and his marriage had been delayed by the continuing
crisis in the domain's finances. He died without heirs. The do-
main's senior counselors decided to conceal Yasuteru's death and
to find as quickly as possible someone he might posthumously
adopt as his son. Yasuteru had an illegitimate half brother named
Miyake Tomonobu (1806–1886). The simplest solution would

Licensed Quarter of Itako. From *True Views of Four Provinces* (1825). (Private collection)

have been to have the dead Yasuteru adopt Tomonobu as his son, but the domain was faced with bankruptcy, and most counselors believed that the only way to surmount the crisis was by adopting the heir of a rich domain as the next daimyo. Insisting that Tomonobu was in poor health and unable to discharge the duties of the daimyo, they chose instead the sixth son of the daimyo of Himeji, a domain with an income of 150,000 *koku*, or more than twelve times that of Tahara. This, however, would effectively mean the end of the Miyake bloodline. Kazan, as a devout Confucianist whose family had served the Miyake for generations, found the plan profoundly distressing.

The dispute between the two factions—one favoring and the other opposing the invitation to the son of the Himeji daimyo—

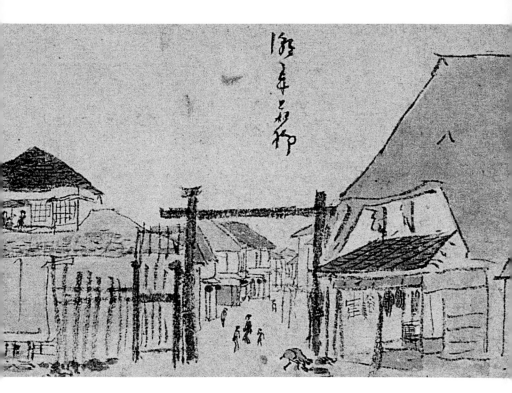

lasted for months. Most samurai of Tahara Domain, aware of its desperate state of finances, favored the Himeji candidate.

On the pretext that Tomonobu could best recuperate from his alleged illness in Tahara, senior domain officials invited him there. He left Edo accompanied by Kazan, a physician, and another man on the eleventh day of the tenth month and arrived in Tahara on the eighteenth. Kazan's brief diary *Kikyō nichiroku* (*Homecoming Journal*) mentions the places where they stopped on their journey, what they ate, and the cost of every item purchased. The most interesting feature of this colorless account is that it includes illustrations by Kazan; he evidently could not prevent himself from inserting, even in an official account, the sketches he made wherever he went.[14]

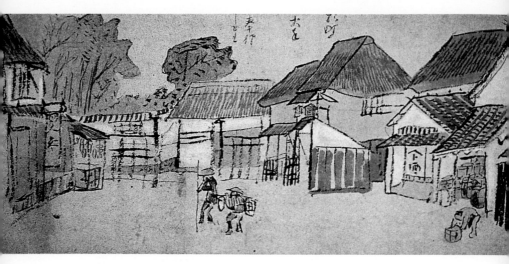

The Residence of the Magistrate at Shinmachi Ōte. From *True Views of Four Provinces* (1825). (Private collection)

On the fifteenth, while Tomonobu and the others were still on the road, an agreement was formally reached between the Tahara senior officials and the Himeji daimyo for the latter's son to be designated as the next daimyo of Tahara. A petition was addressed to the shogunate, stating that because Yasuteru was gravely ill, it was imperative that he be permitted to adopt a son as soon as possible. The shogunate gave its consent immediately, and on the night that the consent was received (the twenty-third), it was announced for the first time (five months after the event) that Yasuteru was dead.[15] The senior officials had cunningly arranged for Tomonobu and Kazan to be traveling, out of communication with either Edo or Tahara, while the final negotiations took place.

As soon as Tomonobu and Kazan reached Tahara, they were placed under house arrest. Kazan was permitted to leave for Edo on the tenth day of the eleventh month, but Tomonobu was detained for seven months until the new daimyo, Yasunao, had been

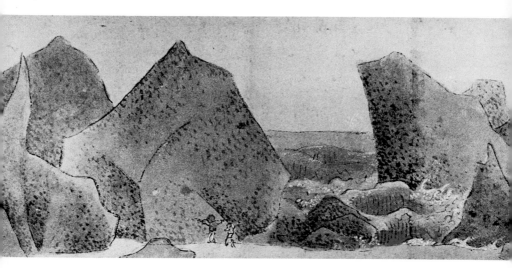

Uranaka. From *True Views of Four Provinces* (1825). (Private collection)

officially installed. Having in this manner destroyed the opposition to their choice of a new daimyo, the senior officials of Tahara Domain decided that although Tomonobu was only twenty-two, he would be officially known as a "retired gentleman," ranking as the father of the daimyo. He was given a comfortable house in the Sugamo district of Edo. Later, with Kazan's encouragement, Tomonobu took up *rangaku* and acquired an impressive collection of Dutch books.

Back in Edo, Kazan was given a promotion, an indication of how important he had become to the domain,[16] but he was depressed by his failure to get Tomonobu named as the new daimyo, and he turned to the comfort of drink. In the first month of the following year (1828), Muramatsu Rokurōzaemon, a *karō* (senior retainer) who had been a strong supporter of the Himeji candidate, asked Kazan for a painting to take back to Tahara with him. Kazan painted one and attached to it the following composition:

His Excellency Muramatsu is a samurai of our domain, a man of noble aspirations. He reads books and composes poetry, and he is an old acquaintance. Now, on the verge of his departure, he has asked for a painting. Of late I have become lazy and waste day after day without doing anything. For this reason my poverty has become more extreme than ever, and my madness has also become extreme. Sometimes in the course of a whole day all I manage to do is drink one cup of water, or sometimes in five days I pick up one stone. That made it difficult for me to reply promptly to his request. But now it is the spring, and after drinking a bit, I have painted this picture and offer it to him. This will be my farewell present. It was dashed off after I had been drinking, and its clumsiness is shameful. I wonder whether I shall escape the charge of "swinging an axe before Han's gate."[17] First month, sixth day.[18]

The painting that Kazan sent to Muramatsu was a rough sketch of plum blossoms he had made on New Year's Day. Kazan inscribed a poem on the painting:

Many flowers of the world are drunk on the warm breezes,
But you, the only sober plum blossoms on the riverbank—
Nobody will show pity if you are felled by snow and frost,
Though your fidelity is steadfast as a pine or cedar.[19]

The sarcasm that fills both the letter and the poem reflects Kazan's bitterness. Not only did Muramatsu's support of the Himeji candidate anger him, but this was the man who years earlier had insisted on closing early the gate of the domain residence, thereby preventing Kazan from studying with Satō Issai.

Kazan's chief works in 1828 were several portraits of Matsuzaki Kōdō (1771–1844). Kōdō, the son of a farmer from Kumamoto, had made his way to Edo at the age of fourteen. He entered the Shōheikō, a Confucian academy, where he studied under Hayashi Jussai (1768–1841), an adherent of the orthodox Zhuxi school.

Kōdō later became the Confucian tutor of Kakegawa Domain and, on Jussai's recommendation, received the Korean envoys who visited Japan in 1811. After his retirement, he returned to Edo, where he opened a private academy of Confucian studies. Kazan, closely attached to Kōdō, whom he revered as a teacher, painted his portrait several times. The two full-length studies[20] are admirable, but the portrait showing only Kōdō's head is a masterpiece. It was painted as a birthday present, and perhaps that is why Kōdō is depicted not in the solemn manner of the full-length works but with a genial expression, as though listening to an unseen interlocutor.

Zenrakudō nichiroku, the diary of Kazan that is richest in information about his life, covers the period 1830 to 1833, from his thirty-eighth to his forty-first year. It opens with an account of his accompanying Miyake Yasunao, the new daimyo of Tahara, to Nikkō in 1830. The shogunate required daimyos to take turns participating in the annual ceremonies held at the mausoleum of Tokugawa Ieyasu, the founder of the shogunate. The unlucky daimyo chosen for the honor of standing in for the shogun on this occasion was required to provide, at his own expense, one hundred men in armor and one hundred spears. This was a burden for a domain with a small income, and daimyos in the past had pleaded illness to escape it; but in 1739 the shogunate issued a decree forbidding anyone to refuse service.

Yasunao, who had become daimyo two years earlier, was now in his nineteenth year. Although he had brought a considerable amount of money in his "dowry" when he arrived from Himeji, it was by no means sufficient to cure the domain's severe financial problems. Moreover, Yasunao had grown up in luxury and had expensive ambitions for himself now that he was a daimyo.

The visit to Nikkō in 1830 was a disaster for the domain's finances, but Kazan profited by the journey to make eighteen sketches of the scenery.[21] Yasunao, having successfully carried out his duties at Nikkō, began to entertain higher ambitions: he coveted the post of *sōshaban*,[22] which often led to higher posts within

the shogunate. He was aware that it would cost dearly in gifts and bribes, but that did not deter him. Yasunao was not a fool, and sometimes Kazan was able to appeal to his better judgment and dissuade him from acting unwisely.[23] Probably that was why he kept his hopes for the post of *sōshaban* a secret from Kazan, fearing that he might once again talk him out of his ambitions. But Yasunao finally divulged his secret to Kazan when the latter was in Tahara in 1833. The appalled Kazan remonstrated with Yasunao about the folly of attempting, with extremely limited means, to obtain the post of *sōshaban*. Yasunao seemed to accept this good advice, but two days later he sent a man to ask Kazan to draft a letter requesting Yasunao's appointment as *sōshaban*. Kazan went at once to the castle and bluntly told Yasunao that he might just as well look for fish in a tree as get the appointment. He added, "It has been fifteen days since I came here, but you have not said one word about the people of the domain. All you talk about is your private ambitions, but you have already lost any claim for realizing them."[24]

Kazan naturally used the appropriate honorifics when addressing his lord, but the meaning of his remarks was clear and devastating. Yasunao, who was only twenty-two, once again seemed to yield to the wisdom of the older man, but in his heart he was not ready to resign himself to a quiet life in Tahara. He had grown bored with domain business and hoped to be recognized by his peers as a person of importance. If he could not get appointed as *sōshaban*, he would at least like something more exciting in his life. He turned to debauchery. He sent a retainer to Nagoya with a picture of a woman whose face met his standards of beauty. The man was ordered to find a woman who looked like the lady in the picture and bring her back to serve as his concubine. The retainer, unsuccessful in his search, returned empty-handed. Yasunao's disappointment and rage were so great that his retainers feared it might bring on some illness.

This was not Yasunao's first attempt at acquiring a harem. Not long after he had taken the post of daimyo of Tahara, he sent for

160 women to be examined as possible concubines, but when they arrived in Tahara, he turned down all of them without spending a night with any. This cost the domain 100 *ryo*, a very large sum of money.[25] Each new act of extravagance by Yasunao caused Kazan fresh anxiety about the domain's desperate financial state. Resort was inevitably made to the usual expedient when the domain was in financial trouble: the stipends of the samurai were cut even further. This had the unfortunate result of causing some samurai to escape to other domains, and others, in disgust, to neglect their duties.

Kazan constantly pondered plans to restore the domain's solvency, but his most pressing concern was restoring the Miyake family to its rightful position. He hit on the plan of a marriage between Tomonobu's infant son, the last of the Miyakes, and Yasunao's as yet unborn daughter. The gods favored Kazan's plan: when Yasunao's child was born, it was a daughter. Tomonobu's son eventually married the girl, was adopted by Yasunao as his heir, and became the fifteenth daimyo of Tahara.

Kazan's plans for restoring the domain's finances included inviting an expert in agriculture, Ōkura Nagatsune (1768–1860?), to Tahara. Ōkura advised strengthening the domain's finances by planting cash crops, thereby taking advantage of Tahara's relatively mild climate to raise sweet potatoes from which sugar could be extracted. He taught the farmers how to use whale oil to rid the rice crop of insects, and he also taught them the importance of planting *kōzo* (paper mulberry), from which paper could be made. Conditions seemed to improve under his guidance, but the plans to increase productivity did not bring immediate results, and the conservatives were so strongly opposed to the changes in agricultural production that Ōkura was dismissed.

In the meantime, in 1832, Kazan was promoted to the rank of *toshiyori yaku masseki*. This was the highest rank that his father had attained, and it placed him among the domain's senior samurai. But Kazan was by no means pleased by the news. He wrote in *Zenrakudō nichiroku*,

I have been selected as a senior retainer and am to receive a stipend of 100 *koku* and 20 *koku* as a rice allowance. As usual, his lordship personally commanded this. . . . I refused and would not accept. Mr. Kawasumi[26] repeatedly urged me to accept, and I had no choice but to do so.[27]

Refusing a promotion to high office would not have been a mere gesture on Kazan's part. In a letter he sent to Suzuki Shunsan, a friend in Tahara, he wrote,

Quite unexpectedly, I have been selected for a high post. Night and day I am all fear and trembling. I am sure you can imagine how I feel. I am not only lazy and incompetent, but from earliest childhood my heart was set on becoming a painter, even if it cost me my life, and I never considered any other kind of profession. But my father was stricken with a serious illness, I had important services to perform for his lordship, and since then I have vacillated, going one way and another, and the situation has continued to this day. To tell the truth, I am guilty of duplicity. Surely there is no worse crime.

At present, not one person in our country is serious about painting; from ancient times nobody in our country has understood the true nature of painting. When I die—it won't be long—the art of painting will be hidden in clouds and mist. That is the situation in which I find myself. Not one person feels compassion for me. My talents were plucked in the bud by my duties as a vassal and as a son, and I am fated to end as a withered tree far back in the garden. The pain is too much to bear. Does no one feel pity that a hidden flower in a back garden, lacking any talent for high office, should emit its fragrance unbeknown to any but its household? You are the only one who understands my feelings.[28]

In this letter, Kazan seems to be expressing despair at the expectation that his duties in a new post would deprive him of

the possibility of ever developing his abilities as an artist. He also is saying, rather immodestly, that he is the last chance for Japanese painting to become truthful. His bitter evaluation of Japanese painting is far more extreme than the criticism he voiced in *Issō hyakutai.*

Kazan was right to be apprehensive. During the years immediately following his promotion in 1832, which in the end he could not refuse, his greatest efforts were devoted to restoring the domain's finances. One of his most important innovations was a new system of paying stipends to the domain's samurai. Up until this time, stipends had been paid on the basis of rank, but in 1833 a proclamation was issued in the daimyo's name calling for a five-year plan, to begin the next year, under which stipends would be paid on the basis of merit. The aim of the plan was to increase production and to end dependence on the usurers who had hitherto managed the domain's finances.

These administrative duties deprived Kazan of time that he might have devoted to painting. All the same, no year passed without his completing half a dozen works. Most, in the manner of the *bunjinga,* depicted traditional Chinese subjects, but his reputation as a portraitist continued to grow. His attitude toward the purpose of art also seems to have changed, as he now believed that art must be serious, not merely agreeable and decorative. Realism had come to be the touchstone of art. Although this attitude may have germinated spontaneously within Kazan, it is more likely to have stemmed from a new experience: his meeting with the West.

The Early 1830s

5

In 1832 Kazan made a new and extremely valuable acquaintance, Takano Chōei (1804–1850). Chōei, who came from the north of Japan, made up his mind at the age of seventeen to become a physician. He went to Edo, where he entered the school of Western medicine run by Sugita Hakugen, the adopted son of the famous Genpaku. Hakugen, not recognizing Chōei's unusual talents, did nothing to lighten his financial burden, and Chōei was obliged to support himself by working nights as a masseur. In the following year, he shifted to the school run by Yoshida Chōshuku (1779–1824), who took him on as an *uchideshi*.[1] This arrangement enabled Chōei to dispense with massaging and to concentrate on his studies.

Chōshuku, Japan's first Western-style physician of internal medicine, was a good choice of teacher.[2] When he began to practice in Edo, he first had to overcome prejudices against this new kind of medicine; but his successful treatment of patients gradually won him a good reputation. He learned Dutch and insisted that his pupils also study Dutch in order to read books of Western medicine. Among his students, two were especially proficient at

learning the language: Chōei and Koseki San'ei (1787–1839). Before long, both would serve as Kazan's translators.[3]

Chōei's interest in foreign learning seems to have been confined at first to medicine, but in 1822 the appearance of a British ship off Uraga, at the head of Edo Bay, startled him into an awareness that there might be danger to Japan from abroad,[4] and he realized he must learn more about the countries of the West than their medicine. Although Chōshuku probably helped Chōei make progress in *rangaku*, Chōshuku died in 1824 as the result of an imperious demand by the daimyo of Kaga for medical treatment. Because Chōshuku had the status of physician to Kaga Domain, he felt obliged to travel at once to Kanazawa, the seat of the daimyo, even though he himself was ill. On the way, his illness became worse and he died, leaving no heir.

Chōei and the other disciples decided to continue running Chōshuku's school. Chōei was especially devoted to Chōshuku's memory and believed that it was incumbent on him to maintain the school's high reputation. But when he learned in 1825 that a celebrated Dutch doctor had arrived in Nagasaki and was teaching medicine to Japanese students, he desperately wanted to study with him.

The "celebrated Dutch doctor" was in fact a German and only twenty-nine at the time. He had been chosen by the Dutch government, on the basis of his university record, to be the first hygienist (*eiseishi*) of the East India Company. This term obscured the doctor's real mission, which was to make a detailed study of Japan, including its geography, inhabitants, and products. In 1799, after almost two hundred years of trade with Japan, the East India Company had gone bankrupt, and its trading stations in Asia (including Deshima) were taken over by the Dutch government. In all the years it had traded with Japan, the East India Company had done extremely little to enlighten the rest of the world about the country. Accordingly, once the Dutch government had recovered from the effects of the French occupation during the Napoleonic Wars, it decided to make up for this failure by preparing a scholarly survey of the country. It was hoped

that better knowledge of Japan would improve commercial relations between the two countries.[5]

The principal duty of Dr. Philipp Franz von Siebold (1796–1866), at least officially, was to look after the health of the Dutch merchants on the island of Deshima, but it was understood that he would have the time to make his survey and to train Japanese physicians. Siebold was expert in many branches of medicine, excelling especially as a surgeon and an ophthalmologist. He soon acquired the reputation of being far more skilled than any of his predecessors on Deshima, most of whom, little better than barber-surgeons, had been permitted to practice only in remote parts of the world.[6] Consequently, physicians from all over Japan came to Nagasaki to seek Siebold's advice, some bringing their patients with them. Admission to Deshima was restricted, however, and Dutch doctors were not allowed to treat Japanese patients off the island. Japanese doctors determined to consult with Siebold thus had to invent plausible pretexts for visiting Deshima.

In the end, the magistrate of Nagasaki, having become aware of Siebold's unusual ability, petitioned the bakufu to relax the restrictions and allow him to leave Deshima and treat patients in the city. Siebold soon was examining and treating Japanese at the offices of two doctors in the city. So many people came as either patients or simply sightseers that it was decided to build a house for Siebold at Narutaki on the outskirts of the city. There he not only treated patients but also gave lessons on methods of diagnosing and curing illnesses.[7]

No sooner had Siebold begun to give instruction on the latest developments in European medicine and clinical experiments than word of his excellence spread among doctors throughout Japan. This was how the students at Chōshuku's school of Dutch medicine heard of Siebold, even though not one had ever been to Nagasaki. By chance, an acquaintance of Chōei in Edo, Imamura Hoan, was from Nagasaki, and when he was about to return home, he suggested that Chōei accompany him. Ever since learning about Siebold, Chōei had eagerly wished to study in Nagasaki but had hesitated to make the move. As long as he remained in

Edo, his food and lodging were provided by the school, and he could devote himself entirely to his studies, but he had no one on whom to depend in Nagasaki and would have no way of earning the money he would need to study with Siebold. Then the lucky accident of the invitation of the friend from Nagasaki changed the picture. Hoan offered to put up Chōei at his house, where he could study without interruption. Nothing could have delighted Chōei more. In the seventh month of 1825, Chōei, aged twenty-one, left Edo for Nagasaki.

Chōei had another stroke of good fortune. Hoan's elder brother, a senior interpreter of Dutch, had connections that enabled him to obtain permission for Chōei to enter Siebold's school. In this way, very soon after his arrival in Nagasaki, Chōei was attending Siebold's classes. He was joined by several dozen students, many of exceptional ability. Their instruction was not confined to medicine but included biology, botany, geography, history, economics, and other branches of learning.[8]

Outstanding even in this brilliant company of students, Chōei was awarded the degree of doctor of medicine by Siebold in 1826. He remained in Nagasaki for several years, employed by Siebold to translate Japanese medical books into Dutch. At the request of the daimyo of Hirado, Chōei also traveled to various islands in search of medicinal plants. In 1830 he returned to Edo, where he opened a practice, gave instruction in Western medicine, and began writing *Seisetsu igen sūyō* (*Principles of Western Medicine*). But despite his exceptional qualifications, he had a difficult time making a living. According to Miyake Tomonobu, when Chōei first met Kazan, he was desperately poor, as it did not occur to most people to consult a Western-style doctor when they were ill.[9] Although Tomonobu did not say so, Chōei's connections with Siebold may have worked to his disadvantage.

In 1826, while in Edo with the Dutch tribute mission, Siebold met Takahashi Kageyasu, probably the finest geographer in Japan. Each was anxious to learn from the other and to display the fruits of his scholarship to someone who could understand their value. Takahashi drew maps of Ezo (Hokkaidō) and Sakhalin that

much impressed Siebold and, in return, asked Siebold about foreign countries. At some point, Takahashi learned that Siebold had the four volumes of Ivan Fyodorovich Krusenstern's *Voyage Round the World*, and he begged Siebold to give him the books. Siebold was willing to do so, on condition that Takahashi give him in return various geographic materials, including the highly secret survey charts made by Inō Tadataka (1745–1818). These were the most precise and detailed maps of Japan that existed. Takahashi was well aware that giving such materials to Siebold was an offense punishable by death but reasoned that the information in Krusenstern's work would greatly benefit Japan. The exchange was made, and Takahashi set about translating the materials.

On the night of September 17, 1828, a violent storm struck Nagasaki. The ship that was to take Siebold and all his possessions to Batavia threatened to capsize, but the Japanese managed to beach the ship and save the cargo. When the cargo was unloaded, the contents were inspected, in keeping with the regulation that anything brought into Japan must be inspected. It was not necessary to inspect goods taken out of the country; if the ship had not been damaged, Siebold could have left Japan without incident, taking any prohibited materials he had accumulated. Some were discovered in the cargo, and he was ordered to surrender the maps he had received from Takahashi. Siebold was warned by an interpreter that his personal possessions would be searched, but, working feverishly, he managed to make copies of the maps. He hid the copies and eventually was able to take them to Europe.

Denounced by a government spy, Takahashi was arrested and died in prison, his body pickled in brine to preserve it until sentence could be passed. He was found guilty, and the head was struck from Takahashi's pickled corpse. Siebold was not sentenced until October 1829. Allowance was made for his ignorance of Japanese law, and he was permitted to leave the country at the end of that year. After his return to Europe, his writings about Japan earned him a place among distinguished scientists of the time.

In Japan, however, most people who knew about the incident considered Siebold to have been a dangerous spy, and Chōei's

difficulty in building up a clientele may have stemmed from this association. Thus it was providential that Chōei, at the end of his resources, met Kazan in 1832. It is not clear under what circumstances they met, but Chōei was soon translating for Kazan[10] and earning badly needed income. Miyake Tomonobu recalled that Chōei, who lived nearby, came every day to his residence to translate Dutch books, from which Kazan derived great benefit.

As a result of their frequent meetings, Kazan and Chōei became friends but were not intimates. Chōei was basically a scientist, and, with the exception of the criticism of the bakufu's foreign policy that he voiced in his late *Yume monogatari* (*Tale of a Dream*), his writings were confined to medicine, chemistry, and other sciences. He and Kazan thus may have had little to talk about apart from the translations.

On the whole, this was a happy period for Kazan. Although he produced relatively few paintings in 1831 (the best known shows Li Bo gazing at a waterfall), in this year he had his first opportunity to examine at leisure important Western books, the start of his serious interest in *rangaku*. In the fifth month of 1831, Kazan was given permission by the domain to travel freely, without obtaining special authorization, in order to compile a complete genealogy of the Miyake family, the daimyos of Tahara. The current daimyo, Miyake Yasunao, had been adopted into the family under the circumstances related earlier, and he had decided to learn more about his adopted ancestors.

The purpose of Kazan's first journey after receiving this commission was to search for the mother of Miyake Tomonobu, the illegitimate son of the daimyo Miyake Yasutomo. Although he was still only in his twenty-fifth year, Tomonobu was officially a retired person. His mother, O-gin, assuming she was still alive, probably would be about forty. By command of the daimyo, Kazan was supposedly being sent to do research for the section on concubines in the family genealogy; but his primary concern was not the genealogy but finding out what had happened to the mother from whom Tomonobu was separated a year after his

birth. Tomonobu hoped to move her to his residence in Sugamo, where he would look after her as a dutiful son.[11]

Kazan's travel account, *Yūsō nikki*, describes the journey he made to Atsugi in Sagami (present Kanagawa Prefecture).[12] He was accompanied by a disciple, Takagi Goan (d. 1862), an agreeable but not very talented young man, at least to judge from his dismally incompetent poetry. The distance they were to travel was extremely modest by our standards of travel, but with the exception of the ill-starred journey with Tomonobu to Tahara in 1827, this would be Kazan's first trip anywhere in six years and he anticipated it with pleasure.

Yūsō nikki cheerfully describes the places the two men passed, the inns where they stopped, the people they met. It is well written and shows Kazan at his sunniest. On the first day, while still in Edo, they visited the haiku master known as the sixth Taihakudō, an old acquaintance. Kazan had studied haiku and had drawn the illustrations and covers for the collections of haiku published by Taihakudō and his disciples. Taihakudō may have supplied Kazan with introductions to haiku poets along the way to Atsugi.

At the first inn where Kazan and Goan spent the night, the innkeeper, a haiku enthusiast, asked Kazan to draw a picture for him. Others staying at the inn crowded around him with the same request. It was quite unusual for a samurai, wearing the obligatory swords, to unbend in a motley group at a tavern; but Kazan, aided by drink, dashed off dozens of pictures, one for each person, and seemed to enjoy the occasion. He also composed haiku, although by this time he was extremely drunk. As Haga Tōru pointed out, during the Tokugawa period haikai poetry served as an important medium of social intercourse, and even persons of little formal education could share in the pleasure of composing haiku with other would-be poets.[13] Goan, unasked, produced several inept tanka that Kazan dutifully recorded as events of the journey.

The two men set out again the next morning on their unhurried way, Kazan at times stopping to make sketches of people and buildings they passed. The sketches have an unassuming charm

but are not comparable to the marvelous illustrations Kazan drew during his *True Views of Four Provinces* journey.[14]

On the third day of the journey, the twenty-second day of the ninth month, they commenced in earnest their search for O-gin. They assumed that after leaving Edo, she had returned to her native village, so that is where they headed. When they reached the village, they asked about O-gin and were told that someone fitting her description was now the wife of a farmer named Seizō. Their informant added, "But they're terribly poor. It's not the sort of place gentlemen like you should go."[15] Undaunted by the warning, Kazan and Goan hurried on.

In the hamlet where O-gin lived, the old man whom they asked for directions told them her story. She was the eldest of four daughters of a local farmer. While still young, she had gone to Edo and entered the service of a daimyo. She returned to the village dressed in fine clothes but later married a poor farmer. Despite his poverty, her husband, Seizō, was hardworking and was reputed to be descended from a retainer of the ancient Hōjō family.

Kazan describes in novelistic fashion how the two men from the city wandered in the remote countryside looking for O-gin's house. Everything seemed worth noting: the barking of distant watchdogs, cocks crowing, the thumping of a wheat pounder, smoke rising from a hearth somewhere. A boy they encountered on the way, whose features resembled what Kazan remembered of O-gin's, led the two men to her house. After a while, a decrepit-looking old woman with a towel wrapped around her head appeared. When she caught sight of the two samurai, she fell down on her knees and bowed, seemingly terrified. Kazan was sure that this old woman could not be O-gin. She must be Seizō's mother. But his doubts lasted for only a moment. He reminded himself that twenty or more years had passed since he last saw her, so it was not likely that she would still look the same. He looked at her face more intently, and then he noticed a large mole under her ear, a mole he remembered from childhood. This was proof that the woman was indeed O-gin.

Kazan spoke, "When I was a boy you were very affectionate to me. I've come to Atsugi hoping that I might repay, in some small way, all I owe you. It took a bit of wandering, but now I have found your house. Look at my face, and think—don't I resemble somebody you used to know?"[16]

O-gin was still too intimidated even to raise her eyes to look at him. She said, "I don't remember anything like that. Where have you came from, your lordship? I wonder whether you haven't mistaken me for somebody else."

"No, I haven't," Kazan said, and then asked her name. She answered, "Machi." "What name did you use in the past?" She repeated, "Machi." Kazan for a moment was at a loss for words, afraid he might have made a mistake, but the mole was proof of her identity. He asked, "Were you ever known as O-gin?"

She looked startled. "Yes, long ago, when I lived in the capital, that's what people called me." A moment later, she asked, "Sir, have you come from Kōji-machi?"[17] The expression on her face changed, and she invited the two men into the house. She brought out some mats and placed them on the wooden floor for the men to sit on. There were no tatami.

She removed the towel from her head. Now there could be no doubt who she was. She choked in tears, and neither could speak for some time. He asked if she remembered his name. She asked if he was Ueda Masami, but he told her that Ueda had died some fifteen years earlier. She said, "Then you must be Mr. Watanabe Noboru." She asked why he had come, still wondering whether it was not a dream. She explained that her husband had not yet returned home from some unavoidable errand[18] and introduced each of her children. They all bowed politely to him.

Kazan offered her money, explaining that Miyake Tomonobu had given it to him for travel expenses. He would keep part for Goan and himself but wished to give the rest to O-gin. She accepted with evident gratitude. O-gin prepared a meal for the two visitors. It was not delicious; the soup, eggs, and tofu tasted equally unappetizing. Kazan managed to get down two bowls of

soba, Goan only one, but the raw saké was undrinkable. The pick-
led plums were the best part of the meal.[19]

Kazan drew a sketch of the room where they ate. Goan sits on
the coarse matting, a sword by his side. O-gin carries in a tray
from the kitchen with more food for the guests. An old man,
O-gin's father, sits facing Goan.[20] Kazan, O-gin, and the old man
join in conversation:

> As we talked about the future and the past, tears fell again
> and again. She wept as she described her present life and
> wept again when she recalled her life in the capital. But she
> would not forget this particular day when an exalted per-
> son—should he be called a buddha or perhaps a god?—vis-
> ited her cottage.[21]

They talked until the sun began to sink in the west. Kazan and
Goan left O-gin's house without mentioning Tomonobu's hope
that she would live with him in Edo. Probably Kazan realized that
she could not leave her family.[22]

Yūsō nikki does not end with Kazan and Goan saying good-bye
to O-gin. They are accompanied as far as Atsugi by O-gin's eldest
son, who led a horse. Although he asked Kazan to ride on the
horse, he insisted on walking.

Kazan did not know a soul in Atsugi, but he had an introduc-
tion to a hardware dealer in the town. He expected that the man
would probably put up Goan and him for the night, but the man
turned them away with the remark, "A traveling artist, are you?
And come to ask me to take pity on you?" His incivility came
as a jolt to Kazan. He and Goan made their way to a local inn.[23]

Kazan was in a mood to have a good time, perhaps as a reac-
tion to the tension of meeting with O-gin or perhaps in order to
forget the sting of the unpleasantness of the hardware dealer. He
introduced himself to the innkeeper:

> I'm a retainer of Miyake Tosa-no-kami named Watanabe
> Noboru. I'm a peculiar guy who travels around painting pic-

tures. If there are any people in this town who share my tastes, I'd like to invite them to spend tonight in my company until dawn tomorrow. I want to hear what storytellers, calligraphers, waka, haiku, or Chinese-style poets, or even people who just enjoy talking, have to say, and I'd like you to invite them. All the drinks and the refreshments will be on me.

He added, no doubt recalling the hardware dealer's words, "I like poetry and painting, but I don't go around begging. I'm a samurai who gets a stipend from his master and has no trouble making ends meet."[24]

The innkeeper was taken aback by this baronial request from a customer he had never seen before, but he decided after looking over Kazan that he was a gentleman and could be trusted. He set about rounding up guests for the party.

Kazan and Goan had six guests at their party that night. Kazan identified them:[25] two local intellectuals (Saitō Kanesuke, a calligraphy teacher, and Karasawa Ransai, a physician); a lantern maker named Uchidaya Sakichi; a maker of eye lotion named Megusuriya Tsunezō, reputed to be the finest samisen player in the area; Ransai's eleven-year-old daughter; and the innkeeper.

Dinner came in many courses, and naturally there was an ample amount of saké. Entertainment began with a samisen performance by Tsunezō and Ransai's daughter. Sakichi, who was proud of his voice, sang for the guests, at which point Ransai and Goan, both of them by this time quite drunk, got up and began to dance. Kazan also staggered to his feet and danced, fan in hand, at which the gathering roared with laughter. Numerous encores were demanded until late that night when another guest rushed in, all out of breath. It was Seizō, O-gin's husband. He made a profound bow, his nose all but touching the tatami. A maid came in with cakes piled high on a platter. Seizō had brought this present from O-gin. When Seizō finally lifted his head from the floor, the others could see his squarish face, reddish-brown complexion, piercing eyes, crocodile-like mouth, and eyebrows that spread out like fish tails. His voice reverberated

like a bell. Invited to join the party, he squatted there like a huge toad. But Kazan, seeing this solidly built man sitting solemnly at a respectful distance behind them, felt greatly relieved. O-gin was safe with a man like Seizō.

This was the first time in Seizō's life that he had met a samurai who not only was kind but invited him to dinner. He was all but overcome with joy, but he sat by himself, deferentially eating and drinking. Kazan drew a sketch of the party labeled *Drunken Dancing at the Inn*.[26] Kazan depicted himself in a drunken sleep. He says in the diary that he was not aware when the other guests left.[27]

Kazan woke in the middle of the night. Someone had put a pillow under his head and thrown bedding over him. He lit a lantern and wrote in his diary until it grew light an account of all that had happened on a most memorable day. It is rare for diarists to state so exactly at what time of day and under what circumstances they wrote the entries. Kazan described not only the meeting with O-gin, the disagreeable hardware merchant, and the feast at the inn but also a conversation he had had with the physician Karasawa Ransai, who described the harshness and corruption of the daimyo of the Atsugi region and the hatred he had inspired in everybody. As an example of the conspicuous mismanagement of funds, Ransai cited the repairs made to the embankment along the Sagami River in the wake of a disastrous flood. These repairs were relatively recent (about 1820), but bidding for the work had been rigged, and the successful contractor, in collusion with officials, had skimped on the construction, using only one-third of the allotted 1,000 *ryō*. The result was that the badly built embankment was swept away in the next flood, causing innumerable deaths by drowning.[28]

Ransai blamed the situation on the inadequate incomes of the daimyos of small domains, who were driven to desperate resorts to raise funds. He thought it would be better to live in a place under the direct control of the bakufu or on a demesne of a high shogunate official who gave greater consideration to the welfare of the people. Kazan was taken aback and pained to hear such criticism. Tahara, the domain to which he belonged, was even

smaller and poorer than Atsugi, but it had never occurred to him to wish to get rid of the daimyo. Despite the setbacks he had experienced in Tahara and his resentment over the daimyo's waste of precious funds, he remained a loyal samurai. But the fact that he wrote down Ransai's complaints is evidence of his willingness to listen to other people's points of view, however incompatible.

Kazan spent the following day, the twenty-third of the ninth month, in Atsugi. That evening, after drinking with Ransai and Kanesuke, he returned to the inn and found that people had been waiting for him. There was to be another party. Everybody there the night before attended, and a painter, the adopted son of Kanō Dōju, who happened to be staying at the same inn, barged in on the party. A priest from a temple in Atsugi whom Kazan had met earlier in the day arrived with some antique objects of which he was proud. The priest sang and danced. A quarrel broke out between the painter of the Kanō school and a man who had wandered in casually, attracted by reports of how good the party had been the previous night. Kazan once again fell into a drunken sleep while the party was still in full swing.

At about 6:00 A.M., Kazan woke up and wrote about the previous day in his diary. By the time he had finished, people had assembled at the inn. Word had got around that a great painter from Edo was staying in town, and many people, from the daimyo on down, came to express their compliments or to ask Kazan the value of paintings they owned. The most striking visitor was a man named Surugaya Hikohachi, the mayor of a village south of Atsugi. Rumors about the distinguished visitor had reached him, and he decided to have a look for himself. Hikohachi was known for his readiness to direct sarcastic abuse at anyone who seemed at all important, but (evidently overcome by Kazan's demeanor) he managed a polite word of greeting. Kazan wrote of Hikohachi that he had a simple disposition, rather like a small child's. He knew how to deal with such people.

Knowing Hikohachi's reputation for denouncing injustice wherever he found it, Kazan asked whether he was dissatisfied with anything. At first Hikohachi seemed uncharacteristically

reticent, but he finally blurted out: "The present daimyo hasn't the slightest particle of compassion for us. All he does is wait for a chance to impose new taxes. In my opinion, the best thing would be to replace the daimyo."[29] Hikohachi's criticism was much in the same vein as Karasawa Ransai's. Kazan wrote that he was stunned by this attack. As a member of the ruling class, such outspoken language must have horrified him. He proceeded to lecture Hikohachi on the gratitude he should feel for all the favors that his master, the daimyo, had bestowed. Hikohachi kept his peace, but he looked unconvinced. Kazan drew a portrait sketch of Hikohachi with his pipe in hand. It is not flattering.[30]

Kazan and Goan left that day. The innkeeper attempted to refuse the money that Kazan offered, no doubt aware that he was unlikely ever again to have such enjoyable guests.

Yūsō nikki is not one of Kazan's major works, but it conveys better than any other the kind of man he was. His gentle affection toward O-gin, even though a hard life had made her almost unrecognizable, is particularly moving. Although he never forgot that he was a samurai, this did not prevent him from inviting people of a much lower station to his party and associating with them as equals. He liked company and did not hesitate to unbend and take part in the party entertainment. He was ready for more the next day, despite his limited capacity for liquor. He listened attentively to the complaints of Ransai or Hikohachi, even when their irreverence shocked him. The famous portrait of Kazan by his disciple Tsubaki Chinzan shows a distinguished gentleman, unmistakably a Confucian scholar. The portrait is convincing, but it is not the whole of Kazan. Another, very ingratiating side to Kazan comes out in *Yūsō nikki*.

Apart from the self-portrait Kazan paints in this work, it provides a picture of bourgeois Japanese society in the 1830s that is hard to find elsewhere. Political discontent is evident. It did not result in uprisings or even protests, however, and for this reason is usually ignored by historians; but the discontent was real and helped dispose ordinary Japanese to welcome the major changes of the Meiji Restoration.

In Kazan's next diary, *Mōbu yūki*, written later in 1831, he describes his accidental meeting with Ikuta Yorozu (1801–1837), a man just as discontented as Karasawa Ransai, although for very different reasons. Ikuta Yorozu was a disciple of the Shintō thinker Hirata Atsutane, who insisted on the supreme importance of the Ancient Way of Japan. Hirata had nothing but contempt for Japanese who worshiped Confucius, a foreigner, and detested Buddhism, a foreign religion. He was convinced that Japan was superior to all other countries and that the introduction of foreign ideas had polluted a country that had previously had no flaws. Six years later, Ikuta died in a revolt, staged in the wake of one incited by Ōshio Heihachirō, demanding relief for the victims of the famine that year.

Kazan, a believer in the teachings of Confucius, had no use for Hirata's philosophy as conveyed by Ikuta Yorozu. His own methods of dealing with the famine would not require violence. Although *rangaku* was more to Kazan's taste, he was above all a Confucianist, which meant, among many other things, loyalty to one's master, regardless of whether he was good or bad. This belief explains Kazan's shock on hearing criticism of the Atsugi daimyo, even though he was conspicuously unkind to the people of his domain.

Mōbu yūki is of special interest because of Kazan's account of his meeting with his sister Moto. In his recounting of the sad fates of all his brothers and sisters, he did not make an exception for Moto, although she was happily married to a prosperous merchant. Kazan spent more than twenty days with Moto and her husband in Kiryū.

These travel accounts depict Kazan in his happiest years. The weight of his responsibilities to the domain were not yet crushing, and he was able to enjoy a few days or even weeks away from his desk. He by no means had all the money he needed for himself and his family, but his plight was not desperate. Miyake Tomonobu not only helped him financially but bought the Dutch books that Kazan suggested.

The one respect in which the years between 1831 and 1835 were disappointing for Kazan was the scarcity of memorable paintings. He continued to paint, of course, and his travel accounts contain charming (or sometimes extremely precise) drawings and paintings, but perhaps the comparative lack of financial and other pressure made it less urgent to paint. Or it may be that his increasing absorption with the West made it harder to paint in a traditional manner.

Foreign Influence and Major Portraits

6

It is not clear when Kazan first became actively interested in the West. As a firm believer in Confucianism, he was predisposed to have a low opinion of any country that did not follow the teachings of the great sage, and it probably did not occur to him to investigate the nature of Western civilization, assuming it existed. He disliked Christianity, not because of its theology, about which he knew extremely little, but because in the minds of Japanese intellectuals it was associated with the European powers' expansion into Asia. Even after he had come to recognize the value of some aspects of Western civilization, Kazan still felt obliged to open an essay on the "shrike tongues" (as the Europeans were called, mocking the sounds of their languages) by declaring,

> The wise rulers of antiquity established the boundaries of the nine provinces, in this way clearly marking the frontier between the civilized and barbarian worlds. They did so in order to preserve the Way of the Sages from corruption by the barbarians. How much worse are the barbarians at the western

extremity of the world! Their religion is false and deceptive, their habits are money-grubbing and avaricious. Is anything about them worth transmitting and making known?[1]

These remarks appear in the preface to Kazan's account of the interview in 1838, mentioned earlier, between a group of Japanese and the Dutch factory director Johannes Erdewin Niemann (1796–1850). By this time, Kazan surely was aware that the Europeans could not be dismissed as mere barbarians, and his transcription of questions and answers was in fact very favorable to Niemann. Presumably Kazan wrote in these terms to protect himself against the charge of being proforeign, but there may have been a residue of antiforeign beliefs, ingrained in the Confucianism he had absorbed from childhood days, that was not effaced by his later study of the West.

Some scholars trace Kazan's burgeoning interest in the West to his meeting in 1815 with Yoshida Chōshuku.[2] Although the entry in Kazan's diary mentioning his first meeting with Chōshuku is cryptic, it is likely he went to see the doctor because he was suffering from stomach cramps, not because he wanted information about the West. The two men got along well, and their conversations continued long after the treatment ended. Chōshuku may have mentioned to Kazan his two outstanding disciples in medicine, Koseki San'ei and Takano Chōei, both of whom would figure importantly in Kazan's future work. Kazan did not record what he and Chōshuku discussed, but the West probably figured in their conversations.

There follows a gap of some years in the documentation of Kazan's growing absorption with the West, but we have one notable piece of evidence, the drawing Kazan made in 1826 of the meeting that he and other samurai had in Edo with Heinrich Bürger (1806–1858), a pharmacist who was Philipp Franz von Siebold's assistant on Deshima. The picture depicts a room at the Nagasaki-ya, the inn where the Dutch stayed while in Edo. Bürger sits on a chair, bent over a desk as he writes.

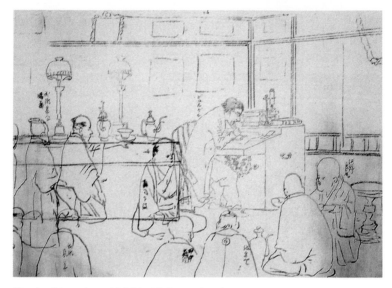

Sketch of interview with Heinrich Bürger (1826).

A semicircle of Japanese sits on the floor facing Bürger. A cof-
fee pot, a table lamp, and other European objects are on a side-
board, and a spittoon has been provided for the Hollanders. The
Japanese are identified by names written on or above their figures.
One man, seated with his back to us, is labeled Watanabe Kazan.[3]
No record of what Bürger said (or wrote) during the interview
survives, but it is safe to assume that the Japanese regaled him
with questions about Europe. The Dutch often expressed irrita-
tion about the endless queries to which they were subjected, but
they felt obliged to respond to even the most tedious. Despite
his youth, Bürger was a highly educated man, versed in a num-
ber of sciences, but he perhaps was not of the most admirable
character.[4] He left Japan in 1828 for Java, only to be shipwrecked
at Canton. There he met Robert Morrison (1782–1834), the great
scholar of Chinese, on November 18, 1828. In the memoirs of
Morrison's life written by his widow, there appears a passage from
his diary describing a meeting with "Burgher":

I dined to-day at D——'s, in order to meet a surgeon from Japan, whose name is Burgher, in the service of the Dutch. He told me a piece of news which I cannot help communicating to you—it is this. The Japanese translators are rendering Morrison's Dictionary into the Japanese language! . . . I hope the Bible will soon reach the Japanese.[5]

The following day he wrote:

Mr. Burgher called and told me a great deal about Japan and the neighboring islands. . . . He say the Japanese write on their fans, at Nagasaki, extracts from Morrison's Dictionary, arranged according to the Alphabet, as an ornament, and present them to each other![6]

Morrison, excited by this good news, sent (at Bürger's suggestion) a copy of his *Dictionary of the Chinese Language* to the translator "Gonski Kokizas" (Yoshio Gonnosuke, 1785–1831). It is hard to imagine that Morrison was unaware of the absolute prohibition on Christianity that made it extremely improbable the Bible would soon reach the Japanese, but Bürger's flattery seems to have convinced him. At least one copy of Morrison's dictionary reached Japan, perhaps brought by Bürger himself.[7] Bürger then inflated this copy into a work so popular that the Japanese inscribed extracts on fans. No wonder Morrison was excited!

Kazan heard the following about Bürger's activities:

Ten years ago a man named Bürger, who had come to Edo as Siebold's secretary, sailed from Nagasaki for Java. On the way, when his ship was near Taiwan, it encountered a typhoon. The mast was broken and the stern of the ship split. It barely managed to drift to Canton. By chance Morrison happened to be studying in Canton at that time. This Bürger was a crafty man, and when he discovered how famous Morrison was, he flattered him and in the end induced Morrison into

arranging a marriage with an Englishwoman. Bürger was singled out for promotion, and when he returned to Nagasaki two years ago, they say he had become very rich. While in Nagasaki he had a child, whom he left before he departed from Japan with Fujiyoshi Hideshige, a merchant who often visited the Dutch trading station. He came to Nagasaki again in 1835. The next spring, he told Hideshige, "I shall be leaving Japan this autumn. My one concern is the future of the boy. The reason I tell you this is because Russia has long been drooling over Japan. The danger is in the north and Nagasaki is a long distance away, but as they say, if even one finger is infected, the whole body hurts."[8]

Even Kazan was somewhat dubious about the truth of Bürger's report that a Russian attack in the north was so likely that he feared for the safety of his son in Nagasaki. However, the rumor served Kazan's own purpose of calling attention to the weakness of Japan's defenses against foreign invasion. This concern, even more than his interest in foreign sciences and arts, had led him to study Dutch learning.

Kazan's first mention of Dutch books in his diary is in an entry for January 2, 1831, about three years after the interview with Bürger:

Visited Matsuzaki Kōdō. He promised to lend me the Dutch book *Kaempfer*. This book was originally in the collection of Kondō Seisai.[9] After his death, his mistress fell on hard times and wanted to sell the book for a good price (about 15 *ryō*). Kaempfer was the name of a man, and the book was named after him. It seems to be a history of Japan. It contains more than forty illustrations, all of them showing in detail Japanese geography and customs. The book is strange but well conveys the special features of Japan, good and bad. Kaempfer visited Nagasaki as an interpreter and left Japan after acquiring a detailed knowledge of the interior of our country. Later, he secretly visited Satsuma and, by pretending to be a deaf-

mute and lame, escaped detection while he surveyed various provinces during the next seven years. Then he returned to his country and wrote this book. To be feared.[10]

Kazan's numerous mistakes in these few sentences about Kaempfer should suggest the confusion and misinformation in Japan concerning the West. Kazan seems to have confused Kaempfer with the Italian priest Giovanni Battista Sidotti (1668–1714), who in 1708 landed secretly on the island of Yaku in Satsuma, intending to propagate Christianity, the forbidden religion.[11] Needless to say, Kaempfer never pretended to be mute or lame, and he was not a spy.

Such mistakes were the result of the extreme difficulty of obtaining reliable sources of information about the West. Censorship of foreign books prevented all but works of a scientific nature from being imported, and they were in Dutch, a language that scarcely one hundred men in the whole country could read.

The most significant part of the entry in Kazan's diary was the conclusion "To be feared." Kazan became an ardent exponent of sea defenses, especially after he was promoted to a senior post (*toshiyori-yaku masseki*) in the domain and placed in charge of Tahara's defenses in 1832.

Two weeks after Kōdō promised to lend his copy of *Kaempfer*, it was in Kazan's hands. Although he could make no sense of the text, he was much impressed by the illustrations. A few months later, on May 27, 1831, he made a new friend who would help him understand the contents of this and other Dutch books. He wrote in his diary,

> Koseki San'ei came. San'ei is from Shōnai in Dewa. He is good at reading foreign books. Although he is a doctor by profession, he does not enjoy treating patients. He has no pleasures apart from reading and drinking. He has no master above him and no wife or children below. He spends the whole day alone at his reading. Being unable to take care of himself, he depends on others for clothing, food, and dwelling. Dr.

Katsuragawa,[12] admiring his fondness for study, looks after him and lets him do whatever he pleases, or so they say.[13]

San'ei told Kazan about the great variety of Western books on medicine, a field that especially interested him. There were studies not only of internal medicine and surgery (as in Japan) but also of anatomy, pharmacology, physiology, and other branches of the art. San'ei's enthusiasm for Western science extended beyond medicine to physics and astronomy and even to politics and rhetoric. He must have overwhelmed Kazan with his knowledge, but Kazan wrote only that he was excited to think that Western science would enable him to understand the basic facts of the universe: what had created heaven and earth, what nurtured them, what might destroy them.[14]

San'ei also touched on the art of painting as it was practiced in the West. European painters, he told Kazan, were experts in anatomy and dissected birds, beasts, plants, and trees to discover their smallest details. They stood at the opposite pole from Chinese and Japanese artists, who sought to convey the spirit, rather than the actual form, of their subjects.

Later that month, Koseki San'ei visited Kazan with four volumes on entomology by A. J. Rösel von Rosenhof.[15] San'ei explained that Dr. Katsuragawa wished to examine Kaempfer's history and was lending him Rösel's work in exchange. Kazan, struck by the exquisite details of the pictures of insects, wrote that they were of a beauty he had rarely beheld.[16] Perhaps Kazan's superb paintings of insects owed something to this encounter with Rösel.

From time to time, Kazan mentioned other Dutch books in his diary, but he never learned Dutch.[17] He knew the alphabet and special terms such as the Dutch names for the sciences, but that was about all. His failure to learn Dutch (which would have given him direct access to Western scholarship) probably was caused not by linguistic incompetence but by the innumerable demands made of him to deal with problems within the domain.

No doubt also, Kazan was reluctant to spend time learning a foreign language. He probably feared that it would interfere with his painting, which still was necessary for income as well as for artistic satisfaction. He had no choice but to depend on other men—in particular, Takano Chōei and Koseki San'ei—for translations. Kazan (or perhaps Miyake Tomonobu) paid them for their services. Both men were proficient at reading Dutch, and Chōei, who had studied under Siebold in Nagasaki, could also speak the language.

Kazan seems not to have esteemed Chōei apart from his linguistic competence. In an undated letter in which he compared people of his acquaintance, he rated Miyake Tomonobu as a *universiteit professoren*, his friend Murakami Sadahira as a *studenten professoren*, and Chōei as no better than a mere corporal with a long way to go before he could become a commander. But perhaps these evaluations were meant mainly to flatter Tomonobu.[18]

Kazan borrowed most of the Dutch books he needed from Tomonobu, whom he had unsuccessfully backed as the next daimyo of Tahara. Tomonobu, encouraged by Kazan to take up Dutch studies (perhaps as a way to forget his disappointment), had responded with enthusiasm. He expressed his gratitude in these terms:

> The fact that I collected Dutch books was thanks to Sensei's encouragement. In the spring of every year, the Nagasaki interpreters used to come to Edo together with the Dutchmen who were bringing tribute to the shogun, and they would take Dutch books with them. (At the time, bookshops in the capital were not permitted to sell foreign books, so this was our only chance to acquire a few.) He persuaded me to use what money I had to buy them. In this manner I amassed a roomful of Dutch books. It was entirely owing to Sensei's guidance that I was able to gain some insight into Western books.[19]

Tomonobu also recalled the nature of Kazan's interest in the West:

From about the time he was thirty-two Sensei became deeply interested in foreign learning. He himself could not read works in the original. At that time, what was known as "foreign learning" consisted entirely of books imported from Holland. Koseki San'ei, Takano Chōei, and Hatanaka Zenryū[20] were among the few in Edo who could actually read these books. Sensei often invited Koseki and Takano to his place and asked them to translate works of geography and history. He took notes, several volumes of them, as he listened to their translations. Sometimes the two men would have trouble understanding the overall meaning of the texts in the foreign books, and there were passages that quite baffled them. Listening to their translations, Sensei copied down what they said. At times he understood by intuition the meaning of a text that the two others had not grasped. He had absorbed the essence of the original work.[21]

If Tomonobu's memory was correct, Kazan was first drawn to Dutch studies in 1824, the year of his father's death. In that year, he became head of the family, with a stipend (at least in principle) of 80 *koku*. He also met at this time Matsuzaki Kōdō (1771–1844) and Suzuki Shunsan (1801–1846), a *rangaku* scholar of Tahara Domain. Both men became lasting friends who showed their mettle when Kazan was in danger. But it is likely that Kazan was interested in *rangaku* even earlier. In a letter written in 1818, the celebrated novelist Takizawa Bakin mentioned that Kazan, who was studying painting in the same school with Bakin's son, was friendly with *rangakusha* (scholars of Dutch learning).[22]

Despite the testimony of Tomonobu, who knew Kazan well over a period of many years, it is unlikely that Kazan's awakening to the West began as late as 1824. Surely by 1821, when he painted the portrait of Satō Issai, invariably described in terms of the

strong influence of Western techniques, he must have had some interest in the West. Yoshida Chōshuku may have shown Kazan illustrations in Dutch books, although they were likely to have been of medical rather than artistic interest. Or perhaps Kazan's interest in Western painting originated in the admiration aroused by such works by Japanese artists as Tani Bunchō's towering copy of a Dutch flower painting.[23] But even if Kazan's eyes were opened to the special merits of European paintings by reproductions in Dutch books or Japanese copies, it has yet to be explained how he was able, without special instruction or direct access to Dutch paintings, to create an unprecedented portrait.[24]

In 1823 he married Taka, the daughter of Wada Den, described as *tawara toritsugi kaku* (a distributor of straw sacks for rice). Taka was only sixteen, fourteen years younger than Kazan. They had three children, and there is no reason to suppose that the marriage was unhappy, but it is curious how seldom Kazan referred to Taka in his letters or other writings. As far as we can tell, he never painted her portrait. Although a few portrait sketches of Taka do exist, they were not painted by Kazan but by his disciple, Tsubaki Chinzan.[25] When Kazan was imprisoned, he prayed that his life would be spared so that he could continue serving his mother, the most important person in his life; but he said nothing about his obligations to his wife. It is true that in his last letter to his elder son, written shortly before he committed suicide, Kazan asked Tatsu to look after his mother, who had suffered much, but this was virtually the only time he mentioned her. For that matter, we do not know Taka's feelings about her husband or how she got along with her mother-in-law. She died in 1871, at the age of sixty-four.

During the years following his promotion to *toshiyori* (elder) in 1832, Kazan's greatest efforts were devoted to restoring the domain's finances. As he had feared, his administrative duties deprived him of time he might have devoted to painting; all the same, no year passed without his completing half a dozen important works. Although most, in the manner of the *bunjinga*,

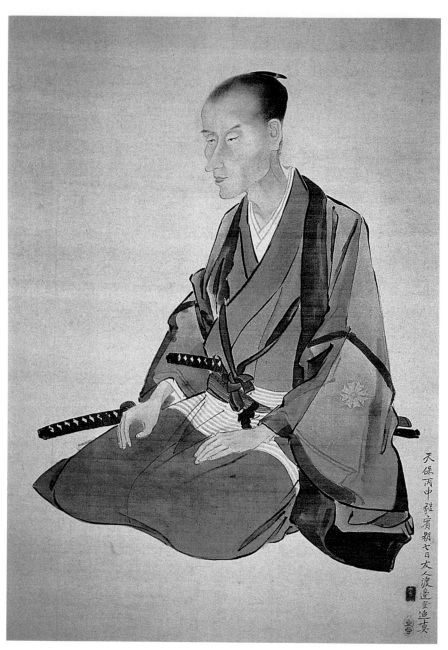

天保丙申鞁賓朔七日友人渡邊登填貞

Portrait of Takizawa Kinrei (1835). (Private collection)

depict traditional Chinese subjects, his reputation as a portraitist continued to grow.

In 1835 Bakin, aware that nothing could save his dying son Kinrei, decided to ask Kazan to paint the son's portrait. He sent for Kazan, but by the time he arrived, Kinrei was dead and in his coffin.[26] Kazan asked to have the lid of the coffin opened. Although he had known Kinrei for twenty years, ever since they were pupils of Tani Bunchō, he wanted his portrait to be exact. Bakin was surprised: he expected that Kazan, like most other portraitists, would paint from memory. The death of Kinrei was a terrible blow to Bakin, and not only as a father: he realized that with the loss of Kinrei, it would not be possible to restore the glorious samurai past of his family. But at least he wanted his descendants to know what Kinrei had looked like.

According to Bakin's account, Kazan shone two mirrors on the dead man's face to catch the features exactly. Impressed by the finished portrait, Bakin said that nobody could mistake the identity of the person portrayed; that was why, he added, so many people wanted Kazan to paint their portrait.[27] Kazan's painting shows a somewhat frail-looking young man with a long nose. Even though it is by no means flattering, it is far more distinctive than contemporary portraits of emperors.[28] Bakin was properly pleased with this memento of his son.

Another portrait painted about the same time but much less well known is that of Iwamoto Kō, the mother-in-law of Kazan's sister Moto.[29] At first glance, the painting is so realistic that it looks like a studio photograph from the late nineteenth century. The features are sharply delineated, but the half-length body seems to be surrounded by clouds. The expression on Kō's face, however, is anything but clouded; she is a woman whose determination, revealed in her every feature, has brought her success. The painting was commissioned by Kō's son.

In 1837 Kazan painted his two most famous portraits, of Takami Senseki (1785–1858) and of Ichikawa Beian (1779–1858).

The portrait of Senseki is considered to be one of the masterpieces of Japanese portraiture and is the only painting of the

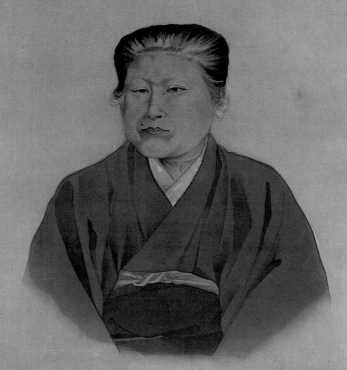

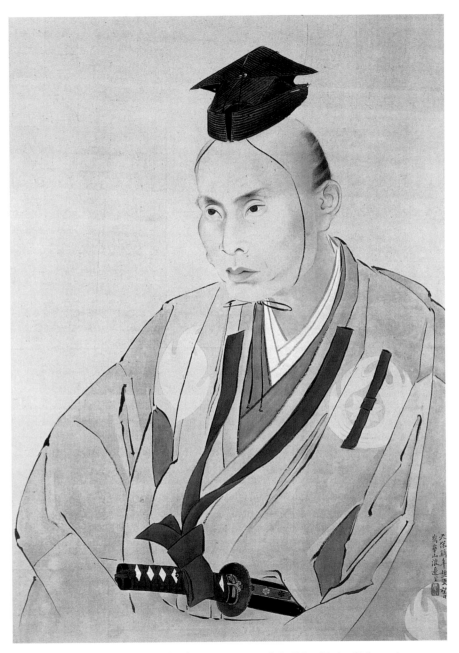

Portrait of Takami Senseki (1837). (By permission of the Tokyo National Museum)

(*Opposite*) Portrait of Iwamoto Kō (ca. 1835). (By permission of the Tahara Municipal Museum)

late Tokugawa period to rank as a National Treasure. Senseki, as is immediately apparent from his sword and his costume, is a samurai. Even without knowing anything about him, we at once sense that he is a person of importance, but he is not a generic high-ranking samurai; this is a particular man with a strong personality. The individuality is accentuated by Kazan's use of Western techniques of shading and coloring.

Like all samurai, Senseki had various names he could use in different capacities. One name was quite distinctive: Jan Hendrik Dapper, a name bestowed by a Deshima factory director. There is something comic about a high-ranking samurai being known as Dapper, but he was by no means the only *rangaku* enthusiast with a Dutch name, and he used it unself-consciously.[30] This may seem unbecoming in a samurai, but he was quite capable of acting in a thoroughly samurai-like manner when necessary. Senseki's primary occupation was that of senior retainer (*karō*) of Furukawa Domain, and it was he who directed the forces that cornered Ōshio Heihachirō after his unsuccessful rebellion in 1837.

Senseki is known for his unswerving devotion to *rangaku*, but it is not clear with whom he studied. His notebooks from as far back as 1806 have Western writing on the covers.[31] We know that he was friendly with at least two of the Deshima factory directors, Jan Cock Blomhoff and Johan Willem de Sturler. In 1826, when Siebold visited Edo, Senseki met him. He afterward sent a letter to the interpreter Yoshio Gonnosuke with greetings to "Mijn heer Sturler" as well as to Siebold and Bürger, all of whom he had known in Edo.[32]

Senseki's interest in *rangaku* was not confined to books. He acquired a telescope and became an enthusiast for astronomy. He also bought a compass and studied surveying. He knew all the prominent *rangaku* scholars, and his interest in foreign learning never flagged, although he seems to have been a dilettante rather than a serious scholar. In 1854, the year of the first treaty between Japan and the United States, Senseki traveled to Edo to meet Nakahama Manjirō (1827–1898), who had been shipwrecked as a boy and later taken to America. No doubt Senseki wished to

learn something about the United States from a Japanese who had actually been there.

The day before Kazan painted his portrait of Senseki, he painted another, most unusual portrait of a samurai. This samurai is dressed more or less the same as Senseki, but he is *smiling!* It is rare in the portraiture of the world for the subject to be shown smiling, not quietly smiling like Mona Lisa but baring his teeth in a grin. Scholars who have commented on the picture admire the manner in which Kazan managed to capture the momentary flash of a smile, but they tend to dismiss the subject's expression as frivolous (*keihaku*); they cannot forget that a samurai was supposed to smile only three times during his life: when he was born, was married, and had his first son. However, it is possible that

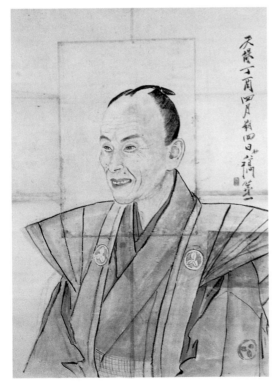

Portrait of a smiling samurai (1837).
(Private collection)

the smiling samurai is none other than Senseki. A mole under the left nostril is common to both portraits, and the nose, eyes, and eyebrows are strikingly similar. The strongest reason for not accepting both as portraits of Senseki is that the crests on the *kamishimo* (hemp jacket) that the two subjects wear are different.[33] But I would like to think of Senseki as smiling.

In 1837 Kazan painted two portraits of Ichikawa Beian that some scholars consider his finest achievement. Both portraits are frontal views, and the expression is more or less the same. Both can also be described as realistic, but the expression in the earlier version is almost overpowering. The deep-set eyes, emphasized by the wrinkles, are the most remarkable feature of the face. The wen on the right side of Beian's face also is carefully delineated, as if to insist that the portrait is unsparingly accurate. Beian, in

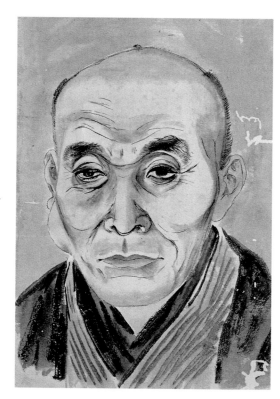

First portrait of
Ichikawa Beian (1837).
(By permission of the
Kyoto National Museum)

(*Opposite*) Second portrait
of Ichikawa Beian (1837).
(By permission of the
Kyoto National Museum)

六旬誕日寫傳神鷲
見蒼顏一老人烏帽
戴來雖似貴綿裘著
得竟應真繫名文苑
瘤相頳游手墨池龜
有因無事散閒能到
七重逢垂白畫中身
戊戌九月六日
未莽自題

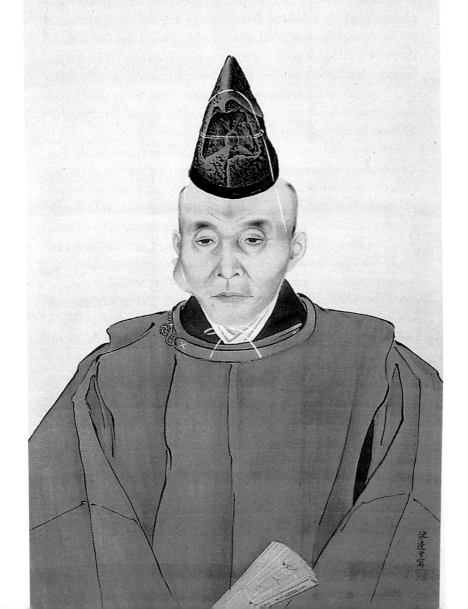

渡邊筆寫

In the same year Kazan, alarmed by reports of foreign ships in waters near Tahara, painted pictures of Russian and British flags for printing and distribution to coastal villages so that the villagers would recognize any foreign ships that might come into sight. His favorite sibling, his brother Gorō, whose portraits (as a small child and as a youth) Kazan had painted, also died in 1837. The famine and this personal tragedy undoubtedly affected Kazan deeply, but he went on painting, not only the portraits but *Ducks in the Reeds in Moonlight, Smoky Rain in Summer Mountains, Little Birds amid Peach Blossoms,* and other uncontroversial works in traditional *bunjinga* style. Somehow he found the strength to rise above misfortune and maintain his devotion to art. Or perhaps he painted in order to feed his family during the terrible famine.

The Meeting of East and West

7

In the third month of Tenpō 9 (1838), a Dutch delegation traveled from Nagasaki to Edo. In the past, the bakufu had insisted that the Dutch pay tribute to the shogun by taking this long journey once every year, but beginning in 1790 the requirement was modified to one visit every five years. The change was no doubt a relief to the Dutch, for they no longer had to offer expensive gifts each year to express their gratitude for the privilege of being allowed to trade in Japan. The Deshima *opperhoofd* (head of the trading station) in 1838 was Johannes Erdewin Niemann. He was accompanied to Edo by his secretary, Gerrit de Vries. Niemann, at least in the reports that circulated, was unusually well educated for a *opperhoofd*. It was said that after graduating from a university in Holland, Niemann had studied for five years in London, eleven in Paris, and one in Vienna.

Kazan wrote two essays about the interview that Niemann gave to a group of Japanese while the Dutch were in Edo. In both he emphasized Niemann's bookishness: "He begrudges any time spent away from books. Even when he is in the toilet, a book never leaves his hand." When Niemann and

his delegation were put up by the daimyo of Hikone at an official residence, he told the interpreter, "I would much prefer to stay at an inn where I can read a book."

Niemann's fondness for books may have been genuine, but there is considerable reason to doubt the truth of his curriculum vitae as related by Kazan. Examination of Dutch East India Company records has revealed that in 1818 the company hired Niemann at the age of twenty-two, and he left the same year for the East Indies. Nothing is mentioned in his dossier about studying in London, Paris, or Vienna.[1] Niemann became the *opperhoofd* in 1834, but he had been working on Deshima since 1830, although in a lesser capacity, as *pakhuismeister* (warehouse manager) and secretary.[2]

Kazan presented an entirely favorable picture of the man. He mentioned with particular admiration Niemann's refusal to become the "general" of the East India Company because he preferred to be sent to Deshima. Kazan continued,

> Niemann's aspirations are strongly directed toward scholarship, and he has little desire for promotion. He has always said that if he were tied down by an official position, it would be difficult to realize these aspirations. I understand that when he returns to his country, he plans to travel overland from India and to make a thorough investigation of the conditions and peoples he encounters. Niemann's field is geography in general.[3] It has been twenty-three years since he left Holland. Niemann stands seven feet, three inches tall.[4] He is as stout as an ox. He has red hair and blue eyes. (Some say that most Hollanders have brown eyes. Those with blue eyes are invariably of northern extraction.) His face has a reddish tinge. He is serious but, I gather, somewhat obstinate.[5]

It is hard to accept these "facts." It was unlikely that anyone of Niemann's age and qualifications would be offered the highest post in the East India Company, and there is a major conflict between the times of his reputed studies in Europe and his known

activities in Asia. Quite apart from the dubious items in the account of his supposedly brilliant career, his height of seven feet, three inches, strains credibility. This would make Niemann even taller than the unhappy giant Ōzora Buzaemon, whose portrait Kazan had painted. Such an abnormal height should have excited some comment. It suggests that Kazan did not attend the interview, and perhaps he never even saw Niemann. Kazan does not state in so many words that he was present, although this is the impression most scholars have received.[6] He wrote rather cryptically, "What is recorded here is not what one person heard, nor were the questions and answers made all at one time. Moreover, when I have written in the text 'somebody asked,' this has been simply as a convenience."[7]

This could be interpreted as meaning that although he himself was not there, he asked those who had attended the interview to tell him what they could recall of Niemann's answers. Kazan then rewrote what he was told in the form of questions and answers. Even without being present at the interview, Kazan could have learned much of what was discussed from his translator, Koseki San'ei, who definitely was there. However, Niemann's answers to some questions, as Kazan recorded them, are so involved and detailed that scholars have found it hard to believe he could have acquired such information secondhand.

The lack of continuity from question to question is striking. To cite one example: a lengthy description by Niemann of the Dutch educational system is, without transition, followed by a question about whether or not a small country like Portugal depended for survival on Brazil. Perhaps Kazan was inexperienced as an editor, but more probably the questions by the Japanese were fired at Niemann at random, without attempting to pursue a particular line of questioning.

At the end of the preface, Kazan stated his reason for compiling the essay. It was not, as we might expect, because of the information the interview provided about conditions in foreign countries: "The above is what I have recorded from what others have told

me. I hope that it will provide a key to the character of Western people. No doubt there are mistakes and conjectures mixed in with the facts, resulting in many unfounded statements."[8]

This suggests that Kazan was interested in Niemann mainly as a specimen of a European, a curiosity from a world extremely remote from Japan. In any case, that was likely to have been the impression Kazan wished to give, thus obscuring his real intent, which was to demonstrate what could be learned from the utterances of a barbarian. The two essays, as the people who investigated him after his arrest correctly concluded, were subversive, upsetting the conviction that Japan had nothing to learn from the Europeans.

The account of Niemann's background given in "Gekizetsu shōki" (Brief Account of the Shrike Tongues), unlike the questions and answers, was not based on what Kazan or an informant heard during the interview. It could only have originated with the interpreters, some of whom had undoubtedly known Niemann in Nagasaki. Kazan reported, for example, that unlike most of his predecessors as *opperhoofd*, Niemann was eager to learn as much as possible about Japan:

> When he meets people he asks them the number of streets and bridges in Edo, the population, the size of the castle, the number of temples, shrines, houses, and so on. Considering how big Edo is, nobody knows such things. He laughs at the shallowness of their knowledge.
>
> He keeps at his side Kaempfer's *History of Japan* and never is without it. He says, "There have been many books written about Japan since this one, but none can touch it. The book is now out of print, but its reputation has not diminished. That proves Kaempfer was really a scholar."[9]

There is no way of verifying the truth of either such reported remarks or the answers given by Niemann during the interview; but it does not really matter much whether Kazan correctly understood what Niemann had said or seriously misunderstood him.

Rather, what interests us is how Kazan's outlook on Japan's position in the world was affected by what he believed Niemann had said. One senses this, for example, in his mention of the scorn with which Niemann spoke of the huge retinues that accompanied daimyos and other dignitaries when they traveled; Niemann's comment probably accorded with his own unfavorable opinion of the pomp that surrounded men in high positions. According to Kazan, Niemann said:

> In regard to the number of people in the escort, these must be the biggest processions in the whole world. Nobody in the West has ever dreamed of having so many men in an escort. An escort of that size is ludicrous and serves no useful purpose. In my country, one sees such masses of people only in military maneuvers. A "general" ranks the same as a magistrate [*bugyō*], but he has an escort of only twelve men. This gives one a good idea of the Japanese system.[10]

Perhaps as he recorded Niemann's words, Kazan remembered his own experience as a boy when he had been beaten for getting mixed up in a daimyo's procession; but he could not risk openly, in his own voice, criticizing any aspect of established usages, even the tradition of high officials being escorted by masses of men. Instead, he quoted Niemann without giving any indication of whether or not he shared Niemann's opinion. Although it was easier in 1838 than in the past for Japanese to obtain European books and their contents could be safely discussed among members of a circle, it still was dangerous to risk annoying the authorities with complaints about the regime, as they were apt to treat criticism of any kind as an offense punishable by death.

Niemann, who was not affected by the prohibition on criticism, found much to complain about in Japan. Like many people when abroad, he tended to glorify his own country to the detriment of the foreign country in which he found himself. He criticized, for example, inefficient Japanese firefighting equipment, giving details of the remarkable pumps employed in Holland to

put out flames. He concluded also from the rapidity with which a Japanese castle had burned to the ground that it could not have been much of a castle; it was certainly nothing like the king's palace in France, which took twelve whole days to burn.[11] When asked about the Japanese character, he replied that it was much like that of the Turks:

> The Turks have ability and knowledge, but they lack the patience to plan for certain victory. They revere profound learning, but they are uninterested in matters close at hand. Important men tend to be arrogant. They are extremely quick to copy any unusual device they have seen, but because their nature is not stable, they are unable to invent anything. In my country, we call such people *lichthoofd* [light-headed], but no European can match them for manual dexterity.[12]

Needless to say, similar remarks about the Japanese character have often been made. But Niemann was not unwilling to praise Japan. When asked the leading question "Is there any other country in the world where for two hundred years there has been no warfare?" he answered, "There is not one such peaceful country anywhere else in the world. In the West one cannot sleep or eat in peace a single day."[13] This reply was no doubt gratifying to his listeners, but Niemann added the observation that unsettled conditions in Europe had fostered scientific discoveries and territorial expansion overseas that Japan could not match because of its long, uninterrupted peace.[14]

When asked which country in Europe was the strongest militarily, a matter of special interest to samurai, Niemann answered that the country whose people were most famous for their bravery was Turkey. The only country that could compare with Turkey was Russia, and for this reason the British were studying the Russian military system.[15] Niemann had no need to cite sources or figures for these remarks; no doubt he felt quite sure the Japanese would never be able to check up on him.

Another question brought a rather surprising response, considering that Niemann was the head of the Deshima trading station:

Question: How would you characterize the wealth of our country?

Answer: From what I have seen of the land and the climate of Japan, it seems to me that the country can do without trading with China or Holland. It is because the Japanese are badly informed about production that they willingly put up with this inconvenience. If they would bestir themselves, they wouldn't need imported wares.[16]

A large number of questions were asked relating to the medical profession, no doubt because this was the part of European learning that had progressed the furthest in Japan. There even were queries about where European doctors obtained the corpses needed for anatomical research. One question seems to have irritated Niemann, judging from his farcical response:

Question: Are there any outstanding scholars in your country?

Answer: There is Bergstijn. He was an errand boy in a liquor store in Amsterdam, but a certain scholar discovered his extraordinary talents and strongly urged him to study. He made great progress in astronomy and geography and developed into a remarkable scholar. He is twenty-two this year and has received an appointment as professor at the academy. He has 3,800 students. By making improvements of his own invention to the telescopes invented by Newton and Lalande, he has created a wonderful new telescope. Of course, the mountains and seas of the moon are nothing new, but he has discovered that there also are tens of thousands of animals on the moon. It is now increasingly accepted, thanks to his work, that the moon and the earth are the same in nature. He has begun a study of Japan, but there are so many differences in the figures

given for houses and people that he is encountering great difficulties.

Question: What kind of animals are on the moon?

Answer: If one examines the moon using the wonderful telescope Bergstijn has invented, one can see plainly all the mountains, valleys, and fields. A certain number of changes take place each year. If one looks at the flat land, one can see many places with vertical and horizontal lines. At one point there is something like a bridge over which many people keep passing to and fro. These human beings are short of stature and look like monkeys. There seems to be hair growing on their hands and feet. There is also one place that looks as if it is the capital.[17]

The part of the interview that undoubtedly meant the most to Kazan, even more than this vision of life on the moon, was Niemann's response to a question about education in the West. Niemann declared,

In the various countries of the West, and not only in my own, it is customary to divide learning into the kingdom of God, the kingdom of mankind, and the applied arts, and to have schools for each where students daily accumulate knowledge.[18] Those who are diligent in their studies are supported by the monarch; those who distinguish themselves rise to the ranks of his advisers. Those well versed in the sciences go on to be professors at technical schools. Those who are proficient in engineering obtain an income to support them.

When a child is five or six, he first enters school. At some later time, he decides, according to his inborn ability, what his future career will be. In most cases the school sees to it that no violence is done to his natural aptitude. As he progresses in his studies, if he makes some discovery, he writes down his findings and submits them to the school. If his thesis obtains the approval of the senior scholars, it is

forwarded to the government, where it is again discussed and the monarch's approval is requested. From this point on, all the candidate's schooling expenses are paid by the government until he completes his research. Even if this takes two or three decades, he is never reproached for slowness.

Those who seek monetary rewards accept positions with business firms and, once they have determined the cost of their research, begin work. If this arrangement did not exist, no discoveries would be made, no project completed. All this is thanks to a government that promotes talent and makes sure everyone in the country knows that it welcomes their efforts. Consequently, nobody is self-complacent, nobody has prejudices. The results of researches are evaluated by the university and then printed. The discoveries are sent out, reaching every corner of the globe. For this reason, there is nothing of the bad habit found in other countries of self-conceit and contempt for others, nor is there any blocking of the ears and eyes in a narrow view like that of the frog in the well; the scholars' horizons are vast. They excel at listening to others' opinions and expounding their own. This is common knowledge, and for that reason practical learning flourishes. Every day more and more people turn to study. Such an environment nurtures plants, now with sunshine, now with rain, and no one with aspirations ever suffers want.[19]

Regardless of whether Niemann's description of the Dutch educational system was accurate or merely patriotic, it is easy to imagine the effect his words would have had on Kazan. He used the expression *seia*, or "the frog in the well" (which is ignorant of the great ocean), again and again in his essays to characterize the Japanese. Mention of "other countries" that were conceited and had contempt for others probably was veiled criticism of China. Kazan soon commented in his writings on the failure of the Chinese to spread their knowledge to other parts of the world. Above all, Kazan doubtless felt envious of the inhabitants of foreign

countries where everyone was able to get an education and could expect to be rewarded for diligence with suitable employment. In Holland, he would not be condemned to spend his days poring over boring domain records.

Even in Japan, the inborn scholarly ability of sons of peasant families was occasionally recognized by benefactors who enabled the boys to attend schools. It also was true that literacy among Japanese was higher than in most European countries. But how Kazan must have wished that the Japanese had an educational system like the one that, according to Niemann, existed in Holland! Kazan often referred in later works to what he had learned from Niemann.[20]

Niemann's answers to the questions posed by the Japanese also must have come as a shock to Kazan. He learned for the first time that in some respects at least, the conditions under which people lived in Europe were superior to those prevailing in Japan. Compared with the feudal system in Japan, based on the assumption that a man's obligations to his lord took precedence over his own inclinations, the Dutch way of life must have seemed enviable but also disturbing. How was it possible for a society to exist without teachings to serve as its guide? Kazan had been trained to consider as barbarians those foreigners who had not been enlightened by the teachings of Confucius, but the educational system in Holland was clearly not that of barbarians. He did not comment about this uncertainty in the essay, but it may have made him feel he needed to know more about the Christian religion. Like all Japanese, he believed it to be deceitful and a menace to Japan, but he may have wanted to discover what lay behind the civilized way of life that Niemann had described.

According to Miyake Tomonobu, Kazan always expressed doubts to him concerning the appropriateness of calling Christianity a heresy, in view of its being the established religion of most foreign countries. Tomonobu went on to say that quite by chance, Kazan obtained a little book describing the life of Christ and asked Koseki San'ei to translate it. Just as San'ei was about to

complete the translation, he learned of Kazan's arrest, and blaming himself for having implicated Kazan in the crime of reading and translating a forbidden book, he committed suicide.[21]

Writing in 1881, when he was an old man of seventy-six and tolerance of Christianity had come to seem meritorious, Tomonobu may have persuaded himself that Kazan had questioned in his heart the harsh condemnation of the forbidden religion; but it is hard to imagine he made it up when he said that Kazan had acquired a book about Christianity and wanted it translated. Other scholars have expressed certainty that Kazan read the Old Testament (probably in Morrison's Chinese translation), but more recent scholars have denied this possibility.[22] It is probably safe to say that Kazan, his eyes opened as the result of the interview with Niemann to intellectual and spiritual aspects of the West, was interested in learning more about Christianity, despite the danger.

The interview came on the heels of the rejection of Kazan's petition to be relieved of his duties as a member of the domain, a shock of another kind. Kazan wanted desperately to realize his artistic talents, but he had been refused, without consideration of his illness or his long years of service to the domain. Judging from what Niemann said, this would not have happened in Holland.

Earlier in the month of the interview with Niemann, Kazan had presented more than 550 books, 20 works of art, and some painter's notebooks to the daimyo of Tahara. It is surprising that despite his poverty, he had been able to amass a collection of this size, but as he related in the appended memorial to the daimyo, each item had been purchased at the cost of his flesh and blood. In the memorial he addressed to the daimyo when presenting his books, he requested that if there ever was another famine like the one that had afflicted Japan two years earlier, the daimyo sell the collection, even if the money it fetched was enough to buy only one grain of rice to alleviate the suffering of the poor.[23] This gesture, giving away his prized collection, suggests that he was turning his back on his career as a scholar.

Kazan's petition was probably rejected because senior officials of Tahara Domain considered him too valuable an administrator to be allowed to abandon his post. It is not clear what exactly Kazan would have done if his petition had been accepted. Probably he hoped to devote himself to improving his painting. But even though his work obliged him to perform many hours of tedious and irksome duties, taking him away from his art, Kazan produced some of the best-known works of his entire career in 1838.

His portrait of Confucius shows the sage as a portly man with a friendly smile on his face. Kazan no doubt intended the painting to be a tribute to the philosopher whose writings had deeply affected every aspect of his thought and behavior, but his

Portrait of
Confucius (1838).
(By permission of the Tahara
Municipal Museum)

Confucius lacks the dignity we expect; he resembles instead one of the jolly Seven Deities of Fortune. The painting, often reproduced in books devoted to Kazan's art, originally may have been intended to serve as an object of worship in the Tahara school for boys of the samurai class. This would explain why Kazan portrayed Confucius wearing a sword, for he surely knew that a sword was inappropriate in a portrait of Confucius. He also signed the painting not with his own name but with Miyake Tomonobu's, perhaps in order to make the painting seem more worthy of worship.

Kazan's painting of a fierce tiger in a storm, painted in the same year, is famed for the traditional story that the domain used it to pay back a debt of 3,000 *ryō*. If this actually happened, it was a huge sum, by far the largest ever paid for a work by Kazan. Admirers of the work find that it perfectly conveys the tiger's wrath, but the glowering beast does not look much like a tiger; it does not even have any stripes. Kazan showed much earlier, in his 1815 painting of a shy tiger peeping around a Chinese gentleman, that he knew what a tiger looked like, but in this work the trees and bushes caught in the storm are painted more realistically than the tiger. The painting was intended to give visual form to a poem by Huang Tingjian (1045–1105), a Song poet whom Kazan particularly admired.

Kazan's portrait of the geisha O-take,[24] painted in the sixth month of 1838, is another popular favorite, often reproduced on posters advertising exhibitions of his paintings. Virtually all of Kazan's other portraits are of men, many of them ugly, and the contrast gives special appeal to his one portrait of a beautiful woman. It probably was the first of its kind. Portraits of women of the samurai class invariably show them seated formally, displaying dignity but little charm. Although the geishas and other women depicted in *ukiyoe* art certainly have charm, these works are not portraits. In her portrait, O-take manages to look both refined and seductive in her informal pose, a gauzy fan held before her face. One authority has opined that she was "most probably" Kazan's mistress.[25] This may explain the exceptional

Tiger in a Storm (1838). (By permission of the Hirano Museum of Art)

care that Kazan took not only with O-take's face but also with her elegant though simple costume, even though he barely sketched the costumes worn by the men he portrayed. The inscription on the painting mentions a government decree against extravagance. Accordingly, O-take, complying with the order, does not wear her usual elaborate hair ornaments or even makeup. Kazan noted she nevertheless looked as lovely as a water lily after the rain.

This portrait, one of the last that Kazan painted, has a long inscription in *kanbun*, written by Kazan himself.[26] Listing examples of the likes and dislikes of famous Chinese poets and painters, he announced that his own preference was for beautiful women. He dedicated the painting of "a beloved geisha" to his disciple Hirai Kensai, with the playful question, "I wonder if your tastes are the same as mine?"[27]

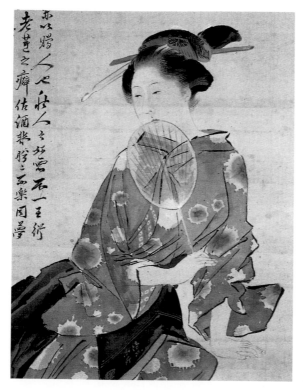

Portrait of a geisha (1838), said to be O-take, Kazan's mistress. The work is entitled *The Editor*, a reference to a learned Chinese courtesan who corrected proofs for a poet. (By permission of the Seikadō Bunko Art Museum)

Another painting of this same productive year, 1838, is the po-
etic *Fine Rain in the Deep Mountains*, one of Kazan's rare landscapes.
While Kazan was traveling, he often sketched the scenery on the
way, but such sketches were quickly executed and Kazan prob-
ably did not intend to sell them. In contrast, *Fine Rain*, a finished
work, is a lovely, quite traditional landscape. In the background,
mountains rise in layers to one high peak, each layer painted in
various shades of brown with clouds in between. The inscription
on the painting says, "The rain has cleared, and at the foot of the
mountains is a village in a bamboo grove. Pools from a mountain
torrent linger in the sandy shore. The gate that a barefoot rustic
approaches, returning home, is half buried in mud, but it does
not bother him."[28] Every element is so familiar as to seem a cliché
of *bunjinga* art, but the subdued colors of the whole make this an
oddly moving work.

Kazan seems, however, to have been reluctant to paint unnamed
mountains, in the manner of those in *Fine Rain*. As he stated in
a letter written to Tsubaki Chinzan while under house arrest in
Tahara, he was convinced that a landscape painting must repro-
duce an actual scene and not be merely imagined. Other *bunjinga*
artists remained serenely indifferent as to whether the mountains
in their paintings faithfully reproduced the appearance of any
known mountains as long as they were poetically evocative.

One feature shared by all four paintings—Confucius, a fierce
tiger, a geisha, and a mountain scene—is the absence of obvious
influence from Western art. Kazan's portrait of Ichikawa Beian,
executed in the same year, uses shading to achieve an effect of
extraordinary realism, but neither Confucius nor O-take was
given the benefit of this or other Western techniques. Despite the
success he had achieved in his realistic portraits, Kazan seems to
have been a *bunjinga* artist at heart.

The unruffled *Fine Rain* was painted in the ninth month of 1838.
In the following month, Kazan experienced a shock that changed
his life, when he and Takano Chōei attended the regular meeting
of the Shōshikai (Respect for the Aged Society) and learned of
the plan to fire on the *Morrison*, a ship that was bringing back

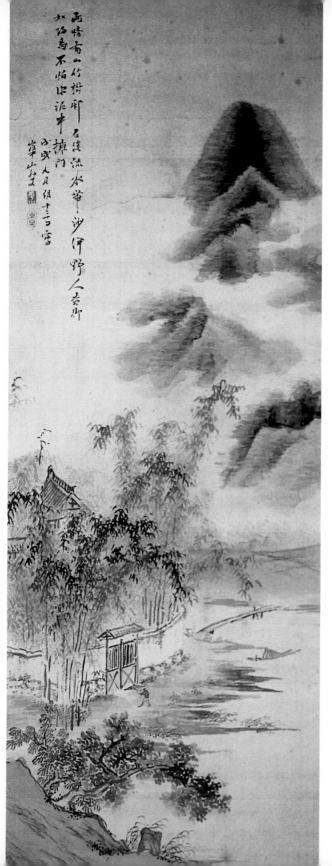

Fine Rain in the Deep Mountains (1838). (By permission of the Seikadō Bunko Art Museum)

some shipwrecked Japanese sailors. In response, Chōei expressed his opposition in *Yume monogatari* (*Tale of a Dream*), intending to show the manuscript to only a few high-ranking officials. Kazan set about writing "Shinkiron" (Exercising Restraint over Auguries), but left it unfinished. Neither man had previously displayed much interest in political matters, but from this time on, the lives of both men would be threatened by their new convictions.

Danger from Overseas

8

Kazan seems to have become seriously interested in *rangaku* only after he had been appointed a *toshiyori* (elder) of Tahara Domain in 1832 with responsibility for sea defenses. Although Tahara boasted few natural resources, it was strategically situated and was considered to be a key point in the coastal defenses of the entire region. In 1739 a Russian fleet under Captain Martin Spanberg, sent to survey Japanese waters, had been spotted nearby. The bakufu warned the domain of the danger of an invasion, and the domain accordingly augmented its defenses. Strongpoints were erected at eight places along the coast, and lookouts and signal-fire stations were built on nearby mountains.[1]

Nothing further developed from the excitement created by Spanberg's ships, but new fears about Russian intentions were aroused in 1771 when an adventurer named Baron Moritz von Benyowsky, who had been captured by the Russians while serving in the Polish army, escaped from a Russian prison on Kamchatka and sailed to Japan. He wrote a letter from the island of Ōshima to the Dutch trading station on Deshima, informing the residents of Russian plans to attack Japan.

He did this, he said, "as an ardent well-wisher" of the Dutch republic, in order to alert it to the danger.[2] After translating Benyowsky's letter from German into Dutch, the Dutch passed it on to the Japanese, causing immense consternation. The letter was supposed to be a secret, but the Japanese interpreters on Deshima and the Dutchmen who made the translation did not hesitate to communicate the contents to interested visitors.

Kudō Heisuke (1734–1800), a physician who visited Nagasaki in 1780 in order to study Dutch medicine, learned of the letter from the interpreters. He discounted the likelihood of a Russian invasion but added, "We do not know what Benyowsky had in mind when he sailed around Japan surveying our coastline, but we cannot ignore the fact that he did so."[3] Kudō's book *Aka Ezo fūsetsu kō* (*A Study of Red Ainu Reports*) discussed both the possible danger of attack from the "red Ainu," meaning the Russians, and the opportunities for colonization that Ezo (Hokkaidō) afforded. Kudō was inclined to discount reports of Russian designs on Japan, saying that he believed them to have been invented by Dutch traders to preserve their trade monopoly. Discussing a skirmish between Russian traders and local Japanese officials that had taken place some years earlier, he wrote, "I cannot believe there is any likelihood of this developing into a major conflict. No importance could have been attached by the Russian government to the incident. I think, rather, that the Russians have heard of the abundance of precious metals in Japan and wish to trade with us."[4]

The book was brought to the attention of Tanuma Okitsugu, who (through his chief retainer) ordered Matsumae Domain, the chief Japanese settlement in Ezo, to report on the situation in the north.[5] The domain sent back a vaguely worded statement that, it hoped, would satisfy the government without revealing its military weakness and inability to combat invaders. Tanuma, displeased by the response, directed that an official expedition be sent to Ezo and the northern islands. The results of the mission were described by Satō Genrokurō in *Ezo shūi* (*Ezo Miscellany*).[6] This work made it clear that although the Russians undoubtedly

were trading with the inhabitants of the Ezo islands, reports of the danger of a Russian invasion were much exaggerated. Indeed, the few Russians whom the Japanese encountered were lonely trappers living under miserable conditions.

The repercussions of Benyowsky's letter were far from over. The most important work inspired by his warning to Japan, *Kaikoku heidan* (*Military Talks for a Maritime Nation*), by Hayashi Shihei (1738–1793), did not appear until 1791. Hayashi went to Nagasaki in 1775 primarily to study Dutch horsemanship but soon became interested in everything concerned with Europe, probably under the influence of his friend Kudō Heisuke. Two more visits to Nagasaki had the effect of making Hayashi impatient with Japan's isolation. His visit in 1782 resulted in his first book, *Sangoku tsūran zusetsu* (*Illustrated Survey of Three Countries*), a work describing the three foreign countries closest to Japan: Korea, the Ryūkyūs, and Ezo.[7] Hayashi was convinced that it was of the utmost importance that Japanese know about neighboring countries, despite the paucity of information available to enlighten them. This book, however, was overshadowed by its successor, *Military Talks for a Maritime Nation*, which opens as follows:

What is meant by a maritime nation? It is a country that is not connected by land to any other, but is bordered on all sides by the sea. Defense preparations appropriate to a maritime nation differ in kind from those prescribed in Chinese military works, as well as those traditionally taught in Japan by the various schools. . . .

Military preparation for Japan means a knowledge of how to repel foreign invaders, a vital consideration at present. The way to do this is by naval warfare; the essential factor in naval warfare is guns. To be well prepared in both respects is the true requisite of Japanese defense, unlike the military policies appropriate to such continental countries as China and Tartary. Only when naval warfare has been mastered should land warfare be considered.[8]

Apart from two abortive attacks by the Mongols in the thirteenth century, the Japanese had never known the fear of an attack from abroad, and their military defense had been planned in terms of internal warfare only. The occasional sighting of a foreign ship always created a stir but did not arouse fears as an immediate threat to Japanese security. The Pacific Ocean seemed to be an impregnable defense.

The possibility was rarely considered that Japan might be attacked by its two closest neighbors, China and Korea. The Confucian scholar Yamazaki Ansai (1618–1682) once asked his students: "If China should attack our country, with Confucius as general and Mencius as lieutenant general at the head of hundreds of thousands of horsemen, what do you think we students of Confucius and Mencius ought to do?" The students, at a loss for an answer, asked Yamazaki what he would do: "Should that eventuality arise, I would put on armor and take up a spear, fight in the service of my country, and capture them alive. That is what Confucius and Mencius teach us to do."[9] Of course, this was a far-fetched parable: nobody expected an invasion from China, let alone one led by Confucius, but it suggests an awareness that a conflict might arise between unconditional worship of Confucius, a foreigner, and patriotic duty to Japan.

The arrival in Nagasaki in 1804 of Ambassador Nikolai Petrovich Rezanov (1764–1807) with a request to open trade relations between Japan and Russia precipitated a much more plausible crisis.[10] Matsudaira Sadanobu, by this time out of office, attempted to persuade the government to deal with the Russians, and his opinions were shared by enlightened men of the day. However, the senior counselors, after keeping the Russians waiting for six months, finally replied that opening the country was contrary to the laws of their ancestors. Rezanov was ordered to leave Japan immediately. This decision aroused outcries among Japanese intellectuals: Shiba Kōkan (1747–1818) declared that the treatment of the foreign ambassador had been inhuman, and he wrote, "The Russians must think we are animals!"[11]

Rezanov, angered by the long wait and the refusal, decided that the only way to get the Japanese to show respect for Russia was to impress them with a display of force. He ordered two junior naval officers, Nikolai Khvostov and Gariil Davydov, to take ships to the northern islands and exact revenge. In 1806 and 1807, Japanese settlements in Sakhalin and the Kurile Islands were burned and pillaged. Marines put ashore from two Russian ships stole provisions and carried off every Japanese they met.[12]

In response to these attacks, some three thousand Japanese troops from four domains in the northern part of Honshū were dispatched to Ezo. There were no more Russian attacks after 1807, but the bakufu ordered the coastal fortifications to be strengthened, and the command was given to repulse with gunfire any Russian ships that came close to shore.

Tension with Russia gradually subsided, only for England to emerge as a new threat. British ships, pursuing whales in the northern Pacific, began to appear in numbers off the Japanese coasts. This prompted the issuance in 1825 of the *uchiharai* edict, a directive that any foreign ship, regardless of nationality, that approached Japanese shores was to be driven off with gunfire. There was opposition to this directive even from within the government. The chief treasurer (*kanjō bugyō*), Tōyama Kagemichi (1764–1837), noted,

> Of late, barbarian ships have repeatedly sailed into Japanese waters and have committed belligerent actions. However, there is not the slightest indication that they plan to seize Japanese territory. It is true that they are barbarians, but does it stand to reason they would travel tens of thousands of miles over the waves in order to wage a war? This is quite unthinkable.[13]

Despite such reassurances, there was in fact a danger that Britain, the most powerful nation in the world, might decide that the time had come to open Japan to foreign trade. The Bonin

Islands,[14] a cluster of small, uninhabited islands, were discovered in 1827 by a British warship, which made known their existence to the rest of the world. Three years later, a group of British and other Europeans living in Hawaii, as well as some Hawaiians, moved to the islands. They asked the British government for recognition and protection as a colony, but the Foreign Office was against the annexation of the Bonins unless it could be demonstrated that possession would be of positive advantage to the China trade.[15]

In 1834, after the East India Company had been deprived of its monopoly over the China trade, the government showed new interest in Japan. The foreign minister, Lord Palmerston, issued a directive concerning the China trade in which he commanded the chief superintendent "to avail himself of every opportunity which may present itself for ascertaining whether it may not be possible to establish commercial intercourse with Japan."[16]

The British warship *Raleigh* made a survey of the Bonins in 1837, and there were rumors that occupation of the islands was imminent. At about the same time, the American ship *Morrison* was making its way toward Japan with seven Japanese castaways aboard. Late in 1832, some Japanese who had spent fourteen months drifting about the Pacific after their ship was wrecked in a storm reached an island off the Canadian coast. Of the original fourteen crew members, only three survived. They were rescued by trappers of the Hudson's Bay Company and eventually sent to London. At first the British government, although willing to repatriate the three castaways, was disinclined to take advantage of the gesture, perhaps out of fear of repeating Rezanov's failure. Some in the government, however, believed that this was an excellent opportunity to extend British influence in the East. They proposed that when returning the castaways, the British act as though this were their sole concern but remain alert to any opportunity to open Japan to trade.

In 1835 the castaways were sent from London to Macao, where they were placed under the protection of the interpreter Charles Gutzlaff.[17] Four Japanese castaways who had been shipwrecked in

Luzon and sent to Macao in 1837 aboard a Spanish ship also were placed under Gutzlaff's protection.

Charles King, the director of an American shipping company based in Macao, became interested in the possibility of using the Japanese castaways. He proposed to the trade commissioners that the seven Japanese be repatriated on the *Morrison*, a ship belonging to his company. They agreed, in the interests of preserving British rights in the Japan trade. The American Board of Foreign Missions also welcomed the possibility of opening Japan to their endeavors. Gutzlaff, a clergyman by profession but also the trade commission's chief interpreter, was taken along to interpret and make a full report of all that occurred in Japan.

The *Morrison* sailed from Macao on July 4, 1837. After a stop in the Ryūkyūs, it proceeded toward Edo Bay, arriving on July 29. The magistrate of Uraga at once informed his superiors in Edo and nearby troop commanders of these unexpected visitors. When the *Morrison* approached Uraga, the Japanese started firing. Those on shore were simply following orders; they knew nothing about why the *Morrison* had come to Japan. Those aboard the ship, not having been informed about the *uchiharai* order, were bewildered by the barrage to which they were subjected. (Everyone agreed, however, that Japanese marksmanship was extremely poor.) Because the ship was traveling unarmed in order to emphasize the peaceful nature of the visit, it was unable to answer the Japanese gunfire. It had no choice but to flee.

The *Morrison* later called at Kagoshima. There it was welcomed with cannon fire from soldiers of Satsuma Domain. The ship, having failed once again to put the castaways ashore, returned to Macao, mission not accomplished.

About a year later, the annual ship from Holland brought to Nagasaki a document that enabled the Japanese to learn for the first time the nature of the mission that had brought the *Morrison* to Japan. This information, passed on to the Nagasaki magistrate by the head of the Deshima trading station, was treated as secret, but the source of the Dutch report was probably no more secret than an article that had appeared in a Singapore newspaper.[18]

Another rumor from the Dutch indicated that the British planned to occupy the Bonins.[19]

The *Morrison* incident and the threat of an impending British occupation of the Bonins combined to make the bakufu acutely aware of national defense. In the twelfth month of 1837, the bakufu ordered an official to make a survey of the Izu and Bonin Islands.[20] When Kazan got word of the plan, he asked for permission to accompany the mission, but his request was refused. Mizuno Tadakuni (1794–1851), the most powerful of the *rōjū*, was particularly upset by the ease with which the *Morrison* had penetrated Edo Bay.

On the fifteenth day of the tenth month of 1838, there was a meeting of the Shōshikai, a kind of intellectual club founded by Endō Shōsuke (1789–1851), a Confucian scholar from Kishū Domain. The Shōshikai had originally been formed to discuss ways of dealing with the great famine of 1836/1837, but its focus gradually shifted toward the study and exchange of information about foreign countries. The membership was varied and included *rangakusha* as well as Confucian scholars and even government officials interested in learning about developments in the rest of the world. Because the society was composed of people with different interests and political attitudes, it had no definite objective. Watanabe Kazan and Takano Chōei regularly attended sessions of the Shōshikai.

During the general conversation that followed the meeting, Haga Ichisaburō, the secretary of the Hyōjōsho, the bakufu's highest-ranking legal body, informed the members of rumors concerning the imminent visit to Japan of the American ship *Morrison*. He showed the gathering the draft of a report in which the Hyōjōsho had recommended, in keeping with the *uchiharai* edict of 1825, the use of force to drive away any ship that intruded into Japanese waters. The report also said that the government had been informed by the Dutch that the British were planning to repatriate some shipwrecked Japanese fishermen and would use this as a pretext for demanding trading rights. It recited various outrageous actions by the British—especially the deceit of

sending the British ship *Phaeton* in 1808 into Nagasaki Harbor flying the Dutch flag—and expressed the belief that the British planned to teach Christianity, the forbidden religion. There was no alternative, concluded the report, to using *uchiharai*, against not only the British but all Christian countries.

This news, although it was very old, came as a shock to the listeners. It is incredible that no member of the Shōshikai was aware that the *Morrison* had already visited Japan and been driven off by gunfire in July of the previous year, but probably the Japanese did not know the identity of the ship or that castaways were aboard. The Dutch, who informed the bakufu of the *Morrison*'s upcoming visit, may have supposed that the same ship was going to make a second attempt to put the castaways ashore in Edo. Or they may have found that the threat of a British ship entering Japanese waters provided a good opportunity to denounce their rivals in trade.[21]

Kazan was outraged by the revelation that *uchiharai* was to be employed. He thus decided that he would join his translator Takano Chōei in doing what they could to persuade influential members of the bakufu to have the edict repealed. They were unaware that Mizuno Tadakuni, realizing that a *uchiharai* incident might provoke foreign countries into starting a war, had already considered rescinding the law. Although some of the daimyos he consulted objected to any weakening of defenses, he had his way, and there were no further instances of *uchiharai*.

Kazan wrote his essay "Shinkiron" (Exercising Restraint over Auguries) immediately after learning about the shelling of the *Morrison*. But he stopped writing the essay midway, fearing that because he had written in white-hot indignation, the contents might be deemed disrespectful. The essay as it stands is confusing. Some pages seem to be out of order, and others are probably missing, but it is evident that the general purpose is less a protest against the inhumanity of firing on the *Morrison* than a call for preparedness against possible enemies. Kazan was sure that knowing one's enemy was an indispensable part of preparedness, and he decided therefore to record everything he knew about the West—

"down to the most trivial things—gossip, dirty jokes, skits."[22] The essay ends well before he reaches these last items.

"Exercising Restraint" opens with a consideration of Tahara's defenses. Kazan believed that they were likely to prove useless because they were not backed by knowledge of the enemy. He moved then to a discussion of the English missionary and scholar of Chinese, Robert Morrison, whom Kazan confused with the ship of the same name. Probably he knew Morrison's name from his *Dictionary of the Chinese Language*, published between 1815 and 1823. Koseki San'ei, one of his translators, owned a copy of Morrison's dictionary and may have mentioned the compiler's name to Kazan.[23] It seems not to have occurred to Kazan (or to anybody else) that a ship and a man might have the same name. Kazan wrote,

> Recently I heard from a gentleman who is a dilettante and a lightweight, an inveterate gossip,[24] that in the seventh month of this year Niemann, the head of the Dutch trading station, secretly reported that an Englishman named Morrison was returning seven Japanese castaways for the purpose of asking for trade and had proceeded as far as waters near Edo.
>
> I gather that this Morrison is a native of London in the country of England and has spent sixteen years at a merchant house in Macao in China. He is extremely familiar with Chinese writings and has many publications, as I can affirm even with my limited knowledge. . . . No matter how great a genius Morrison may be, one can easily imagine that for a Western person, learning Chinese must be the most difficult of tasks.[25]

The Dutch, Kazan remarked, often praised Morrison as a man of ability and astuteness, and they reported that in his country he enjoyed the highest rank and wielded great influence. Kazan conjectured that Morrison must be between fifty and sixty years. At this point, Kazan broke off his account to describe the

complicated love life of Heinrich Bürger and his indebtedness to Morrison for having found him an English wife. This sidelight is followed by a digression on Polish history. Kazan finally returned to his discussion of Morrison with the comment that there must have been some special reason for choosing so eminent a man to lead the expedition to Japan. Morrison, for all the interest he aroused in Kazan and his associates, who believed that the ship of which he was the captain was a menace to Japan, had in fact died in 1834, three years before the *Morrison* incident.

Shifting the subject again, Kazan declared that foreign countries were well aware of Japan's strict seclusion laws. As evidence, he cited works by the admirals Ivan Fyodorovich Krusenstern[26] and Vasilij Mikhajlovich Golovnin,[27] proof that these books, both highly critical of Japan, were known at least to the circle of Kazan's friends. He commented,

> Surely they must be aware when they come here in the attempt to open trade, using castaways as go-betweens, that they will not be successful. . . . For its part, the bakufu, in keeping with its decision at the time of the Russian embassy [of 1804/1805], for reasons of national interest will not change our country's policy [of seclusion]. Even if this should lead to some unfortunate development, it is a great principle that must not be changed.[28]

It may seem surprising that Kazan defended the seclusion policy. Perhaps he wrote in these terms because he hoped that expressing such orthodox views might shield him from criticism as an opponent of state policy; but more likely, this was his sincere belief. Like Yamazaki Ansai in the parable, Kazan was faced with choosing between patriotism and cosmopolitanism. Although he chose patriotism, he did not abandon his belief that it was crucially important for Japan to learn about the West. He believed that the seclusion policy was still Japan's most effective way of maintaining its independence in the face of

possible attack from abroad, but the policy had to be bolstered by a knowledge of the enemy. Kazan reinforced this statement in a characteristic manner:

> What is thought of as *michi* [the Way] in the West should logically be the same as what we also think of as *michi*, and not two unrelated things, but there are many differences, great and small. Unless one studies their ways carefully, it will be like blind men trying to decide from the tail or a leg what an elephant is like. If they catch hold of the tail and say that's what an elephant is like, how are they to explain the hanging nose and the long tusks?

For Kazan to state that the Way in the West is logically the same as the Way in Japan implicitly placed the West among the civilized countries. Its customs were not the same as those in Japan, and therefore required special study, but the people were not barbarians. To old-fashioned Confucianists, this would probably have seemed like an enormous concession. What follows would have been even less congenial:

> The countries of the West are not all the same. Depending on the country, the government may be good or bad, the customs admirable or unattractive, and the people wise or not; but one may say in general that the people are endowed with self-control and perseverance, and their countries are ruled by laws. . . . Those at the top are known as either sovereigns or bishops. A sovereign is succeeded by his son, the bishop by a man of wisdom.[29] In this way, learning is divided between secular and religious. On a lower level, there also are two kinds of learning. People choose the profession they will follow, whether academic or technical, depending on their inborn talents. They do not consider some professions as noble and others as base; they reserve their criticism for men who fail to realize their talents. For this reason, their learning is both precise and broad. China is no match for them.

Moreover, they use their profound knowledge of astronomy and geography to diffuse their learning throughout the world and to enrich their own countries. In this respect, too, China is surely not their equal.[30]

This passage is full of surprises. Kazan had been raised to believe that all barbarians were equally barbarous in their ignorance of the Confucian teachings. Here, however, he recognized both the differences in foreign countries and their general similarity in practicing two virtues of which Confucius would have approved: self-control and industriousness. Although this may seem like merely common sense, no one else in Kazan's time recognized it.

Kazan's division of authority between secular and religious was intelligible in Japanese terms as the different roles in the lives of the people played by the shogunate and the Buddhist temples. In Japan, however, the balance was so heavily weighted in favor of secular authority that most people would not have known the names of the leading Buddhist priests of the day. Indeed, Kazan rarely had occasion to mention a temple in his writings except in connection with services for the dead.

The freedom that people in the West enjoyed to choose their profession according to their particular talents was perhaps the way in which Europeans differed most conspicuously from Japanese. Japanese society was officially divided into four classes—samurai, farmers, artisans, and merchants—and children born into one class were not expected to shift their class or profession out of personal preference. Nonetheless, there were exceptions. It was not impossible even for a peasant's son to become a Confucian scholar, but birth was still of paramount importance. In one of his plays, Chikamatsu has a samurai explain the reason for the failure of his daughter's marriage to a merchant:

A samurai's son is reared by samurai parents and becomes a samurai himself because they teach him the warrior's code. A merchant's son is reared by merchant parents and becomes a merchant because they teach him the ways of commerce.

A samurai seeks a fair name in disregard of profit, but a merchant, with no thought to his reputation, takes in profits and amasses a fortune. There is a proper way of life for each.[31]

Finally, the adverse comparison of China with the West was surprising. Worship of Chinese civilization was still deeply ingrained in the samurai class. It is true that Sugita Genpaku had discovered that Western studies of anatomy were more accurate those of the Chinese, but Kazan was probably the first Japanese to state that China was no match for the West in the uses of learning or in the transmission of its learning to the rest of the world.

At this point, Kazan's essay moves on to a much less attractive aspect of Western civilization: the acts of aggression by European countries that had resulted in the conquest of Asia, Africa, the Americas, and Australia:

Among the five continents, three—America, Africa, and Australia—have become possessions of the Europeans. Even in Asia, barely three countries—ours, China, and Persia—[have preserved their independence], and our country is the only one not in communication with Westerners. I mention with the greatest trepidation, although my fears may be groundless, that I cannot endure the thought our country may seem in the eyes of Westerners like so much meat left lying by the wayside. How could a ravenous tiger or a thirsting wolf not notice it?

If the English are refused when they ask for trade, they will say, "Your country has a long-standing policy [of exclusion], and it is not to be violated. However, ships of foreign countries, our own included, while sailing the seas will at times drift in a storm, or run short of firewood and water, or have sick men aboard, and will seek help in an emergency by going ashore. Your country's strict defense of its coast is harmful to navigation. All countries on the face of the globe must suffer for one country's benefit. We all live under the

same heaven and walk on the same earth. Should like harm
like? How can such conduct be called human?"

After presenting the reasons that the British were likely to give
for opening the country, Kazan foresaw that the Japanese govern-
ment would not yield and that its refusal would give the British
the necessary pretext for declaring war. Although the peoples of
the West were barbarians, they never took up arms without cause,
and Kazan cited the two reasons Napoleon gave for invading
Egypt. Japan's refusal to open the country would probably lead
to war with not only Britain but also Russia, a country of wolflike
ferocity and evil intent.[32]

Kazan next contrasted the British, who excelled in naval war-
fare, with the Russians, who were masters of land warfare. This
led to a consideration of China as a land power inept in naval
warfare. Taking advantage of this, the British had twisted China's
neck from the sea. Now they intended to strike China in the
back by first conquering Japan. Kazan quoted the old Chinese
adage "If the lips perish, the teeth will be cold," giving it the
meaning that if Japan should meet with misfortune, the British
would find it easier to invade China: "England knows this and,
while making detailed and patient preparations, is polishing its
fangs. What the British want of us they will persistently seek,
like flies scavenging for putrid fish. We may drive them away, but
they will certainly return."

It was certainly unusual to think of Japan as a shield protect-
ing China from ravenous European powers, but its decadence,
demonstrated by the conquest of China by northern barbarians
(the Manchus), is frequently mentioned in Kazan's writings. He
believed that once a society reaches its peak it begins to decline
and may end up being conquered by barbarians. Ceylon (now Sri
Lanka), the Buddha's birthplace, was conquered by the British;
India, by the Moguls; Egypt and Constantinople, by the Turks.
Rome, which once ruled the whole world, became lazy and deca-
dent. In China, too, at the end of the Ming dynasty, "people,

worshiping elegance and refinement, gave themselves to drink and song, with never a thought to taking precautions against war. The martial spirit grew increasingly corrupted, and finally they lost their country."[33]

The last words of "Exercising Restraint" express in the strongest terms Kazan's despair over the current situation in Japan. He wrote that he would like to call the attention of the high-ranking officers of the state to the danger now faced by Japan (just as China faced danger at the end of the Ming dynasty), but

they are flatterers who have bought their positions with bribes. Only the Confucian scholars have a conscience, but they have shallow aspirations and choose the small, not the great. It has become a world where prudence is the rule. Since that is the way things are, I wonder how long we shall go on waiting with folded arms for the arrival of an invader?

The Road to Prison

9

Kazan's troubles may have begun with a quite trivial incident that took place in the spring of 1838 at the housewarming of the Confucian scholar Asaka Gonsai (1790–1861). At some point in the party, Kazan spread open a map of the world and, pointing at various countries, described the conditions in each. The gathering was dazzled by his knowledge of foreign countries and by his eloquence, but Hayashi Shikibu, the third son of Hayashi Jussai, the head of the Shōheikō, a Confucian academy, listening by Kazan's side, merely smiled coldly.[1] The Hayashi family, the pillars of orthodox Confucianism, had a strong hatred of *rangaku*, and it was no doubt particularly distasteful to Hayashi Shikibu that Kazan had chosen to display his familiarity with foreign affairs at the house of Asaka Gonsai, a devoted disciple of Jussai.

We should not exaggerate the importance of this incident, even assuming it occurred. Nothing unpleasant happened as the direct result of Hayashi Shikibu's expression of disapproval, but his sneer was symptomatic of the increasingly unfriendly attitude of orthodox Confucianists toward foreign learning. Several more

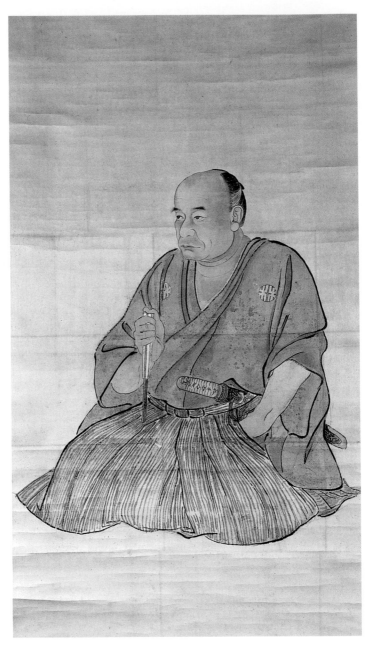

Portrait of Hayashi Jussai (1827?), the highest-ranking Confucian scholar of his day. (By permission of the Tahara Municipal Museum)

progressive Confucian scholars, friends of Kazan's, had displayed an interest in studying the West. This had angered the Hayashi family, who considered Kazan a traitor to his Confucian heritage. Most Confucian scholars, without bothering to ascertain whether information received from the West was true or false, condemned it simply because it was foreign and refused to give it a second glance. But some had lately grown aware that a knowledge of the geography of the world might enable them to understand order or disorder in different countries, their rise and fall, their peoples and social conditions; and a few were so strongly attracted to *rangaku* that they openly declared they preferred foreign learning to traditional wisdom.[2] The hostility aroused in orthodox Confucianists by these developments can easily be imagined.

Kazan's background in Confucianism was solid, and he never renounced it, but by this time his conspicuous interest in foreign matters—in what the Japanese must learn from abroad—absorbed his full attention. Although he intended "Exercising Restraint over Auguries" to be a polemic directed against *uchiharai*, he never completed it, and in the parts that did survive, Kazan did not get around, as we might have expected, to condemning the firing on foreign ships or to predicting the terrible recrimination that would follow. But the text is of interest particularly because of what it tells us about Kazan's sources of information about the West.

For example, Kazan devoted a fairly long section to Poland, a country of minor interest to Japanese intellectuals. First of all, he identified the country as being the same as the Polonia found in works by the Italian Jesuit Giulio Aleni (1582–1649) and the Flemish Jesuit Ferdinand Verbiest (1623–1686), both of whom, centuries earlier, had published maps and works of geography in Chinese. Because they were the work of Catholic priests, these books were strictly banned in Japan, but somehow Kazan had gained access to them. When writing about the partition of Poland and other developments of recent Polish history, his sources were the *fūsetsugaki* for 1815, 1826, 1829, 1830, and 1832. The *fūsetsugaki*, presented each year by the Dutch *opperhoofd* to the

shogun, summarized events that had taken place abroad during the previous year. They were not made public, but Kazan obtained copies, probably from an interpreter. In any case, the *fūsetsugaki* for 1832 was his source when writing about the Russian suppression of a Polish insurrection in the previous year.

It is curious that Kazan should have written in such detail about Poland, but he had heard the rumor (probably originating with Heinrich Bürger) that officers of the defeated Polish army had been exiled by the Russians to Siberia and were likely (in perhaps thirty or forty years) to attempt to escape by way of Sakhalin.[3] Fearing that Japan's security would be threatened if Polish soldiers were active in regions claimed by his country, Kazan urged the preparation of defenses along the northern coasts.[4]

In "Exercising Restraint," Kazan quoted translations of European works of geography.[5] He had acquired at considerable expense Dutch books that he asked Takano Chōei or Koseki San'ei to translate. But he was not content with merely transmitting what the European geographers had written. Instead, as he read these books, Kazan developed a theory of history, concluding that northern barbarians had always been a menace to civilized countries in the south. He declared that all the sages of Europe and Asia were born in Asia and that only Confucius was born north of 35 degrees of latitude. The five great religions (Judaism, Christianity, Buddhism, Islam, and Confucianism) all flourished in warm climates: India, Persia, Anatolia, Arabia, and Egypt. Civilization spread north to Central Asia and then entered Europe, where "at that time the people ate the flesh of animals and clothed themselves with animal skins." Unfortunately, northern barbarians had since overrun the entire world.

Two countries that fitted Kazan's definition of northern barbarians were Russia and England. Russia had expanded its territories steadily eastward until they reached the west coast of North America (Alaska). England had expanded westward and now possessed territory from the eastern coast of North America deep into Canada. To the south, England had conquered "the islands of Asia" and part of Australia:

The British are resourceful and excel in naval warfare; the Russians have a benevolent government and excel in land warfare. Each uses its special strength to gain advantage over the other. If the British obtain anything from us, the Russian will at once demand the same. Holland, caught in between, will resort to deceit of every kind, in the end creating problems for our domestic administration.[6]

On the whole, however, Kazan was favorably impressed by Western civilization. Far from decrying Christianity in the harsh language used by the Confucianists, he included it among the five great religions. He was impressed particularly by education in Europe and spoke approvingly even of its religion:

The thriving state of religion and politics in the countries of the West is such that a bishop [kyōshu] ranks as high as the king. Because priests bear the responsibility for the conduct of each individual, from the king down to the lowliest commoner, they exercise a power of life and death. If the king fails to behave in a manner worthy of a king, they censure him, and what they say cannot be disregarded. I gather that because of this responsibility, they yield their positions only to men of wisdom [and not to a son]. The king, as the highest political figure, has absolute control of appointments and dismissals. He unites his powers with those of the priesthood to keep religion and politics from breaking apart. One might say that being a king is a kind of profession. His most important duty is self-cultivation and the cultivation of others. To that end, the foundation of schools for education and research is considered the most basic part of government. The flourishing state of the schools is without counterpart in China or anywhere else.[7]

In the same essay, Kazan recognized that because it was forbidden to import Dutch books apart from those dealing with the sciences, his description of education in Europe inevitably

was incomplete. Open discussions of Christianity naturally were forbidden, and many aspects of European society had to be deduced from the handful of books available in translation. Sometimes Kazan's deductions went hopelessly astray, but at other times we are likely to be surprised by the sharpness of his vision when he compared practices in the West with those in Japan. He noted, for example, the absence of secret traditions in the West, contrasting this with the closely guarded secrets of the different schools of each art in Japan. Far from keeping their discoveries a secret, people in the West consider secrecy unnatural and disgraceful. Instead, they publish descriptions of all their discoveries in weekly newspapers, in this way spreading knowledge throughout the world.[8]

Kazan was not the first to call attention to the difference in attitude between Japanese and Europeans with respect to secret traditions. In 1798 Honda Toshiaki had expressed admiration for Dutch encyclopedias:

> These are most helpful books that seem to lead one by the hand. Although parts of the explanations are difficult to understand, it is always attempted to make them as clear as possible by means of the illustrations. We are really fortunate that such books exist. In contrast to the Westerners, however, Japanese keep good things for themselves and are reluctant to pass them on to others. It is a shameful state of affairs when people think only how they can profit themselves.[9]

Kazan admired the West, but he was apprehensive about what designs the European powers might have on Japan. In the past, Japan could depend on the ocean to protect it against enemies, but now that was not enough. Japan must fortify its coasts. Although Kazan's military experience was confined to the use of traditional samurai arms, he felt confident that his knowledge of Western works of geography would enable him to ascertain the best sites for coastal defenses. He attempted unsuccessfully to obtain permission to accompany various missions of exploration.

At the end of 1838 the bakufu, in the wake of the *Morrison* scare, at last seemed willing to recognize the danger threatening Japan and the need to fortify the coasts. Mizuno Tadakuni (1794–1851), the senior councillor, ordered Egawa Hidetatsu (1801–1855)[10] and Torii Yōzo (1796–1873) to make a survey of the coasts of Edo Bay as preparation for the intended improvements in defenses.

It was a peculiar combination. Egawa, soon to be recognized as the greatest expert in Japan on Western gunnery, was an advocate of progress and a friend of Kazan. He was a member of the Bangaku shachū ("Barbarian studies group," usually abbreviated as Bansha), a band of like-minded men revolving around Kazan, who wished to learn about whatever was new in the world. Kazan favored modernizing the Japanese military with the latest European weapons, which was why he was attracted to Egawa, the best man for this task.

In contrast, Torii was an archconservative like his father, Hayashi Jussai, and he detested foreign studies. The opposition between Egawa and Torii was complicated by the fact that Egawa (like Kazan and many other progressives) had studied Confucianism under members of the Hayashi school. Their apparent defection from the Zhuxi school thus was bitterly resented. Torii, who became a *honmaru metsuke*[11] in 1837, considered it his duty as the senior emissary to keep an eye on the deputy emissary, Egawa, during their travels together and to make sure he did nothing at variance with the loyal devotion expected of bakufu officials. Indeed, Torii felt a personal need to exercise strict control over any word or action that differed from bakufu policy.[12]

Mizuno probably was not aware of the antagonism between the two men. He knew that in the past Egawa had done Torii a considerable service. During a famine, people on land owned by Torii in Izu were dying of starvation, and Egawa, the *daikan* of Izu, had come to his rescue with money and medicine.[13] Torii was grateful, and their relations seemed quite friendly. Mizuno, however, seriously underestimated Torii's capacity for harming people who did not obey his wishes or who sought a share of credit that he thought belonged entirely to him.

From the outset, relations between the two men were strained. In response to Egawa's request that he recommend surveyors to accompany the party, Kazan supplied the names of two well-qualified men, but Torii objected to employing men of their low social status and did what he could to block the appointments. One of the men was sent back to Edo; the other, working under Egawa, proved to be far more qualified than Torii's surveyor. Torii, as the senior emissary, assumed that Egawa's function was simply to assist him, but Egawa, taking a different view of the duties of a second-in-command, believed that he was expected to contribute as he saw fit to the mission's success. Torii was particularly annoyed with Egawa for having turned to Kazan, a leader of the "enlightenment faction," for information and guidance concerning the places they were to visit.

Torii and Egawa disagreed about everything. In the end, they drew up quite different plans for the defense of Edo Bay. Egawa favored equipping the major domains in the area with modern Western weapons with which to repel foreign invaders, but Torii was opposed to using foreign weapons and worried about arming daimyos with weapons superior to those of the bakufu. The two men also had completely different ideas about where along the bay fortified points should be constructed. In making his survey of the coast, Egawa had the help of a man who knew modern techniques, but Torii relied on a hack of the old school. When the two plans were submitted to the government, it was obvious that Egawa's was far superior.

The report Egawa wrote when he got back from his tour of Edo Bay greatly disturbed the bakufu authorities. He declared that there was no way to prevent foreign troops from landing on the coasts of the bay. There were virtually no fortifications, and most of the domains along the bay were small and weak. It had traditionally been assumed that danger to the bakufu would come from internal enemies, not from foreign invaders, and the bakufu had divided the country into many domains to make it difficult for the country as a whole to oppose its authority. These

divisions, however, also made it difficult to organize defenses against threats from the sea.

After presenting his report, Egawa asked Kazan to prepare a brief on conditions abroad, which he wished to add as a proposal for improving the defenses. Under Kazan's influence, Egawa had decided that it was essential for the Japanese to know their enemies. But when he found Kazan's first draft of "Gaikoku jijō sho" (Report on Conditions in Foreign Countries) to be inflammatory, he asked Kazan to tone it down. Kazan complied, but the revised text was hardly less critical of shogunate policies than the first. Kazan sent Egawa four different versions of the same manuscript.

Kazan had reached the conclusion that change was inevitable in the country's feudal division, but as an intermediate measure, he recommended transferring the most senior daimyos, who had the means to raise troops, to areas threatened from the sea. He also strongly favored stationing bakufu troops on both sides of the entrance to Edo Bay. Kazan was sure that the only way to defend Japan against powerful foreign warships was with ships of equal capability; but at the time, Japan had no such ships and was incapable of building them. He predicted that if smaller ships were used against the foreign warships, they would be blown to bits in one blast.[14] Kazan made some specific suggestions for improving sea defenses, but, on the whole, his outlook was bleak.

Torii, smarting from the defeat at Egawa's hands over the surveying charts, decided to take revenge by attacking Kazan, Egawa's mentor of Western learning. He sent for a man in his employ named Ogasawara Kōzō and, pretending it was by Mizuno's command, ordered him to investigate the Englishman named Morrison and also Watanabe Noboru, said to be the author of *Yume monogatari* (*Tale of a Dream*).[15] It is strange that Torii still had not realized that the ship *Morrison*, which had threatened Japan, and the missionary Morrison were unrelated. He also was mistaken in identifying *Tale of a Dream* as Kazan's work. The spy soon discovered that it had been written by Takano Chōei.

Tale of a Dream,[16] the best-known polemic to emerge from the *Morrison* crisis, was Chōei's first and only attempt at literary expression. It opens as the narrator, a scholar, weary after long study by lamplight, falls into a dazed state and dreams that he is carried off to a place where men of great learning have gathered. He overhears a conversation between a conservative named A and a progressive named B. A says to B,

> I've lately heard a strange rumor. The Dutch say an Englishman named Morrison is in command of a ship now anchored in Edo Bay with seven or eight Japanese castaways aboard. They intend to ask for trade, using the castaways as an inducement. Can you tell me what kind of country England is?

B's reply is something of a panegyric. He has heard that England is about the size of Japan but that, perhaps because it is a cold country, the population is small.[17] The people are intelligent, fond of study, and not indolent. Above all, they desire to make their country strong. B enumerates the many places the British have conquered all over the world. Finally, he gets around to Morrison. He relates that Morrison, unhappy because the British were disliked and sneered at in China, decided he would learn Chinese. Although the language and the system of writing were completely unlike those of his own country, he mastered Chinese during his residence of twenty years in Canton. B describes Morrison's many scholastic accomplishments and the honors that have been heaped on him by his government. Chōei, too, still did not realize that Morrison had no connection with the *Morrison*.

In response to a question from A about the *uchiharai* edict, B tells of the high respect for human life in Western countries, where people consider that there is no greater merit than saving lives. In the present instance, the British, acting out of compassion, have brought back Japanese castaways. If the Japanese fire on the ship, Japan will gain the reputation of being a country without benevolence. Chōei thought that the *Morrison* should be

allowed to enter port and land the castaways. However, the British should be informed that Japanese tradition from ancient times had prohibited trade with foreigners. If the Japanese follow this plan, they will not be guilty of a lack of humanity, and the British will go away quietly, resigned to the inevitable.[18]

This unsensational fantasy created a great stir when word of its contents got around. Chōei did not advocate entering into trade relations with the British, much less opening the country to the West, and he was careful to show the book to only a few persons in high places. It was unsigned. Torii no doubt hoped that his spy would come up with proof that Kazan was guilty of having written a seditious attack on the government, but instead Ogasawara's discovery of the real author put Chōei's life in danger. Even criticism based on Confucian benevolence was intolerable to the government.

Ogasawara returned with other news: Morrison was a hero of the times, a "supreme magistrate" who ruled over eighteen islands in the area of India. He planned to call at Uraga with the seven Japanese castaways he was returning and with rich gifts he would offer as tribute. But if his request for trade were rejected, he would burn down all public and private buildings on the coast and block the passage of Japanese coastal shipping. Ogasawara said this information was derived from a statement made by Johannes Niemann when he visited Edo in 1838.[19] This shocking but groundless rumor seems to have created surprisingly little panic.

Ogasawara also brought back the news that two Buddhist priests—Junsen and his son Jundō—were planning to sail to the Bonin Islands, despite the strict ban on travel there, and that Kazan was involved.[20] Torii pounced on this item and ordered Ogasawara to make a more thorough investigation. It turned out that the two priests indeed wished to travel to the Bonins but that it was not a secret. They had formally requested permission of the bakufu, and their purpose was not to meet covertly with foreigners or to use the islands as stepping-stones for travel abroad but merely to make money by obtaining rare plants and

oddly shaped rocks and selling them in Edo. Kazan was in no way involved.[21]

Torii was not a man to be fazed by facts that contradicted his thesis. He presented a bill of accusation to Mizuno Tadakuni that not only mentioned the intention of the two priests to travel to the Bonins but implicated Kazan in their plan. A second charge was that Kazan was fond of *rangaku* and, like Takano Chōei and Koseki San'ei, had criticized the current government. According to Torii, Kazan had predicted that if foreign ships off Uraga succeeded in preventing Japanese cargo ships from bringing supplies into Edo, Edo would be forced to yield to the foreign demand for trade. He also asserted that if Kazan got as far as the Bonins, he would not stop there but go on to Luzon, Hawaii, and America.[22] Finally, Kazan was guilty of having written an essay in which he set down the criticism of the regime uttered by the Dutch *opperhoofd* Niemann.

The last charge was the result of information that Torii had received from Hanai Koichi, a fledgling *rangakusha* who had been on friendly terms with Kazan. Torii ordered Hanai to look for incriminating evidence against Kazan. Hanai was in luck. He arrived one evening when Kazan and his family were about to eat dinner. Kazan, intending simply to give Hanai something to read while he waited for the family to finish dinner, absentmindedly handed him the manuscripts of his two essays concerning the interview with Niemann.[23] This was all Torii needed.

On the fourteenth day of the fifth month (June 24, 1839), Kazan was suddenly summoned to appear before the North Magistrate's Office in Edo.[24] Two weeks earlier, he had been warned by a secretary of Mizuno Tadakuni of rumors that he was in danger because of the increasing repression of *rangaku*, but he wrote in his diary, "Today I was told I was treading on a tiger's tail, but I didn't believe it. I was sure it was just a rumor."[25]

This time, however, it was no mere rumor. After a few questions, the magistrate ordered Kazan sent to the *agariya*, a prison for samurai. Kazan was charged with three crimes:

1. He was a blind devotee of foreign learning.
2. He had intended to travel to the Bonin Islands.
3. He was a collaborator of Ōshio Heihachirō, who had staged a revolt in 1837.

Kazan denied these charges and insisted that his sole motive in reading about foreign countries was to improve his domain's sea defenses. On that day, his house was searched, and rough drafts of incriminating documents were discovered in a wastepaper basket.

At first, Kazan seems to have been bewildered by the charges levied against him, but a letter sent from prison three weeks later (on July 19) reveals that he was convinced that Ogasawara had initiated the charges and that behind him was Torii Yōzō. He now knew his enemy.[26]

Ogasawara named other men in high places he suspected of being collaborators of Kazan, including Egawa Hidetatsu, but all the eighteen men arrested on the day Kazan was called before the magistrate were (like Junsen and Jundō) minor figures. Takano Chōei temporarily evaded arrest, and Egawa and the other high-ranking suspects were cleared by order of Mizuno Tadakuni, whose private investigation had revealed that they were innocent of any wrongdoing.[27]

Kazan's teachers, friends, and disciples were astonished to learn of his arrest. On the following day, they frantically attempted to find out what had happened and how they might get Kazan released. It did not take long to discover the seriousness of the charges. Worried about how Kazan would fare in prison, they managed to bribe prison employees into providing Kazan with food and other things he would need in his cell. They also established channels for getting letters to and from Kazan. The central figure in the attempt to save Kazan was Tsubaki Chinzan, his disciple and closest friend.

At first, Kazan was optimistic that he would soon be released. Both the magistrate and the prosecutor, acquainted with his work

as an artist, seemed solicitous. The charges were so flimsy that at one point the magistrate asked Kazan if he was aware of having any enemies. Kazan, confident that the charges would be easily refuted, was most worried about his mother. In a letter he sent to Chinzan six days after being imprisoned, he wrote that he was sure his mother would die of worry if she could not see him, and in that case he would have no reason to go on living.[28] Three days later, he wrote to four disciples (including Chinzan) that he had learned the nature of the charges against him:

> I am a victim of slander, plain and simple. Just when it seemed that the untruthfulness of the accusations had become apparent, some inconsequential manuscripts were found in my house, and yesterday I was questioned about them. I believe that I will be charged with having abused our government and idolized foreign countries. For this reason, the punishment, if light, will be exile to some distant island or else house arrest. That is how things stand now. I am truly hesitant to ask your help, but it's all right with me if I never see my wife and children again, providing I can go on serving my aged mother the rest of my life. Please do what you can so that the punishment is house arrest. If that is arranged, it doesn't matter where I am sent, including Tahara. Arranging even that much will probably be difficult. This may be a parting for life. Please try to imagine what I feel.[29]

Life in prison was not only depressing but filled with fear and suspicion. He wrote to Chinzan on July 14 describing the darkness of the cell, the strict control over correspondence, and the possibility that others in the same cell might be spies. He trembled with fear that a guard might catch him even as he wrote.[30] Again and again, he denied that there was any truth in the accusation that he had criticized the government or gathered people around him to discuss political matters.

In his letters, Kazan constantly reverted to his concern for his mother, who no doubt was worrying day and night about how he must be suffering in prison. His letter of July 21 indicates how he tried to comfort her:[31]

I cannot forget my aged mother for one instant. At night in my dreams I often call to my mother, and my cellmates laugh at me. When I recall her I can only weep like an infant. This is how I yearn for my mother, and I am sure she yearns for me twice as much. So please reassure her, tell her I am happy in prison. Anyway, please think of something. All my cellmates are of lower rank than myself, and that makes me all the more self-indulgent. They knew me by reputation even before I arrived, so they call me Sensei, and even the prison officials come to ask me questions about all kinds of artistic matters. One might say this is a rather cramped hot-spring cure. Please be sure to tell her this in detail.[32]

Two weeks later, in a letter to Tsubaki Chinzan, he wrote that he expected a light sentence: permanent house arrest in Tahara. The only thing that bothered him now was the fear of not being filial. The rest he would discard as easily as a broken *waraji*.[33]

At first, Kazan was cheerful in prison, believing that the worst punishment he would receive was house arrest. The testimony given in court by Hanai Koichi had been so confused that the magistrate reprimanded him. Furthermore, the longer the trial went on, the more apparent it became that Hanai was lying. In the end, the investigation by the prosecutor Nakajima Kaemon determined that

1. There was no evidence Kazan had planned to sail from the Bonin Islands to Luzon, Hawaii, or America.
2. There was no evidence he had sympathized with Ōshio Heihachirō or had prior knowledge of his plot.
3. He was not acquainted with people who planned to go overseas.

4. His essays relating to the interview with Niemann described events that had taken place in the past, some of them fifteen years earlier.[34]

In the meantime, Kazan's friends were doing everything possible to secure his release or, at the very least, to save him from execution. Kazan continued to insist, however, that they should worry about his mother rather than himself. One colleague had already fallen victim to Torii's plot. Three days after Kazan was arrested, Koseki San'ei committed suicide. As befitted a physician, he died not by disembowelment but by cutting his wrists with a scalpel. Takano Chōei at first went into hiding, but a week later he turned himself in to the magistrate and confessed the crime of having written *Tale of a Dream*.[35]

Kazan's letters from prison were intended to comfort his friends and, above all, his mother. His accounts of prison life, however, grew less and less cheerful. He shared a cell with two other men. Each man had one *jō* (a mat of about six feet by three) to himself.[36] Air and light entered from an opening in the wall about three inches square. The place where the prisoners got water and were given their meals was close to the toilet and unspeakably dirty. Most of the other prisoners were gamblers. The guards were homeless men or farmers, but they were surprisingly humane. All the same, because letters were smuggled out with the connivance of guards who might betray him, Kazan took pains to mention people in letters only by code names, lest they be implicated in his crime.

He noted that the one thing the prisoners feared most was sickness. Even if a man ran a high fever, the prison doctors were not at pains to help. Their only comfort was words—one thing or another. The interior of the prison was so dirty that the doctors disliked going in to take a sick man's pulse. Most would scribble a random prescription and leave. The medicines for four or five hundred men were brewed together, and different kinds of medicine—whether for eczema, colds, or fever—would be mixed together in one pot. Even when, once in a while, the medicines were

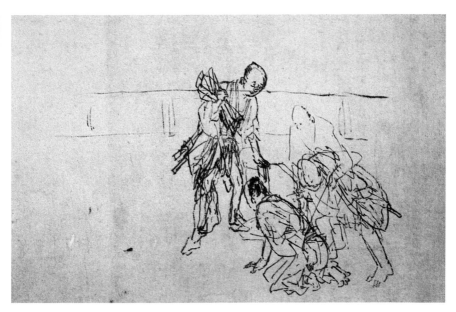

Kazan being trussed by jailers (1839). (By permission of the Tahara Municipal Museum)

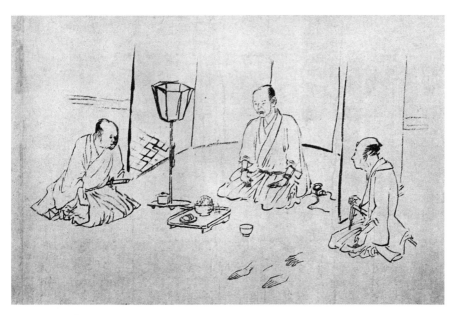

Kazan being interrogated (1839). (By permission of the Tahara Municipal Museum)

mixed separately, there often were mistakes because the pharmacist found making the medicines bothersome. That was why men who were seriously ill did not depend on the prison doctors but took medicines they bought from outside.[37]

Kazan was summoned before the court for questioning four times. In one of his sketches, made after he was released, he depicts a man, probably himself, on his knees and being trussed by one man and menaced by another who stands over him. The sketch brings to mind the letter he wrote to Chinzan not long after being sent to prison, in which he described how he had been bound with ropes and dragged through the streets.[38] Another sketch shows him in a cell, hands chained together, as he is informed by two sworded samurai of the sentence passed on him. He recalled a year later in a letter to Chinzan that as he became convinced that he would die, he had been unable to sleep at night or to eat.[39]

This was not because he feared death, although he certainly would have preferred death to be self-inflicted and not administered by an executioner. Rather, Kazan worried about one thing, his filial duty to his mother and what would happen to her if he died:

asanawa ni	If I am fated
kakaru ukimi wa	To be bound in hempen ropes
kazu narazu	It means nothing to me;
oya no nageki o	If only there were some way
toku yoshi mogana	To relieve my mother's grief![40]

The Trial

10

The most severe examination to which Kazan was subjected took place on July 2, 1839, before Magistrate Ōkusa Takayoshi. Kazan's responses to the magistrate's questions were, on the whole, unsatisfactory. With respect to the key charge, that he had criticized the government, he claimed that he never discussed politics in his writings, only the need for improving defenses against foreign intruders. However, when Magistrate Ōkusa read the passage from "Exercising Restraint over Auguries" in which Kazan accused officials of having obtained their positions with bribes and demanded what he meant by this slander, Kazan replied rather lamely:

I never expected to be accused of slander. I am truly overcome with shame. I don't remember every particular in the manuscript you mention. Last winter and this spring I was so upset about the danger from foreign countries that I felt compelled to set down my opinions, but what I wrote was much too emotional, rather like a kabuki play, so I discarded the manuscript half-written. It was only a first draft, and I

wasn't very careful with the language. There are many things in it I now wish I hadn't written.[1]

With respect to another passage, this one in an illegible scrawl, Kazan said that he himself could not remember what he had written because he had scribbled it in a great fury, distraught at the thought of foreign ships in Japanese waters. This emotion had been so overpowering that he had been unable to express fully what he really thought. He asked Nakajima Kaemon, the assistant magistrate, to disregard what he had written in "Exercising Restraint" and to consider the unfinished essay as no more than an unborn infant, only five months in the womb. Nakajima sympathized with Kazan, but said that a *metsuke* had been present when the charge was made and high-ranking officials had read the accusation. It could not be disregarded.[2]

No doubt under great stress, Kazan made mistakes of fact in his testimony before the magistrate. He may also have consciously lied in order to protect Egawa Hidetatsu, who had asked him to write "Report on Conditions in Foreign Countries," the work that (along with "Exercising Restraint") contained the most damaging statements of admiration for the West and criticism of the shogunate.[3] Although he clung to his assertion that all his seemingly adverse comments about the government were inspired solely by his concern for national defense and that he was fundamentally uninterested in politics, the writings were so outspoken in their criticism of the shogunate's "frog in the well" mentality that they could not be dismissed as a mere excess of patriotic indignation. His testimony did little to exonerate him. A confession was drawn up based on the testimony, and on the twenty-fourth day of the seventh month (September 1) Kazan affixed his seal to the document.

The confession was more a self-justification than an admission of guilt.[4] Kazan began by briefly mentioning his record of service to Tahara Domain from the time when, as a boy, he had been chosen to be the playmate of the daimyo's son. Eight years before his arrest, he had been appointed as an elder (*karō*) of the

domain and had been charged with maintaining its sea defenses. In this capacity, he had been dismayed by the arrival of foreign ships, knowing the inadequacy of defense preparations. Deciding that he would have to learn more about foreign countries, he sought out three experts in *rangaku*—Takano Chōei, Koseki San'ei, and Hatazaki Kanae[5]—and asked them to translate Dutch books for him.

From childhood, he had been schooled in the literary and martial arts, but in his leisure hours he had studied painting and, quite unexpectedly, had become famous and attracted many disciples. Although he had been too busy with service to the domain to study *rangaku*, he had learned about the rest of the world from translations made by other people of works written in Dutch. The European conquests in Asia that had left only Persia and Japan independent shocked him particularly, and he had become convinced that Japan must be able to defend itself. This concern was so strong that he had expressed himself in intemperate language.

Kazan's confession then moved to the subject of Morrison and his plan to demand, in exchange for returning Japanese castaways, the opening of trade with Japan. Kazan not only opposed yielding to this demand but put forward his theory of northern barbarians habitually menacing civilized countries to the south. He denied the accusations against him and admitted only at the very end of the confession that by using images like that of the frog in the well, he had been guilty of criticism of the government. It is surprising that the magistrate was satisfied with such a confession, but the small admission of guilt by Kazan was enough to cost him his head if that was what the government desired.

Kazan must have realized that he had not been successful in his attempt to rebut the accusations leveled against him. He sent three letters[6] to Egawa's secretary, asking what had happened to the revised versions of "Report on Conditions in Foreign Countries." He was sure that the extensive changes he had made when expressing his views would demonstrate that the first, inflammatory version had been no more than a momentary aberration

induced by extreme concern about the foreign presence threatening Japan. Kazan obviously intended the letters to be read by not only the secretary but also Egawa, who presumably still had the manuscripts in his possession.[7] Egawa failed to respond. He had been cleared by Mizuno Tadakuni of complicity in Kazan's seditious writings, but he knew that Torii Yōzō had not forgiven him and might still cause trouble. Egawa withdrew to Izu and did not appear in Edo for another two years.[8]

Other members of the Hayashi school who had been friendly with Kazan and displayed an interest in his Western studies were frantically eager to dissociate themselves from him after his arrest. Akai Tōkai, who among the Confucian scholars had been perhaps the closest to Kazan, insisted that although he had known Kazan for seventeen or eighteen years, they had never been really intimate. He emphasized that recently he had hardly seen Kazan apart from exchanges of New Year's greetings.[9] Asaka Gonsai was terrified lest a poem of his might be interpreted as expressing sympathy for Kazan. When he was informed by the Hayashi family that a mere poem was nothing to worry about, he was immensely relieved.[10]

When Satō Issai, who not only was Kazan's teacher but had his portrait painted by him, was approached by the Confucian scholar Tsubaki Ryōson[11] and asked to join in the effort to rescue Kazan from prison, he said that he would wait until he heard the verdict. On being informed of Kazan's confession, Issai accurately predicted that Kazan would probably be left in someone's custody or sentenced to house arrest. He warned Ryōson that it was not advisable to show too much partiality toward Kazan when discussing the charges against him, that this would actually be a disservice to Kazan. Issai made no effort to help free Kazan, perhaps because he was the professorial head (*jukutō*) of the Shōheikō, the Hayashi academy.[12]

Takizawa Bakin, who not many years before (in 1835) had asked Kazan to paint a portrait of his late son, was now eager to dissociate himself from him. In a letter dated September 19, 1839, about three months after Kazan was imprisoned, he wrote,

I have been acquainted with him for a long time, but we have rarely met and we have not been intimate, so I cannot judge his scholarship, but I gather that he is especially fond of *rangaku* and that he has made many discoveries. I suppose he intended to start a school that would combine painting and *rangaku*. Four years ago, before I moved to my new house, I met him when I went to pay him for a portrait, but that was all; he never once visited my new house.[13]

Bakin went on later in the letter to a more serious charge:

There is one thing rather puzzling about him. In the past, whenever he was short of money he used to forge old paintings so as to make a profit by deceiving people. My late son whispered this to me. He told me that Kazan was a clever man but he was not trusted because of one thing, the forged pictures. When my grandson was thinking of studying painting, he thought he would like to study under Kazan. Four years ago, when I met Kazan, I mentioned this to him, but on thinking it over, I found something uncongenial in his disposition, and last autumn I entered the boy in the school of Hashimoto Sekkei. Now that I think of it, I smile to myself—it was a good thing I didn't let the boy become Kazan's disciple.

The one thing I regret is that because he was a friend of my late son and painted his portrait, I gave him a copy of my *Nochi no tame no ki*.[14] I gather that all the books in his possession were impounded. No doubt this book was also seized. However, the book is about personal matters and has nothing to do with the barbarians, so I have nothing to worry about. We should be careful about giving secret books to people who are not intimates, and we should not lend them.

Hiraga Gennai, Hayashi Shihei, and Watanabe Kazan all became famous because of *bangaku* [barbarian studies], but not one of these men ended well. We should learn from other people's mistakes. I always try to be absolutely sincere with

friends. I simply advise them to be discreet and cautious. It is not because it gives me pleasure to speak ill of others.[15]

When a friend of Kazan's defended his actions to Bakin, saying that Kazan had devoted all his energy to saving the country from attacks by the barbarians, Bakin replied that he had no business in taking this responsibility on himself. Every man has his own duties, and it was not Kazan's to get involved with important matters of state.[16]

Bakin certainly was honest in expressing views that most people would keep to themselves, but his honesty is hardly endearing. When he learned that Kazan had been imprisoned, he congratulated himself on not having allowed his grandson to study with him. His one mistake was giving Kazan a copy of his book. The police were sure to discover it, and this could conceivably involve him in Kazan's crime. But, he reassured himself, the book contained nothing suspicious. Still, it was advisable never to give one's books to people who were not intimates.

We can forgive Kazan even if he in fact forged paintings, both because of his years of poverty when he desperately needed money and because of the superior skill that enabled him to pass off his works as those of old masters. It is harder to forgive Bakin for his pusillanimous rejection of the man whom he had chosen to paint his late son's portrait.[17]

Other men, fearing to be implicated, hid or burned documents they possessed relating to Kazan or blotted out some of the wording. Some even tampered with the texts, making it difficult to establish what actually happened.[18]

One Confucian scholar who did not turn away from Kazan was Matsuzaki Kōdō. When he first heard that Kazan had been arrested, the person who gave him the news explained that this action had been taken because Kazan had been planning to sail to England aboard Morrison's ship! Later, on learning of Kazan's confession and the general expectation that he would be put to death or sent into distant banishment, Kōdō passed sleepless nights trying to think of some way of saving a beloved disciple.

He could only wait, like the many friends and disciples of Kazan who were desperately trying to rescue a man they all revered.

The verdict was slow in coming. In the meantime, Kazan fell seriously ill with a rash that itched so persistently and so severely that it left him exhausted. According to the account in his diary, written after leaving prison, he was several times on the point of death.[19]

The verdict was finally rendered on January 22, 1840. It was delivered by Mizuno Tadakuni, who only two weeks earlier had become the chief *rōjū*. Kazan was to remain confined to a house in Tahara, his legal residence. The leniency of the verdict surprised many. The officer in charge of punishments at the North Magistrate's Office had, on the basis of Kazan's confession, recommended beheading, and Magistrate Ōkusa duly forwarded this recommendation to the government, only for it to be returned with the command that its appropriateness be reconsidered. Two of the four *rōjū* favored a lesser punishment. It is not clear what induced Mizuno to be lenient, but probably the long petition that Matsuzaki Kōdō sent him on behalf of Kazan was an important factor. Kazan certainly thought so. In a letter he sent to Kōdō after reaching Tahara, he declared that not even the debt he owed to his lord and his father could be greater than his debt to Kōdō.[20] Kōdō had thrown himself into saving Kazan despite his age (sixty-nine) and poor health.

In his petition to Mizuno, Kōdō described in detail Kazan's sterling character and his long service to the government. He noted that the main charges originally brought against Kazan had been as the author of *Tale of a Dream* and as a would-be participant in a secret expedition to the Bonin Islands. These charges had been dropped, and Kazan was accused instead of having slandered the government in two manuscripts. Kazan had been placed in jeopardy by the lies of one man, no doubt a reference to Torii, and now slander of the government was the main charge against Kazan, although slander was not recognized as a crime by the laws of either China or Japan. Moreover, the manuscripts in question were merely scrap paper and had never been circulated.

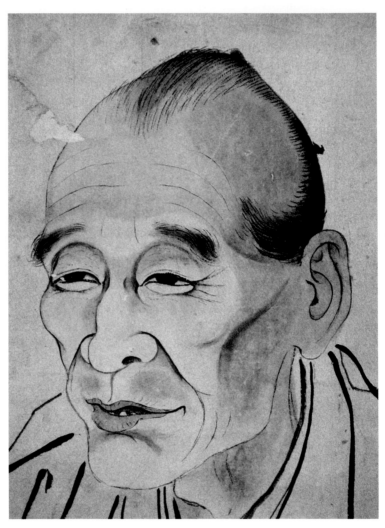

Informal portrait of Matsuzaki Kōdō (1826). (Private collection)

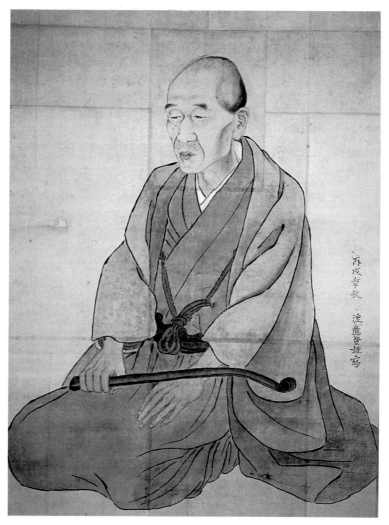

Portrait of Matsuzaki Kōdō (1826). He is holding a *nyoi*, a kind of Buddhist wand used by teachers. (Private collection)

People were now saying privately that if all houses were searched and every piece of wastepaper was examined, who would not be considered a criminal? Kōdō begged Mizuno to show mercy in view of Kazan's great learning and pity in view of his profound devotion to his aged mother. Everyone would then acclaim the pervasive benevolence of Mizuno's rule.

There was no immediate response to the petition. Kōdō became so worried that he went to see Odagiri Yōsuke, Mizuno's secretary. He learned that Mizuno had read the petition, and although he had not agreed with everything Kōdō had written, he had taken into consideration the applicable parts. Mizuno was moved above all that a man of his venerable age had gone to such efforts to save a disciple.[21]

Once the verdict had been handed down, Kazan was moved from the prison to the domain residence in Edo. He was mentally and physically exhausted by his long imprisonment and was still suffering from a severe case of scabies. He was closely guarded at all times, and when Tsubaki Chinzan and others who had devoted themselves to his cause asked to see him, they were refused. Just before leaving Edo, Kazan managed to send Kōdō a letter in which he expressed his gratitude for all Kōdō had done.[22] But there was no question of the guards waiting for his illness to be cured before taking him into exile; Kazan was bundled into a palanquin on February 15 and carried off.

During the journey, which took seven days, Kazan was not permitted to leave the palanquin even to relieve himself. (He compared himself sardonically to a bird in a cage.) His illness had not abated, and he suffered excruciating pain at each jolt of the palanquin. The journey continued relentlessly, despite the bitterly cold wind and a blizzard at Hakone Pass in the mountains. It was at Hakone that Kazan was suddenly stricken with acute abdominal pains and diarrhea. He temporarily lost consciousness when the palanquin reached Kakegawa. He was treated by a physician who expressed astonishment that anyone in Kazan's condition would be permitted to travel and said that the trip was risking his life. The stop in Kakegawa delayed by a day his arrival in Tahara, but

Kazan was not permitted a longer rest. Incredibly, he managed to draw sketches of places passed during the journey, as seen from his palanquin of misery.[23] He reached Tahara on February 22.

At first, he was closely guarded by armed men, day and night, but after a time the guards withdrew. His family—his mother, wife, and three children and a servant—joined him in exile four days after his arrival. On March 13, the family moved into the house vacated by Ōkura Nagatsune, the agricultural expert whom Kazan had invited to the domain.

It was undoubtedly a joy to Kazan to be reunited with his family, but he still was ill and very weak. He wrote to a disciple on April 7 that he was incapable of describing in words all that he had suffered since they parted. His worst affliction was the extremely bad case of scabies. He was now able, somehow or other, to walk. He recalled exiles of the past like Su Dongpo who were punished for what they had written. He remembered, too, the passage in *Essays in Idleness* in which Kenkō speaks of the pleasure of "seeing the moon of exile, though guilty of no crime."[24] Perhaps he hoped that he, too, might eventually enjoy banishment.[25]

In other letters, he was franker in describing his physical condition. After moving into what would be his permanent residence in Tahara, he wrote that he felt slightly more cheerful, but the scabies had not still not improved. He had to crawl to get to the toilet. He commented: "Just imagine how inconvenient this is!"[26]

In his letter to Kōdō written on April 6, after settling in Tahara, Kazan stated that he himself had invited the disaster that had struck him. Many factors were involved, but especially his "not having chosen his friends" as Kōdō, following the *Great Learning* of Confucius, had advised and his not having kept silent. He felt ashamed of himself and vowed that henceforth he would keep his mouth shut about matters that occurred outside his house, especially foreign learning.[27] He recalled that the Confucian scholar Arai Hakuseki had said that foreign learning was material learning.[28] If from now on, he could advance to the highest realms of

metaphysical learning; it would be like moving from the ground to a tall tree. But he now was in a remote place where he had few friends and where there were not many books. He begged Kōdō to continue to give him guidance, although their correspondence would necessarily have to be kept secret.

The letter goes on to the most vivid description Kazan had yet given of the terrible journey to Tahara and of his life as an exile in Tahara, still suffering from illness.

Kazan largely abided by his professed resolution to turn away from foreign learning. This was surely a most painful decision. Not so long before, he had come to realize that the Confucianism that had formed the backbone of his education and had constantly served as his guide to behavior as a samurai was insufficient in the modern world. This was particularly true at a time when the conservative Confucianists, typified by the Hayashi family, refused to admit the validity of any approach other than their own in understanding the world. Kazan discovered that he would no longer be content to be a frog in a well, ignorant of the great ocean, and he had applied himself to acquiring new knowledge. Excited to learn about conditions in the different European countries, Kazan was impelled to inform other Japanese of what he had discovered, even though he was aware, of course, that any discussion of foreign countries, and especially any comparison of foreign countries with Japan, was likely to arouse the anger of shogunate officials.

In his letter to Kōdō, he spoke of looking forward to leaving behind the earthbound realities of Western learning and soaring to the heights of Eastern metaphysics. Although Kazan was still strongly attracted to the realism of European painting, he seems to have renounced all other interest in the West. He probably still believed in the value of his painfully acquired knowledge of Western science and statecraft, but the alternative to abandoning this knowledge was death. He also had to convince other people of the sincerity of this transformation. Kazan was in the same position as were Japanese in the 1930s who, truthfully or not,

professed to have abandoned Communism and to have discovered instead the sacred mission of Japan.

In a letter to his closest disciple, Tsubaki Chinzan, from his place of exile, Kazan wrote in retrospection:

> When a superior man is faced with a predicament he could not otherwise have experienced, even if he had desired it, he finds in it an opportunity for perfecting himself. The men of old again and again experienced great calamities, and as one reads about them, one sees that undergoing hardships is what enables one to improve himself, to become a better man. I had supposed that the saying "Good fortune is the bad fortune of a samurai" had nothing to do with me, but I unexpectedly was placed in such a situation. This, I thought, is my opportunity, and when I responded seriously to this opportunity, I sensed, beyond what I had imagined, the grandeur of heaven and earth and the immensity of the universe.[29]

Despite his persistent illness and the burden of unpaid debts, Kazan said that imprisonment and a near encounter with death, although a traumatic experience, had benefited him spiritually. He seems to have convinced himself that he had been reborn as an enlightened man. While in confinement, if he were careful not to overstep the bounds restricting him, he could live in endurable poverty with his family and might even be happier than ever before. This was the compensation he was to receive for giving up his faith in the future progress of Japan.

The house he was assigned in Tahara, although small, had been built only six or seven years earlier and was, in Kazan's words, "meticulously clean." He was provided with a stipend that, although grossly inadequate, helped pay his household expenses. There was quite a bit of property adjoining the house, and if Kazan had known how to farm, he could have harvested a plentiful supply of vegetables. In his letter of April 28, he mentioned looking forward, when he had recovered from his illness,

to carrying a hoe and cultivating the fields;[30] but his life had been spent in the city, and after a few attempts to use a hoe, he realized that he was not cut out to be a farmer.

Kazan was able to write with contentment about his present life even while still suffering from a terrible rash. On April 27, he wrote to a friend, thanking him for the gift of a set of tea utensils:

> Things are gradually getting a little more enjoyable. I crawl out from my bed, make my way to the desk, and divert my-self with my brush. I am sending you some sketches of my sequestered retreat. I hope they will amuse you. Then I take out the tea things you kindly sent. I have my daughter make the tea and we drink it together. I shall treasure for the rest of my life each little piece in the tea set because I know it came from the bottom of your heart.[31]

As he grew stronger, he began in his letters to friends in Edo to praise the vegetables and the fish in Tahara, which, he said, tasted better and were cheaper than those in Edo. But it is clear that (when he was not contemplating the grandeur of the universe) he suffered from boredom. Again and again, his letters mention that he had not one painter friend nearby with whom he could talk. He knew a few people in Tahara, and after the initial ban on receiving visitors had been lifted, he saw them occasionally. He wrote, "Most of them are simply acquaintances and can do nothing to help me. Those who know me and have the power to help don't necessarily keep it up."[32] Others came to his house to ask for pictures. Kazan commented that such people wanted his paintings only because they hoped to make money from them.

Tahara, a sandy, largely featureless peninsula, was an exception-ally lonely place to be an exile. As Kazan described it,

> This place is surrounded by the sea. The sound of the waves reverberates day and night. If I happen to wake in the middle of the night, I sometimes soak my pillow with tears over

loneliness at not being in the capital. When I go to the toilet, a fox may menace me there. Or I may be frightened by a snake in the living room. I am worried all the time that my children may fall into a river or a pond or that they may cut their feet on sharp bamboo splinters. Because of my situation, I don't have many visitors, but if somebody happens to come along, I am certain to hear more than I desire about wild boars, monkeys, vegetables, radishes, hunting, and the like. If I have something to ask of people, my nearest neighbor is far away, and there are bound to be disappointments. Worst of all, there is nothing to amuse my mother, wife, and children. Once in a while they go for a walk on the shore or they visit a temple, but on one side there are only rugged mountains, on the other side only the boundless sea, and in between a checkerboard pattern of paddies. There are paths slanting off into the distance, but nothing worth looking at. If they get tired, there is nowhere for them to rest. When they set out on their excursion they take lunch boxes with them, but there won't be anything to make the children jump with joy. The one thing I keep recalling is the capital. When the sun comes up I tell the children, "That's the direction of Edo." And when I think how much my mother must yearn to return there, you can imagine how I am oppressed by feelings of being an unfilial son. When a letter arrives from Edo, my wife and I huddle together under the lamp and read it over and over again. She tries to keep me from seeing her tears, and I, too, though I look unconcerned, let the tears fall.[33]

Kazan's mother, noticing this, says, "Your illness is getting better; you have your wife and children with you. This is even better than being on a picnic." She forces a smile, and when he sees this, he feels indescribable pain:

Because of my habitual fecklessness and instability I have endangered my mother. I have made her leave the graves of our ancestors, turn her back on her flesh and blood, leave her

friends, and move to this remote and lonely spot. We all have left behind the place that gave us pleasure, the place where we felt secure, and here in these desolate mountains, on this forlorn shore, we mingle with fishermen and farmers' wives. We grind wheat, pound beans—much hard work and few pleasures. My mother is approaching her seventieth year and has not much longer to live. Please try to imagine the anguish I feel trying to provide for her.[34]

To comfort his mother, he privately arranged for old ladies in the vicinity and former servants to visit her. He also tried to keep up her spirits by spending the whole day in cheerful conversation so that the time would pass as pleasantly as possible. But although on the surface he seemed to enjoy even becoming the butt of family jokes, the life they were leading was possible only because he was secretly pawning his clothes, and he knew that this could not go on very much longer.

Friends and disciples gave him money, which he gratefully accepted. He was seriously in debt, and only these gifts enabled him to stave off creditors. He wrote to Tsubaki Chinzan, thanking him for money:

When I read your letter conveying your sympathy for my present distress, I felt as if my heart would break. I have told my mother and my wife in detail what you have written. Not even a brother could show such deep sympathy. I am most profoundly grateful; it is impossible to express my feelings adequately. I have gratefully received the 200 *hiki*.[35] I was faced with so many perplexing matters that I finally appealed to you. Now, for the moment, my mind is at ease.[36]

Kazan's sole way of earning additional money was to paint and sell pictures, even though he was aware that if he did so, enemies in the domain were likely to denounce him for improper behavior while under arrest. But he did not have much choice. In a letter to Tsubaki Chinzan dated November 26, he stated that

although his expenses in Tahara were far less than they had been in Edo, he was receiving a stipend of less than 30 percent of his former income.[37] He simply had to paint. Fearful of possible consequences, he dated his new works 1831, a decade earlier than the actual date, hoping that people would think they had been painted long before his arrest.

All the same, in the same letter to Chinzan he declared,

> I am glad to tell you that my illness is completely cured. Day after day I sit in my tiny room, my mind a blank. I feel in the mental state described in the poem by Tang Zuxi included in *Haolin Yulu*,[38] and I can understand better and better Tao Yu-anming's "yesterday's mistakes."[39] In addition, though I lack the "three pleasures" of Mencius,[40] I have a loving mother to serve, my wife and children are well, and I have good friends like you. This pleasure is too great for words to express. As long as I have these pleasures, I shall not lack anything, even in my poverty.[41]

On October 28, Kazan had a visit from his disciple Fukuda Hankō (1804–1864). Hankō was dismayed by Kazan's evident poverty, but the two men painted together, and this was the best possible remedy for the boredom from which Kazan had suffered, despite his insistence that he was content. Here is Kazan's account of the week that he and Hankō spent painting:

> Hankō suddenly paid me a visit during the first week of this month. He remained here about two weeks, returning home on the eighteenth. Our great pleasure during that time was to spend each day leaning over a desk looking at pictures. As soon as a picture was completed, we each would appraise it. When it was praised, the artist was elated. We had by our side a copy of *Fan Shihuji* [to provide subjects for our paintings].[42] In about two and a half days we painted twelve scenes of *Pleasures of Rural Life*. We also painted on silk *Wind and Rain at Yanmen* and *Marine Creatures*. The latter shows fish

swimming in the depths of the sea, a subject that our pre-
decessors never painted. We gave a somewhat antique feel to
the waves. The fish we depicted were red sea-bream, mackerel,
pike, and anchovies. We also painted weeds, bamboo shoots,
and tree frogs in the background for *Chickens in the Rain.* The
above were two-foot-wide paintings on silk. There also was a
two-foot-wide landscape in imitation of Wuzhen,[43] painted
at the request of somebody named Gōroku.[44] We also did
some comic pictures and experienced the excitement of the
coming of spring. . . . I wish I could show you the pictures
mentioned above. I said, by way of a jest to Hankō, that
my pictures had improved somewhat, but quite frankly, I am
by no means as good as [Yamamoto] Baiitsu, let alone you,
and when it comes to landscapes, I am not even as good as
[Takahisa] Aigai or [Nakabayashi] Chikudō. Privately, I feel
quite ashamed. On top of that, having no contact with soci-
ety, even when (once in a great while) I see a quite ordinary
painting, I am impressed. I wonder whether my critical facul-
ties have not grown dull, compared with when I was living in
the capital. Or perhaps, because my mind is untroubled, I am
able to look at pictures more closely.[45]

As this indicates, in solitude Kazan found solace in the words
of Chinese poets and philosophers, and when he painted, his in-
spiration came from Chinese painters. This is not surprising for
someone brought up on samurai traditions, but Kazan, as though
returning to his youth as a promising Confucian scholar, seems
to have blotted out the memory of the Dutch studies that had
dominated his thought during the preceding ten years.

The oblivion was not complete. In November 1840, he painted
a portrait of Hippocrates. Although he dated the painting 1831, as
usual on works painted during his exile, his diary entries for No-
vember 12 and 13 mention painting the portrait at the request of
a physician in the nearby city of Toyohashi. Kazan wrote on the
work that he had copied it from a portrait in a foreign book. No
doubt an etching in a Dutch book was his source, but his painting

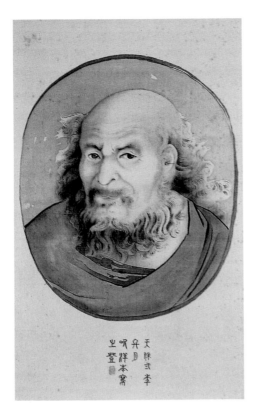

天　兵　呵　坐
保　隼　月　明　覧
二　二　　　祥　鼉
季　　　　本
　　　　　寓

Portrait of
Hippocrates (1840).
(By permission of the
Kyushu National Museum)

is in colors. The portrait, the first he had painted in some years, is unusually vivid, the hair and beard done with great care and the gaze convincingly realistic. It is no mere copy, but one of his most impressive works. Kazan seems to have expressed one last time his admiration for European science and, especially, for medicine, the science from which *rangaku* had been born.

Kazan
the Painter

11

In histories of Japan written by foreign scholars, Kazan often makes a brief appearance, usually as an intellectual of the late Tokugawa period who was dissatisfied with contemporary conditions. He is mentioned more prominently abroad in surveys of Japanese art, although he has never attracted the attention accorded for more than a century to Hokusai and the great *ukiyoe* artists. The following concise evaluation by an American scholar is probably representative:

His sketches of landscapes and his *kachōga*, not too far from the *nanga* style, are deft and amusing. Also adopted Western laws of chiaroscuro and perspective but used only Japanese painting media; gave volume to his figures by means of shading and anatomical drawing. Really outside any mainstream of Japanese painting: independent, naturalistic artist, one of the most distinguished of his period.[1]

Any Japanese account of Kazan, however brief, would certainly state that Kazan was a disciple of Tani Bunchō. It might also mention

the possible influence of Kaneko Kinryō and even of Shirakawa Shizan, who disowned Kazan for not paying the expected fees. Influences are not hard to detect in Kazan's work, especially in the Chinese-style paintings of traditional scenes. Japanese scholars are at pains to trace these influences but also to point out distinctive touches in Kazan's work that reveal, despite all the influences, that he was a Japanese and not a Chinese painter. The non-Japanese scholar is likely to be attracted most by Kazan's unconventional paintings that do not reveal obvious influences—that is, not only the superb portraits but also the many sketches that owe little to either his teachers or the paintings he copied.

Because Kazan painted mainly in order to provide a living for himself and his family, he produced a very large number of works over his lifetime. Some were destroyed in the great earthquake of 1923, others in the bombings of 1945, and many others (like his early *hatsuuma* paintings) were simply thrown away by people who did not recognize their worth.[2] Nonetheless, a great many survive. It is regrettable but not surprising that no one has thus far attempted to make a catalogue of his paintings.[3]

Most of Kazan's surviving paintings are in the style of the *bunjinga*—the paintings of the *bunjin*. The term *bunjin* was used in Japan from the middle of the eighteenth century as an appellation for gentlemen of culture and leisure who were devoted to all aspects of Chinese culture. The Japanese government's seclusion policy prevented the *bunjin* from traveling to China, but they strove anyway to create a Chinese atmosphere around themselves. They referred to one another (and to themselves) by *gagō* (elegant names), often borrowed from phrases in Chinese poems or from the names of Chinese mountains and rivers. They wore clothes that were intended to make them look Chinese, conversed in a Japanese larded with Chinese expressions, and, for recreation, enjoyed gathering with friends to drink *sencha*, tea that was quite unlike the variety consumed at the tea ceremony and was drunk not from large bowls but from dainty cups. By preference, they imbibed *sencha* while seated on chairs in the Chinese manner

rather than on the tatami with their legs folded under them. The cosmopolitan behavior of the *bunjin* has been interpreted as a form of antiestablishment escape from both the seclusion policy and the many regulations that controlled society during the Tokugawa period.

The *bunjin* particularly loved the different products of Chinese artistic life, especially the paintings of the Chinese *bunjin*. The founding of the *bunjin* tradition in China usually is traced back to the eighth-century poet Wang Wei, who in his late years withdrew from the contamination of urban society to live in the countryside. Some *bunjin* claimed that the inception of their tradition went back even further, all the way to the second or third century; but it was not until the fourteenth and fifteenth centuries that *bunjin* paintings became an important part of Chinese art. In Japan, the earliest *bunjinga* were not made until almost four hundred years after they first flourished in China, perhaps delayed because of the predominance of Buddhist art. When Japanese went to China, even after *bunjinga* had become popular there, they usually brought back not *bunjinga* but paintings of a much earlier time or plausible imitations.

The Chinese *bunjin* were typically men of the upper classes who turned their back on worldly possessions to live close to nature. Some were officials who, after the fall of the dynasty they had served, refused to serve a second master and, like Wang Wei, took refuge in the countryside. Although they might be in straitened circumstances, they painted solely for their own pleasure and did not cater to the tastes of prospective customers, let alone sell their pictures. This, they believed, would be an insult to their dignity. They valued particularly what they called *qiyun* (spirit resonance),[4] a term that came to mean a natural impulse that led them, unlike professional artists, to paint as amateurs out of pure devotion to the art of painting.

The Japanese *bunjin* tradition dated back only to the mid-Tokugawa period, when it became prominent along with Confucianism and the vogue for writings in Chinese. The foundation by Chinese priests in 1661 of the Manpuku-ji in Uji, a temple of

the Ōbaku branch of Zen Buddhism, helped awaken this inter-
est in contemporary Chinese art. The temple owed much to the
shogun Tokugawa Ietsuna, who placed it under his protection and
provided for it lavishly. The priests were learned Chinese who
had been specially chosen to transmit the sect's teachings. Japa-
nese who visited the Manpuku-ji were intrigued by the impres-
sive buildings, in a style that differed conspicuously from that of
traditional Japanese temple architecture, and by the sounds of
the Chinese language used in the prayers and sermons. They also
enjoyed the elaborate vegetarian cuisine that the Ōbaku priests
had invented. It was like a trip to China, the only one they could
take during an era of seclusion. The great importance that Ōbaku
Zen attached to painting and calligraphy provided fresh stimula-
tion to Japanese artists.

The painting of *bunjinga* was fostered also by the popularity
of Shen Nanpin, a Chinese artist who resided in Nagasaki from
1731 to 1733. Long before Kazan became interested in the West,
he yearned to go to Nagasaki to study what he thought of as
the new style of Chinese painting. It was at this time that paint-
ings of the Ming and Qing dynasties (roughly, the fourteenth
to the eighteenth century) were introduced to Japan;[5] previously,
Japanese knowledge of Chinese art had been confined to earlier
dynasties.

Unlike the Chinese *bunjin*, who were generally of the upper
class and had the means to live in retirement, the Japanese *bunjin*
included many men of the merchant class who had no choice but
to make a living by selling their paintings. This obviously was
a departure from the Chinese ideal, but the Japanese otherwise
tried to follow as closely as possible the foreign manner, and their
depictions of Chinese scenery and people found a ready market.
The prosperity brought about by the long years of Tokugawa
peace encouraged people to use their money to buy objects of art
instead of hiding it in a safe place.

Not all Japanese intellectuals of the time subscribed to the *bun-
jin* philosophy. Critics denounced the passion for foreign things
and the imitation of the unconventional behavior of the Chinese.

Bunjin of the samurai class risked being disowned by their do-
mains if they joined others in the craze for Chinese culture, but
they nevertheless were willing to take the chance. Most of Kazan's
disciples were samurai.

The favorite subjects of the Japanese *bunjin* artists were flow-
ers and birds, and landscapes. The flowers tended to be Chinese
flowers like the peony, and the birds were sometimes exotic, like
the peacock. The landscapes frequently were depictions of Chi-
nese-looking mountains. Even if they bore no resemblance to
specific Chinese mountains, they definitely were not Japanese,
as one could tell from the typical Chinese houses, towers and
bridges, trees and rocks, with which the mountains were dotted.
Such paintings often included little boats, also Chinese, from
which people fished—the quietest, most conducive to meditation
of sports. The people in the paintings were what the Japanese
imagined were typical inhabitants of China, most often bearded
gentlemen in flowing robes, but occasionally a boy riding on an
ox. If a painting illustrated a legend or historical event, it was
invariably Chinese. The *bunjin* acted as though they assumed that
nothing in Japanese history was worth illustrating.

The greatest influence on the Japanese *bunjin*ga was exerted by
Yun Nantian,[6] an artist famous especially for his flower-and-bird
paintings. One distinctive feature of Nantian's paintings is the
absence of the customary ink outlines around the flowers, leaves,
and other objects portrayed. Watanabe Kazan, who learned much
from Nantian, referred to him in his writings more often than to
any other painter.

Kazan had many disciples, although only one of them, Tsu-
baki Chinzan, developed into a major painter. No doubt Kazan
gave his pupils advice on such matters as composition, the use of
pigments, the works of the past to copy, and the way to achieve
a desirable tone, but it was only after he was exiled to Tahara
that he set down on paper a more or less sustained expression
of artistic beliefs. His views are contained in two long letters he
sent to Chinzan in 1840 and are cast in the form of answers to
questions Chinzan asked.[7] Some of the matters he discusses are

technical, and other passages are made tedious in translation by Kazan's many quotations from Confucian writings, but his comments intermittently reveal distinctive thoughts about the state of painting in his day.

Here is Chinzan's first question:

> People often say that *fūin* [refinement] and *fūshu* [taste] are the most important things in painting. The world is generally agreed on this, but what do the terms basically mean? I'm sure a superior man would have an appropriately superior way of interpreting these terms, but how should the likes of me decide their meaning?

Chinzan was not a member of the literati, the educated class associated with creating *bunjinga*. Although he was from a samurai family that claimed descent from the twelfth-century despot Taira no Kiyomori, his livelihood depended on his paintings, and he did not pretend, like the Chinese *bunjin*, to be indifferent to considerations of payment. Nor did he pretend that his paintings embodied the ideals of *fūin* and *fūshu*, sacred to *bunjin* painters; indeed, he was not even sure what the terms meant. In reply to Chinzan's question, Kazan told him not to waste time worrying about such matters. Unfortunately, Kazan did not express his opinions in straightforward language but in the manner most congenial to a man of his background, by quoting (from memory) passages in the Confucian classics:

> If you consider *fūin* and *fūshu* in terms of people's appearance, they are like a person's facial features, manner of speech, or general comportment. "Yu Jo resembled the Master in his manner, but Tseng Tzu did not agree."[8] "If I judged people by their language I would be mistaken in Tsai Wo's case. If I judged people by their looks, I would be mistaken in Tzu Yü's case."[9] How much truer this is of those who insist that *fūin* and *fūshu* are the most important qualities in art! Such people might be called fake superior men. It says [in the

Analects], "Tzu Chang is so self-important that it is difficult
to do good while working side by side with him."[10] Such
people hardly merit discussion. However, unless you appreci-
ate this fully, you will not understand the basic principles.
You should examine the brushwork of men of the past if
you want to understand the real nature of beauty. You'll find
such study of considerable value.

Behind the Confucian quotations, Kazan was saying that one
should not be deceived by the pretensions of artists who take
pride in their superior knowledge of tradition and who produce
paintings in what is accepted as good taste. Their resemblance to
authentically superior works may be only on the surface. Chinzan
responded:

I have never had the slightest intention of achieving *fūin* or
fūshu. I have always tried to comprehend, as an artist of *shasei*
[painting from life], the true nature of things and have veri-
fied my perceptions by comparing them with old paintings.
When I set about painting, all I do is paint whatever occurs
to me, modifying it with the composition and brushwork
of Yun Nantian. I could understand it if people who saw
my paintings said, "How realistic they are!" or else "How
he lapses into vulgarity!" But instead, they praise me for my
fūin and *fūshu*! As the result of trying to maintain steadfastly
what you have taught me, I have quite naturally attained
this distinction. I myself was not aware of it. I am quite
stunned. Unfortunately, of late my hand has become stiff,
and my thoughts have become constricted. I fear the flowers
I paint will start looking like artificial flowers and the birds
like birds made of clay. I must try to be more careful and
more disciplined.

Kazan shifted the subject from *fūin* and *fūshu* to *kiin* (*qiyun* in
Chinese), a term frequently found in classical Chinese discus-
sions of painting. Unlike most Chinese painters, however, he took

the term to mean the energy (*ki*) essential to painting: "When a painting seems so full of life it all but moves, this is because there is vitality in the brushwork, producing an effect like resonance in sound." He went on,

> I have recently discovered that there are two kinds of *ki*, masculine and feminine. The masculine *ki*, which conveys the beauty of strength, is like the darting, vibrant movements of fish, the appearance of young bamboo rising up into the sky, summer clouds, or perhaps an emperor commanding all creatures to come before him. This masculine art is suitable for screens or *fusuma* [sliding doors], but not for scroll paintings or picture albums. This is the style of the Ming painters Lin Liang and Lü Ji.[11] The beauty captured by the feminine style of painting is typified by the brilliance of deep-colored jade or the placid flow of a clear stream or perhaps a swarm of fish playing. This style is suited to scrolls or albums, but not to screens and *fusuma*. This is the style of Yun Nantian and Wen Zhengming.[12] However, even if an artist draws his sword in a fury, in art this does not merit being called strength; and when paintings become excessively finicky, they do not merit being called feminine. Strength must be helped by *yin* and *yin*, by strength.[13]

Returning to Chinzan's letter, Kazan wrote:

> If you use *shasei* to convey what you have discovered about the principles and natures of things, bearing in mind the techniques of the masters of the past, once you commence a painting you will naturally follow to perfection the style of Yun Nantian. However, this is the work of the talented painter, not the highest realm of art. You are now close to forty years old. By the time you are fifty you will probably reach the "realm of transcending good and bad."[14] When you are close to reaching that realm, we can then discuss the matter again, but it probably will not be of any help to you.

You should advance on the path ahead of you, polishing the ability you now possess, and wait for the change to occur by itself. You say that when people see your paintings, instead of commenting (as you expect) that they are realistic or vulgar, they praise the paintings as having *fūin*. No doubt they are right. The fact that your paintings do not look excessively realistic is thanks to the help you receive from the old masters; they do not look vulgar because the tone of Yun Nantian keeps you definitely from ever from falling into banality. You say that of late you fear your hand is becoming stiff. This must be because the vulgarity of the world has coiled around your hand and given rise to doubts. You should be more careful. The constriction you feel comes from not having good friends. Choose them wisely.[15]

Kazan gave more specific advice to Chinzan in a letter he wrote some six months later.[16] In response to a question by Chinzan about "landscapes being vacuous," apparently an opinion that Kazan had expressed earlier, Kazan described the changes that had occurred in the function of paintings. They first had been used to teach and guide, as we know from the anecdote telling about the portraits of great men of the past that were hung on the four walls of the building where Confucius served as an adviser to the duke of Zhou. These pictures, it was believed, would inspire beholders to strive to perform similar deeds. However, with the growth of landscape painting, this function of art had disappeared. The consequent lack of significance in art had been intensified when instead of painting in colors, artists used only ink, making their works all the less realistic. Kazan continued,

In my opinion, the basic quality of a painting, regardless of whether it is of a person, birds and flowers, insects or fish, is fidelity to the object portrayed. The same was true of landscapes, as we know from typical paintings of the Five Peaks and Four Great Rivers, of the Flow of the Yellow River, of Lakes and Mountainous Land.[17] Seeing the portrait of a

man, one could tell who he was, and if flowers and birds, one could tell just which flowers and birds had been depicted. That was what was meant by painting. But if one paints a landscape in such a way that no one can tell which mountain or which river has been depicted, and all that the painting shows is clouds and mist, smoke and haze, and a feeling for the four seasons, one can't very well call it a landscape. . . . Landscapes today, like the heresy of Laozi and Zhuangzi, are harmful to the true nature of painting. That is why I say that landscapes are the ultimate in emptiness.[18]

To Kazan, a firm believer in Confucianism, Daoism (the philosophy of Laozi and Zhuangzi) was a heresy that denied the ethical or didactic purposes of art. He may also have been thinking of painters who claimed that their "empty" works accorded with the ancient Chinese traditions of Daoism.

Despite his advocacy of realism, most of Kazan's paintings, especially at this stage of his life when he was living as an exile in uninspiring surroundings, were not realistic. One of his best-known works, *Sanzan bansui zu* (*A Thousand Mountains and Ten Thousand Waters*), was painted in the sixth month of 1841. This is a bird's-eye view of a vast landscape, most likely Japan, although it does not include Mount Fuji or any other famous landmark and there are no cities or other identifying features. Resemblances to parts of the Japanese coastline have been detected by scholars who believe that Kazan intended his landscape to represent Japan, but the resemblances may be accidental. It seems hardly possible that Kazan was attempting (but failed) to give a bird's-eye view of the Japanese islands in the realistic manner of, say, Kuwagata Keisai.[19] More likely, the painting was conceptual, and the artist did not intend to portray recognizable mountains and rivers but only to suggest a remote, thinly populated land that might be Japan.

Hibino Hideo has called attention to the tiny ships in the middle and far distance. He insists that these are not Japanese ships, but most likely European, and that Kazan may have intended the painting to warn of the danger of foreign ships in

Japanese waters. If that was Kazan's motive, it is strange that he did not make the ships bigger and more menacing or attempt in some more dramatic manner to call the attention of the authorities to the danger. But as Hibino recognizes, desperate loneliness in Tahara, the end of the earth, may have led him to paint *A Thousand Mountains*. Hibino quotes from the letter that Kazan sent to Fukuda Hankō shortly before making this painting:

> As you know, my lot is one of extreme hardship.[20] Above, I have heavy responsibilities toward my lord and my mother. Below, I have ties with my wife and children. And I am completely cut off from my friends. If I speak, I suffer for it; if I move, there is the net of the law. Bearing great rocks on my shoulders, I go into a steep valley. My legs have lost their strength, my buttocks pain me. Stones and brambles block my path, and the rain and snow have come. I feel that even if I call, nobody will answer; even if I scream, nobody will help.[21]

In this despondent frame of mind, Kazan may have yearned for an escape. As a whole, *A Thousand Mountains* is a powerful evocation of a mysterious land of mountains whose coast is indented by bays and arms of the sea; but at the top of the painting, where sea and sky meet on the horizon, the sharp clarity of the mountains of "Japan" dissolves into hills dimly visible in clouds.[22] Ozaki Masaaki believed that the land covered with clouds may represent the West, the distant world that Kazan yearned to see.[23] Sections of the painting are closely modeled on Chinese works of art, but Kazan also made use of Western perspective, a combination of styles that still was unusual in Japan, although Kazan used it in all his late paintings.

Another painting of about the same time, *Gekka meiki zu* (*The Singing Loom in Moonlight*), at first glance seems to be purely Chinese

A Thousand Mountains and Ten Thousand Waters (1841). (Private collection)

in inspiration, perhaps a copy of a Chinese original.[24] But on closer inspection, one notices the use of perspective, and the realistically drawn elements in the painting—houses along the shore, clumps of trees here and there, and wild ducks sheltering under reeds—have seemed to scholars to demonstrate that the painting is Japanese. The theme is didactic: virtuous women take advantage of the bright moonlight to work their looms at night while men work in the fields. The inscription on the painting describes the women, in thin linen garments, shivering in the cold as they weave and urges those who wear the silk to remember their toil.

We do not know why Kazan chose this particular theme for a painting at this time, whether it was in response to a commission or whether this was merely a "safe" theme for him to paint while a prisoner in confinement. He dated the painting the twelfth year of Bunsei (1829), although he actually painted it in the twelfth year of Tenpō (1841), attempting as usual to conceal the fact he was painting while in imprisonment.

Another product of this last spurt of activity as a painter, *Uko kōmon zu* (*The High Gate of Lord Yu*), was based on the story of Lord Yu, a virtuous judge whose decisions were so fair that no one had ever complained. When his gate fell over, the people of the region displayed their gratitude by erecting a new gate. Lord Yu said, "Make it a little bigger and taller, with room enough to admit a team of four horses and a high topped carriage. In deciding criminal cases I have done many unknown kindnesses and I've never inflicted injustice upon anyone. My sons and grandsons are bound to come up in the world!"[25] His sons and grandsons not only prospered, as he had predicted, but were ennobled as well. Kazan made this painting as a gift for Nakajima Kaemon, the assistant judge when Kazan was being investigated, by way of expressing his gratitude for Nakajima's kindness and fairness. No doubt Kazan was conveying in the choice of subject

The Singing Loom in Moonlight (1841). (By permission of the Seikadō Bunko Art Museum)

The High Gate of
Lord Yu (1841).
(Private collection)

his hope that Nakajima's family would be rewarded in the same way as Lord Yu's was.

The painting shows Lord Yu happily watching as the construction proceeds on his new house and gate. Men stripped to the waist busily carry material for the construction while other men put the finishing touches on the roof of the gate. In contrast with this activity, on the other side of the house the sea and slowly poled boats are visible. In the far distance is a rocky shore. The painting is richly detailed, imitative of Chinese paintings on the same subject but fresh in the use of Western perspective.[26] Painting this work was clearly a major effort for Kazan and cost him time that he could ill afford to spare. In a letter to Tsubaki Chinzan dated October 14, 1841, he mentioned that the painting was taking up so much time that he was delayed in filling orders for paintings that would bring in badly needed income.[27] His disciples continued to supply him with money, but he was deeply in debt and there was no likelihood he could ever repay what he owed.

Kazan's last major work, painted the day before he committed suicide, is *Kōryō issui zu* (*The Bowl of Millet Gruel*). It illustrates the famous Chinese story of Lu Sheng (Rosei in Japanese), who, while traveling in search of advancement, meets in the remote village of Handan (Kantan in Japanese) a Daoist priest. They go together to an inn and order a meal of millet gruel. The priest offers Lu Sheng a pillow on which to take a nap while waiting for the millet gruel to cook. Lu Sheng falls asleep and dreams that he has passed the imperial examinations with the highest marks. He is given a senior post in the government, marries the daughter of a distinguished family, has children and grandchildren who prosper, and finally, in his eightieth year, dies. At this point, Lu Sheng wakes and discovers that the millet gruel is not yet ready. All his glorious triumphs were a dream.

The painting was based on a work depicting the same subject by the Ming painter Zhu Duan (active 1510–1520) but surely reflects Kazan's feelings as he guided his brush, having decided to commit suicide the next day. It was clear to him now that his renown as a painter and even his success as the administrator of

a domain had been no more than a dream. In keeping with such emotions, the tone of the picture is bleak. Leafless trees hang branches over a ramshackle hut with a patched roof and peeling plaster walls. In the background, a steep and barren cliff threatens. The coloring is entirely in shades of brown. The painting, unlike the amusingly ironic tale of Lu Sheng's dream, is tragic. Awakening from the dream, Lu Sheng will once again wander and may find success, but Kazan, who was not free even to wander, will go only to his death. About this and the other paintings of Kazan's last months, Kōno Motoaki wrote that they were unprecedented in their metaphorical significance.[28]

In addition to these major works, Kazan painted during this period *Chūgoyochō*, an album of twelve pictures of realistically depicted insects and fish. On the album page facing each picture is a Chinese poem. Experts' opinions are divided over the album's intent and success.[29] Kazan wrote in a letter to Tsubaki Chinzan,

> Before you cut the seal of this album, think carefully about what I might have had in mind. Look at the titles on each page and you will uncover the meaning. But you must not do this in the presence of other people. I ask you to examine the pictures alone.[30]

It is obvious from these words that the pictures meant more to Kazan than merely realistic representations of insects and fish. The album contains a secret, but we do not know what it is. One specialist in Kazan's art believed that the pictures of insects convey his loneliness in the days immediately before his suicide. A near contemporary of Kazan wrote that although the pictures might appear lighthearted, they burn with Kazan's indignation; but Hibino confessed that it was not clear to him in what way they convey indignation.[31]

The Bowl of Millet Gruel (1841). (Private collection)

The Chinese poems do not much elucidate the mystery. Although each poem was undoubtedly chosen to accord with the mood of the facing picture, neither the poems nor their titles enable us to infer Kazan's intent. Kazan nevertheless expected Chinzan to "uncover the meaning." Chinzan was probably the person closest to him, even closer than his mother (despite his reiterated expressions of profound devotion). If anyone could understand Kazan, it was surely Chinzan. But what in these pictures and poems was controversial? Why was he so anxious that others not be present when Chinzan examined the contents of the album? Was it a general fear that anything he expressed, controversial or not, might be held against him? Or was there some secret known to Chinzan that enabled him alone to understand the meaning of the album?

Some of these pictures can be explained even without special knowledge. Perhaps the fierceness displayed by the insects fighting with other insects was meant to convey Kazan's rage over the forces aligned against him. The insects he chose to depict in his album were not butterflies but praying mantises, cannibal insects, flies that cluster around rotting clams and oysters. The Chinese poem about the flies, by the Ming poet Zhang Wei, was based on one in the *Shijing* (*Book of Songs*), which opens:

Buzz, buzz the bluebottles
That have settled on the hedge.
Oh, my blessed lord,
Do not believe the slanders that are said.

Buzz, buzz the bluebottles
That have settled on the thorns.
Slanderers are very wicked;
They disturb the whole land.[32]

"Slanderers" is likely to bring to mind Torii Yōzō. Another picture, of two tortoises, one big and one small, has been interpreted as symbolizing Kazan's impatience to escape, even though

he can move only slowly, like a tortoise. But the little tortoise in the picture seems to be threatening the big tortoise, and this has been taken to mean that Japan (the little tortoise) will drive off the big foreign tortoises that threaten it.[33] Many other explanations are possible, but the ultimate meaning still eludes us. One thing seems quite evident: the marvelously alive insects and fish, like the great paintings of his last period, were painted by an extremely unhappy man.

The

Last Year

12

On New Year's Day 1841,[1] Kazan composed the following poem:

> For forty-nine years a useless
> tree in government service,
> I did not correct what was
> wrong; I am ashamed
> before Qu of Wei[2]
> A man's most precious joys
> are heaven's redress:
> A mother of seventy and
> some shelves of books.[3]

The poem suggests that Kazan had become resigned to his exile, unjust though it was. He regretted mistakes that he had made as administrator of Tahara Domain but was comforted by heaven's gifts of long life to his mother and his books. The words "I did not correct what was wrong" probably did not represent his real conviction; surely he did not doubt that his reforms had benefited the people of the domain. Perhaps he used the expression to explain why samurai of the conservative faction, who had long since been jealous of Kazan's fame as an artist and his success as administrator of the domain, were now denouncing him. Their anger was aroused particularly when they learned that other samurai of the domain were

visiting Kazan's cottage to ask his advice, and they circulated rumors that Kazan's unseemly behavior while under house arrest was causing the daimyo great anxiety. Some openly declared that they wished he were dead. Miyake Tomonobu recalled:

Sensei was driven to suicide by the machinations of evil men within the domain. Sensei was famous and the way he administered the domain was just; that was why these evil men had previously been unable to give free rein to their wickedness, for fear of stumbling and falling. So they secretly rejoiced when Sensei was unexpectedly arrested, feeling exactly as if the clouds had been chased away. After he was released from prison and sent back to the domain, samurai who shared his views visited him constantly, even though he was he was officially a prisoner confined to his quarters, in order to discuss the classics and history or to ask his advice on domain affairs. In addition, many villagers of the neighborhood came to ask him for paintings. At times an unbroken stream of strangers stretched to and from his house. This aroused the envy of men who, if not wicked, were stupid or obstinate. They declared that Sensei's meetings with strangers in this manner, at a time when he was supposedly in confinement, was proof that he did not fear the government, and they privately informed a certain sinister member of the shogunate of this development.[4]

The daimyo of Tahara, Miyake Yasunao, who had ineffectually tried to secure Kazan's relief when he was first arrested, now did nothing.[5] He was in Osaka, charged with defending the castle, a post he hoped would lead to promotion to higher office, and was much too busy with his ambitions to worry about Kazan's welfare. Not long after Kazan committed suicide, Yasunao at last received his long-desired promotion to *sōshaban*. Takizawa Bakin praised Kazan in these terms:

Not long ago he was found guilty in connection with *rangaku* and spent a long time in prison. In the end, he was placed in the custody of Lord Miyake and sent to Tahara in Mikawa where he was confined to his house. However, somebody told him that as long as this situation persisted, it was harmful to his lordship. In the middle of the twelfth month of the twelfth year of Tenpō [1841] Kazan committed suicide, leaving behind notes explaining his reasons. He was only in his forty-ninth year. It may have been because of Kazan's suicide that soon afterward Lord Miyake was appointed as *sōshaban* and took up this office. Kazan's loyal death may be said to have been effective in bringing about this result.[6]

The main reason that Kazan gave for committing suicide was remorse that his imprudent behavior had caused the daimyo anxiety. Not only had he painted while under arrest but he had allowed the paintings to be sold. Earlier in the year, when Fukuda Hankō paid the visit just described, it occurred to Hankō that Kazan's paintings still were popular, and it would not be difficult to sell whatever he painted. Hankō consulted with a dealer, Miyake Ryokka,[7] and the two men persuaded Kazan to paint again.

At first, Kazan was enthusiastic about having an exhibition of his works. He wrote to Tsubaki Chinzan,

The kindness of all of you in arranging an exhibition of my paintings is higher than the mountains and deeper than the sea, but I wonder if it will not involve you in much hard work and yield few results. There was talk of a similar exhibition in this part of the country, but the circumstances would have been different. It was to be private, and no doubt there would have been some profit, but I refused. . . . This time, however, because you will serve as the go-between, I am sure everything will be arranged at your discretion to reach a happy solution. I feel confident, not only concerning this occasion but for the future. Not even a thousand pieces of gold would suffice to convey my thanks for your kindness.[8]

Kazan started painting again in earnest, although still ob-
serving the precaution of predating the works. Hankō and
Ryokka decided to sell paintings only in nearby Tōtōmi and
Mikawa provinces, so as not to attract the attention of officials
in Edo. The stratagem was initially successful, but gradually
word spread beyond these provinces of the availability of new
paintings by Kazan. This, Kazan believed, was the cause of his
misfortune and ultimately of his death. He had been particu-
larly dismayed by the rumor that Odagiri Yōsuke, a secretary of
the *rōjū* Mizuno Tadakuni, was coming to the area, ostensibly
for other reasons but in fact to investigate the sale and distribu-
tion of Kazan's paintings.

In a letter to Fukuda Hankō that bears the superscription "To
be thrown into the fire," Kazan wrote that Odagiri's impending
visit terrified him, not for possible danger to his own life but for
the effect that an investigation would have on both his lord and
his mother. He was sure that Odagiri's visit boded disaster.[9] Inap-
propriate behavior while under house arrest was a serious crime,
and he feared that he would be punished, most likely by being ex-
iled to an even more distant place.[10] The possibility that he would
be separated from his aged mother caused Kazan to tremble with
fright and consternation.

The rumor that so upset Kazan was false: Odagiri had been
sent by Mizuno Tadakuni not to investigate Kazan but to arrange
for the establishment of a school in Hamamatsu, Mizuno's origi-
nal domain. As far as Mizuno was concerned, Kazan's case had
been settled. He was much too busy with preparations for reform
of the shogunate and with possible repercussions in Japan of the
Opium War to worry about whether or not Kazan had violated
the terms of his house imprisonment.[11]

Kazan's greatest fear was that the daimyo of Tahara would be
blamed for having allowed him to sell his paintings. It appears
that Miyake Ryokka had sold perhaps as many as forty to fifty
of his paintings.[12] Kazan became increasingly convinced that the
only way he could stave off the possible threat to his lord's seren-
ity was by committing suicide and atoning for his crime.

Most of the works that Kazan painted at this time were probably conventional flower-and-bird paintings, popular with local customers, but his last paintings, and especially *Kōryō issui zu* (*The Bowl of Millet Gruel*), had particular meaning for Kazan. The inscription he wrote on the painting begins with a summary of the story of Lu Sheng and the magic pillow and then comments,

> The story is more or less nonsensical, but its warning to the world is profound. If those who enjoy wealth and rank realize its truth, they will not fall into the habits of pride and greed. They will revere the way of truth and experience no difficulty in following it. If poor persons pay due attention to the tale, they will not become servile or crave pity, and if they exert themselves, they will find it easy to preserve their honor as samurai. Those who grasp the meaning of the millet dream will have eyes opened to the vanity of the world.[13]

Having passed this judgment on worldly fame, Kazan prepared to kill himself on the tenth day of the tenth month (November 22, 1841). He left farewell letters to several intimates, including Tsubaki Chinzan, his brother Sukuemon, and his elder son Tatsu. The letters are similar in content and the expression is restrained, but one senses the turbulence of Kazan's emotions. The letter to Chinzan is the most detailed:

> I am writing you a few lines. In the hopes that it would enable me to take better care of my mother, I made the mistake of agreeing to Hankō's proposal for a benefit exhibition. I painted the works commissioned up to the third month, but the rest were left unfinished.[14] Of late, there are more and more rumors and groundless gossip, and I feel sure they will lead to some calamity. On top of this, the peace of his lordship has been threatened. For this reason, I intend to kill myself tonight. People will blame this on my failure to behave with greater prudence after being found guilty of criticizing the government. My misfortune without doubt comes from

a neglect of duties and a lack of self-examination that re-sulted in a contradiction between my words and actions. This was not the doing of Heaven but unquestionably the fate I brought upon myself. If this situation is allowed to continue, it will obviously cause great hardship to my mother, my wife, and children, and even his lordship will surely not escape unscathed. That is why I have made the decision mentioned above. No doubt I shall become a laughingstock, and bad reports about me will seethe like a cauldron. I ask you, in the name of our warm friendship, to endure this for the time being. If, a few years from now, there is a major change, will there be people to grieve over it? A most secret and eternal farewell. I bow my head in respect.[15]

The last sentences of the letter continue to puzzle Kazan scholars. The "major change" that Kazan anticipated has been interpreted by some as meaning that he foresaw the fall of the shogunate, although nothing in his writings suggests that he anticipated such a change. Satō Shōsuke, the leading Kazan author-ity, declared that for all Kazan's enlightened views, his object was to strengthen and correct the feudal system, not to abolish it.[16] Satō believed that the "major change" referred to the imminent danger of new European incursions in East Asia following the Opium War. News of the outbreak of the war had been late in reaching Japan, but as soon as the shogunate was informed, Egawa Hidetatsu was commanded to establish coastal defenses along the lines of his earlier proposals, an indication of how seriously the government considered the danger that the war posed to Japan.

Satō thought that Kazan's words "major change" may have re-ferred specifically to a possible attack on Japan by European ships, a danger often mentioned in Kazan's writings. The annual Dutch ship had brought rumors from Batavia that the British were plan-ning to take revenge on Japan for shelling the *Morrison*. Mizuno Tadakuni was so alarmed by these rumors that he canceled the *uchiharai* order that required coastal batteries to fire on all foreign ships; he could not risk the possibility that another shelling might

provoke a war with Britain. Kazan may have believed that the British were about to launch an attack on Japan, for he seems to have discussed this possibility with his friends.[17] After learning about the Opium War, Suzuki Shunsan declared that the situation in East Asia was exactly as Kazan had predicted.[18]

Satō offered no explanation for Kazan's words "most secret and eternal farewell." Kazan's letters are difficult to understand because of his complicated epistolary style and especially because he tended to omit words necessary for ready comprehension. He may have deliberately used obscure language to make it harder for government spies who might see his letters to grasp the meaning. The concluding remarks in his letter to Chinzan undoubtedly had a specific meaning for Kazan, but they have resisted attempts to decipher them.

Kazan added a postscript to this letter, saying that he had destroyed all the letters he had received from Chinzan. Perhaps he feared that if these letters were discovered after his death, Chinzan might be charged with having abetted the crimes for which Kazan had been punished.

In this last letter to Chinzan, dated the tenth day of the tenth month, Kazan wrote that he would commit suicide "that evening," but he did not kill himself until the eleventh. The delay is ascribed by most scholars to the watchfulness of Kazan's mother, who, sensing that something was disturbing her son, perhaps the thought of suicide, had not let him out of her sight all day and night on the tenth.[19] On the following day, a visitor interrupted her surveillance. Kazan slipped out of the house, went to a nearby shed, and killed himself there.

Kazan's letter to his brother Sukuemon, written on the same day as the letter to Chinzan, contains the striking phrase "disloyal and unfilial" (*fuchū fukō*) to characterize himself. The letter opens:

This evening I shall kill myself out of shame that my imprudent actions have caused his lordship to suffer. I have no way to apologize to Mother. I shall leave behind in the world

the reputation of having been disloyal and unfilial. I have no way either to apologize to you. No doubt my action will cause you trouble, but I implore you to do what you can to comfort her. . . . This kind of letter can only excite tears, so I shall abbreviate the rest.[20]

The phrase "disloyal and unfilial" appears in the inscription that Kazan wrote on a strip of cloth that he asked to be placed above his grave because (as he knew) a criminal could not be given a tombstone.[21] The phrase had also appeared in a letter written to Chinzan on the third of the eleventh month of the previous year (November 26, 1840):

I am fortunate that my mother is alive. Politeness forbids saying she is old, but there is no order of old or young when it comes to dying. One cannot be sure what will happen tomorrow. If, like Kyosho,[22] I should die young, I ask that my grave bear the inscription "Here lies the disloyal and unfilial—" . . . And since it is my fate to have my body rot away in the vegetation of a hamlet somewhere, all I ask is that the stone placed over my grave be one that quickly disintegrates.[23]

The words "disloyal and unfilial" also are found in Kazan's brief farewell letter to his son Tatsu, probably written about the same time as the other suicide notes. It lacks a date, probably because Kazan had not yet decided on the day that he would kill himself:

Please do your best to take good care of your grandmother as long as she lives. You should also do your best to be a good son to your mother. She is an unfortunate person.

Even if you are starving, you must not serve a second master.[24]

This letter, although not obscurely worded, is puzzling. Kazan's emphasis on the importance of Tatsu's serving his grandmother

(Kazan's mother) with devotion comes as no surprise, but it is not clear what Kazan meant when he characterized his wife as "unfortunate." Unfortunate because she was soon to be a widow? Or unfortunate because Kazan's "crimes" had kept her from enjoying a happy married life? Even more puzzling is the admonition to Tatsu not to serve a second master. Not serving a second master was an axiom of samurai conduct, and many a samurai in the past had committed suicide after the death of his master rather than serve a successor. But why did Kazan issue this warning to his son, who was still so young that he had yet to serve a first master, at this moment of eternal farewell?

The letter to Tatsu is signed "Your disloyal and unfilial father Noboru," followed by the curious postscript: "Do what you think best for your sister and brother." With the death of his father, Tatsu would become head of the family. But why was it necessary to remind him of this in such impersonal terms?

Kazan left behind his mother (aged seventy); his wife, Taka (aged thirty-five); his daughter, Katsu (aged fifteen); Tatsu (aged ten); and his younger son, Kanō (aged seven).[25] Kazan probably hoped that out of compassion for his sacrifice, friends and admirers would support his family after his death.[26] But we may feel that although he was neither disloyal or unfilial, he did not take sufficiently into account the hardships that his death would cause his family. But to speak in such terms is to ignore the samurai tradition of rejecting any concessions to human feelings when overriding principles are at stake.

Kazan committed suicide in a shed near his house that the agricultural expert Ōkura Nagatsune had used for his experiments with making sugar from sweet potatoes. The building was not suitable for a solemn ceremony, but Kazan had no choice. Seating himself formally, he unsheathed his dagger and plunged it into his abdomen, drawing it across in a straight line. He drove in the dagger so deeply that his intestines dropped out from the wound. It was customary for a friend to terminate the agony of a disemboweled man by decapitating him, but with no one to

perform this service, Kazan used the dagger to slash his throat, falling forward with his last gasp.

His mother, upset by his absence, hurried to the shed, apparently judging that it was the most likely place for Kazan to hide. She found him in a pool of blood. At first supposing that he had died from the wound in his throat, the mother cried out, "For shame! Why did you cut open your throat instead of your belly? That's the way a woman kills herself!" But when she pulled back the outer kimono and saw that he had first disemboweled himself, a smile crossed her grieving face, and she declared, "You are truly a son of mine."[27]

Word of Kazan's suicide was sent immediately to the shogunate, and two officials hurried to Tahara from Edo to inspect the body. It took about a week for the message to reach them and another week for the men to arrive in Tahara. The body was preserved in lime pending the inspection. Once the officials had drawn up their report on the details of the suicide, the body was taken to the cemetery of a nearby temple and buried there. As Kazan had foreseen, a monument was not permitted to be erected over the grave of a convicted criminal.[28]

On learning two weeks later of Kazan's suicide, Matsuzaki Kōdō wrote in his diary, "Kazan suffered punishment because of unfounded fears and died because of unfounded fears."[29]

Kazan's mother died in 1844 at the age of seventy-two. In the same year, Tsubaki Chinzan visited Tahara for the first time and paid his respects to members of Kazan's family, which now consisted of Kazan's widow and three children.

Very little is known about Kazan's wife, Taka. When they were married in 1823, she was only sixteen, fourteen years younger than Kazan. Kazan says nothing about her in his writings, but her daughter-in-law[30] described Taka as a chaste and dutiful wife who obediently served her mother-in-law. There are no anecdotes about Taka, apparently a retiring person of few words. She probably did not share her husband's interests. She died in 1871 and was buried in the same plot as Kazan.

Kazan's daughter, Katsu, the oldest of his three children, was born in 1826. In 1845 she married Matsuoka Jirō, a samurai of Tahara Domain,[31] but they were divorced a year later for unknown reasons. She spent most of the remaining years until her death in 1883 looking after the children of Miyake Yasuyoshi, the last daimyo of Tahara.

Kazan's elder son, Tatsu, died in 1856 in his twenty-fifth year, too young to make a mark as a samurai, although his steady promotions to higher rank indicate that his services were valued by the daimyo.[32]

The second son, Kanō, was only six years old when his father died, but Kazan's disciples decided that he would realize Kazan's hope that a son would succeed him as a painter. In 1847 three of Kazan's disciples—Tsubaki Chinzan, Fukuda Hankō, and Kaneko Hōsui—accompanied the twelve-year-old boy to Edo, where he was formally registered as a pupil of Chinzan. The latter, feeling the responsibility of raising the son of his beloved teacher, brought him up together with his own son, strictly supervising his study of the classics, martial arts, and painting. Kanō's first artistic name was Shōka (little Kazan), but it gradually became apparent that he would not develop into a second Kazan. He served the daimyo of Tahara not only as a painter but also in administrative functions. He died in 1887 after contracting typhoid fever. He had no children of his own, and this meant that with his death, Kazan's bloodline came to an end.[33]

The last surviving person to have known Kazan was the former daimyo of Tahara Domain, Miyake Yasunao, who died in 1893.[34] The relations between Yasunao and Kazan had not been good ever since Kazan attempted to have Miyake Tomonobu, the illegitimate son of the previous daimyo of Tahara, chosen as his successor. Yasunao also had exasperated Kazan with his repeated extravagances, but the two men probably came closer during the years when Kazan successfully served as the administrator of the domain. When Kazan was arrested, Yasunao had been anything but assiduous in his attempts to win freedom for Kazan,

but in 1865 his successor, Yasuyoshi, petitioned the shogunate for permission to erect a monument over Kazan's grave. Nothing happened then or when Yasuyoshi submitted a second petition in 1867, but in the following year, immediately before the fall of the shogunate, Kazan at last was pardoned.[35] A gravestone without the inscription that Kazan had prepared, describing himself as disloyal and unfilial, and with only his name, written by Kanō, was erected in the cemetery of the Jōhōji.[36]

Of Kazan's many pupils, all of them capable of turning out a pleasing painting in the *bunjinga* style, only one is of special interest: Tsubaki Chinzan. He was the most gifted of the disciples, the closest to Kazan, and his confidant. Chinzan excelled in flower paintings, but his most impressive work is a cluster of portraits in the style of Kazan. The finest is one of Kazan himself, painted in 1853, twelve years after Kazan's death. This portrait, reproduced innumerable times, is almost always included in studies of Kazan, indelibly creating in the minds of all who see it an impression of not only Kazan's appearance but also his personality.

This was not the first portrait Chinzan painted of Kazan. Apart from a number of sketches, he left several finished portraits, including one painted in 1829, during Kazan's lifetime.[37] Kazan was thirty-six at the time but looks considerably older, perhaps because of his melancholy, even depressed, expression. The portrait is exceptionally moving, as though Chinzan captured some inner grief in Kazan, even at this relatively happy time of his life. Another portrait by Chinzan, this one dated 1842, the year after Kazan's death, is less appealing.[38] Kazan seems much younger but rather ordinary; nothing suggests the ordeal he had endured in prison and afterward.

In Chinzan's portrait of 1853, Kazan looks older than a man of forty-five, although that is how an inscription on the painting describes him. His appearance conveys the calm of age after a life of trials. He sits before his little desk, his right hand extended as though making a gesture as he speaks, addressing us across time and great distance. All of Chinzan's portraits of Kazan probably

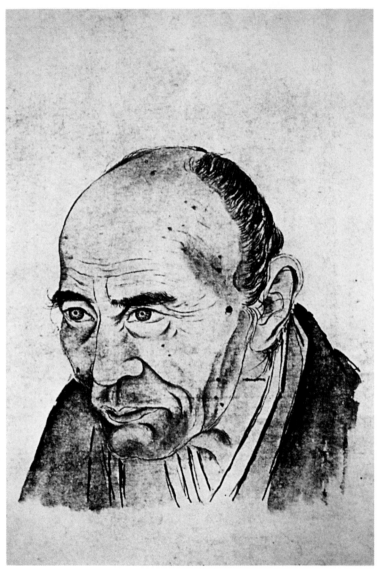

Portrait of Satō Issai (1841), by Tsubaki Chinzan. (By permission of the University Art Museum, Tokyo National University of Fine Arts and Music)

resemble him, at least in certain moods or in certain of Chinzan's recollections, but the 1853 portrait is the essential Kazan, distilled by Chinzan from memories of the teacher he worshiped.

Chinzan painted portraits of Satō Issai at seventy and at eighty years, graphically depicting the toll of time on his features. Chinzan's realism was unsparing: in the least attractive of these portraits, Issai looks all but repulsive. Chinzan's portrait of Kazan may have idealized his features, but if one can judge from the portraits of Issai, Chinzan had little affection for a man who had not found peace even in old age.

Chinzan also painted portraits of quite ordinary men and women of the samurai class. They are extraordinarily vivid, the most convincing examples of the realism that Kazan had preached. Portraits of Japanese of the past generally do not look much like the Japanese one might see in the streets today, but Chinzan's portraits, even more than Kazan's, depict people who in features and expression look extraordinarily like present-day Japanese. Chinzan had numerous pupils, but he seems not to have transmitted to them the techniques of painting effective portraits. Perhaps the introduction of the photograph, with its possibilities of even greater realism, had ended the market for portraits.

Although Kazan's paintings continued to enjoy popularity during the years after his death, the first collection of his writings did not appear until 1910.[39] The introduction, explaining why the Kazan Society had decided to publish these works, was the first statement of Kazan's importance as a political thinker. It opens,

During the days when the country was closed and complacent, Watanabe Kazan *sensei* made detailed studies of conditions abroad and conceived the grand design of opening the country and ending the long years of somnolence. It was in 1838 that he wrote "Report on Conditions in the West" and "The Shrike Tongues: Questions and Answers." The draft of "Exercising Restraint" dates to the following year. This was

in fact thirty years before the reforms of the Restoration. Moreover, the changes that took place did not go beyond what he had already proposed.[40]

At the time these remarks were published, the country had long since been opened, and there was no danger that members of the Kazan Society would be punished for endorsing Kazan's views, at one time so controversial. He was praised as a man far ahead of his time, a precursor of the age of enlightenment that followed the Meiji Restoration. Similar praise for the pioneering aspect of his paintings would be given by Jack R. Hillier: "In his landscape sketches from nature, and even more, his portraits, he anticipates by half a century the Westernization of Japanese art that ensued in the Meiji era."[41]

Neither Kazan's art nor his criticism of Tokugawa society exerted much immediate influence. Apart from Tsubaki Chinzan, no disciple continued Kazan's use of Western techniques in painting, and the major figures who effected the changes of the Restoration were not inspired by Kazan's writings. His essays, ignored for more than half a century after his death, were discovered by a generation searching for the reasons for Japan's success in the Meiji era. Only in retrospect did Kazan's advocacy of opening Japan to the knowledge of the world acquire importance; he came to be seen as a martyr to this cause.

Kazan had called himself "disloyal and unfilial," but he was lauded not only as a consummate exemplar of loyal and filial behavior but also as a devoted believer in the sanctity of the emperor, even though in fact he never mentioned the emperor in his writings and did not indicate what role an emperor might play in Japan in the future. The praise bestowed on Kazan became indiscriminate, extending to virtues of which even he was unaware.

Today, Kazan is recognized as a major painter, the last of the Tokugawa era. He is admired especially for his portraits, but his works in many other styles—traditional Chinese, traditional Japanese, genre paintings, sketches, and so on—are equally skillful

and often captivating. His writings, for many years forgotten, have been collected in seven volumes, and individual works appear in sets devoted to works by thinkers of the premodern period. But it is, above all, as a man that he is likely to attract future generations, a man who persevered in his art despite poverty and persecution and who left behind a gallery of unforgettable portraits.

Introduction

1. Kurahara Korehito, *Watanabe Kazan*, p. 10.
2. Miyake Tomonobu, "Kazan sensei ryakuden," p. 314.
3. Watanabe Kazan, "Shinkiron," in Satō Shosuke, ed., *Kazan, Chōei ronshū*, p. 40.
4. Watanabe Kazan, "Saikō seiyō jijō," in Satō, *Kazan, Chōei ronshū*, p. 85. Kazan meant that people who are devoted solely to writings of the past will be oblivious to the present danger.
5. Kazan, "Shinkiron," p. 40.
6. Kazan, "Saikō seiyō jijō," p. 90.
7. The oracular utterance is contained in the farewell letter that Kazan sent to Tsubaki Chinzan, his favorite disciple, on November 25, 1841, the day before he committed suicide (*Watanabe Kazan shū*, vol. 4, p. 233).
8. George Sansom wrote about Kazan, "It was men of his type who were both authors and leaders of the revolutionary movement of the eighteen-sixties" (*The Western World and Japan*, p. 278).
9. Miyake Tomonobu, the author of "Kazan sensei ryakuden," was an illegitimate son of the eleventh daimyo of Tahara.
10. Kazan, "Saikō seiyō jijō," p. 108.
11. A *kotatsu* is table draped with cloth and with a small charcoal fire underneath, still used in Japan.
12. *Hatsuuma* is a festival in the second lunar month held on the first day of the horse.
13. This would make each picture cost about 1 cent.
14. Yoshizawa Tadashi wrote about the "immeasurably great influence" that Kazan's *hatsuuma* paintings had on his development (*Watanabe Kazan*, p. 13).
15. For an account of the painters of Nagasaki, see Calvin L. French, *Through Closed Doors*, pp. 59–68. See also Masanobu Hosono, *Nagasaki Prints and Early Copperplates*.

Notes

16. Satō Shōsuke, "Keiseika Kazan to kagakusha Chōei," p. 43. Satō suggests that Kazan saw not the daimyo of Bizen but his son, but he does not explain why Kazan continued believing for thirty years that he had seen the daimyo.

17. For a concise account of what actually happened to Kazan's siblings, see Satō Shōsuke, *Watanabe Kazan*, pp. 11–12. The brother (Jōi) who was taken off in the snow had long wanted to become a Buddhist priest; it was not forced on him.

18. This explanation of why Kazan was so desperately eager to leave service follows that in *Watanabe Kazan shū*, vol. 7, p. 65.

19. Takizawa Bakin, *Kyokutei ikō*, p. 126. Bakin attributed to this audacity Kazan's willingness to feel a dead man's face in order to ascertain the bone structure. (This was in connection with the posthumous portrait that Kazan made of Bakin's son.)

20. Miyake, "Kazan sensei ryakuden," p. 316.

21. See, for example, Haga Noboru, *Bansha no goku*, p. 184. Kazan's last letter to Tatsu, his elder son, in which he asked the boy to be filial to his unfortunate mother, is in *Watanabe Kazan shū*, vol. 4, p. 238. For a translation, see chapter 12.

22. Because he died while under a sentence of house arrest, Kazan's family was not permitted to erect a tombstone over his grave.

23. Yoshizawa, *Watanabe Kazan*, p. 206. Zheng's dates are given variously as 1239–1316 and 1241–1318.

1. *Dutch Studies in Japan Before 1793*

1. Engelbert Kaempfer's original title was *Heutiges Japan* (*Present-day Japan*). The first translation into English, by Johann Gaspar Scheuchzer, was called *The History of Japan*. The far more accurate translation by Beatrice M. Bodart-Bailey is called *Kaempfer's Japan*, but I have found it easier to use Scheuchzer's title.

2. Although he was German by birth and nationality, Kaempfer had to pretend to be Dutch while in Japan because the Japanese permitted only Dutchmen to reside on Deshima.

3. Kaempfer referred to the Japanese Catholics who either renounced their faith or were killed. He wrote of one site a little later in his work, "This is the mountain where in an earlier period newly converted Christians were taken and tortured in the hot baths to cause them to apostasize" (*Kaempfer's Japan*, p. 58).

4. Elsewhere, Kaempfer termed Deshima a prison (*Kaempfer's Japan*, p. 188). He also described the severe restrictions under which Chinese merchants lived in Nagasaki after 1688 (pp. 225–226).

5. Kaempfer, *Kaempfer's Japan*, p. 27.

6. Quoted in Donald Keene, *The Japanese Discovery of Europe*, p. 9.

7. Carl Peter Thunberg, *Travels in Europe, Africa and Asia*, vol. 3, p. 64.

8. Ibid., p. 206.

9. The murder of this king at a masked ball is the subject of Giuseppe Verdi's opera *Un Ballo in Maschera*.

10. The map, by George-Louis Lerouge, is reproduced in Hugh Cortazzi, *Isles of Gold*, p. 155. The French text says, "I give only a part of the locations, in view of the slight interest the public has in knowing the names of villages in Japan." Another map, published as late as 1763, "shows Kyushu slanted to the east with Nagasaki and the nearby peninsula almost parallel with southern Kyushu. Shikoku is almost square, except for a deep inlet on the north side" (p. 50).

11. A screen painted as early as the end of the sixteenth century depicts Asia, Europe, and Africa with surprising accuracy, and South America and the eastern half of North America are recognizable. It is reproduced in Cortazzi, *Isles of Gold*, pp. 102–103.

12. Kaempfer, *Kaempfer's Japan*, p. 362.

13. Keene, *Japanese Discovery of Europe*, p. 55.

14. Kaempfer, *Kaempfer's Japan*, p. 188.

15. A classic condemnation of *sakoku* (the closure of the country) is in Watsuji Tetsurō, *Sakoku: Nihon ni higeki*. Some more recent scholars have, however, defended *sakoku*. See, for example, Kobori Keiichirō, *Sakoku no shisō*. There even is a small group of scholars known for their *shinsakoku shugi*, the advocacy of new *sakoku*.

16. Engelbert Kaempfer, "An Enquiry," in *Amoenitates exoticarum politico-physico-medicarum*, a work published in Latin in 1712 that discusses many other parts of Asia besides Japan. Excerpts are given at the end of Scheuchzer's translation of *History of Japan*.

17. Bodart-Bailey, "Translator's Introduction" to Kaempfer, *Kaempfer's Japan*, p. 19.

18. Ibid., p. 18. Bodart-Bailey mentions Jean Bodin in France, Thomas Hobbes in England, and Samuel von Pufendorf in Sweden and Prussia as advocates of this thesis.

19. The most useful importations were probably medicines and books.

20. Kaempfer, *Kaempfer's Japan*, p. 187.

21. Tempura cooking, a typical element of Japanese cuisine today, was apparently learned from the Portuguese; the term *tempura* itself was derived from the Portuguese *tempero* (cooking). *Kasutera*, a kind of sponge cake, dates from the same period; the name is said to come from the Portuguese pronunciation of the Spanish place-name Castilla.

22. Thomas F. Leims, *Die Enstehung des Kabuki*; Donald Keene, *Landscapes and Portraits*, p. 56.

23. Although this is generally true, there were exceptions: poets of *kanshi* were influenced by the works of late Ming poets, and the paintings produced by Shen Nanpin during his stay in Nagasaki from 1731 to 1733 considerably influenced late Tokugawa painters.

24. For an account of the dissection, see Nichiran gakkai, ed., *Yōgakushi jiten*, p. 720. See also Rai Kiichi, ed., *Jugaku, kokugaku, yōgaku*, pp. 302–303. Yamawaki Tōyō obtained permission from the Kyōto *shoshidai* to perform the experiment, but he was not permitted to examine the severed head of the criminal. For a month following the dissection, Tōyō had services said for the soul of the executed man and even had a Buddhist posthumous name bestowed on him.

 For a more detailed account in English of the beginnings of the study of anatomy in the Western style, see Grant K. Goodman, *Japan and the Dutch*, esp. pp. 76–81.

25. This is, I believe, the general meaning of the quotation, but the language is extremely concise and I have had to expand the text. See Rai, *Jugaku*, p. 302.

26. Maeno Ryōtaku nevertheless continued his studies of Dutch and made valuable translations, especially in his later years. See Goodman, *Japan and the Dutch*, pp. 79–81.

27. The work was more properly known as *Tabulae anatomicae*, but for some reason Sugita Genpaku gave the work a mistaken title, which has been used ever since.

28. Sugita Genpaku, *Rangaku kotohajime*, pp. 51–52, translated in Keene, *Japanese Discovery of Europe*, pp. 21–22.

29. Sugita, *Rangaku*, p. 52.

30. The numerous and lengthy footnotes in the original work were not translated.

31. It is also known (to pedants) as *Rantō kotohajime*.

32. Ōtsuki Gentaku, *Rangaku kaitei*, p. 226.

33. Ibid.

34. For the background of the decision by Matsudaira Sadanobu (1759–1829) to impose orthodoxy, see chapter 2.
35. The painting is now in the special collections section of Waseda University. It is the subject of a most interesting study by Reinier H. Hesselink, "A Dutch New Year at the Shirandō Academy."
36. For the menu (derived from Morishima Chūryō's *Kōmō zatsuwa*), see Hesselink, "Dutch New Year," p. 199. It included fish prepared in various ways, roasted boar and deer, duck, vegetables, and lobster soup.
37. Hesselink believed that the portrait was of Lorenz Heister ("Dutch New Year," pp. 199–202). The problem is that the portrait of Heister known in Japan shows him as clean shaven (Calvin L. French, *Through Closed Doors*, p. 63), but the portrait on the wall is bearded, like all other Japanese portraits of Hippocrates.

2. *Japan in 1793*

1. The term *rōjū* is often translated as "elder" (irrespective of the age of the person); it was the highest position within the shogunate after the shogun himself. At any one time, there were generally four or five *rōjū*. The term also was used to designate the body of *rōjū*; in this case, the translation is usually "Council of Elders."
2. Fujita Satoru, *Matsudaira Sadanobu*, pp. 31, 37.
3. Ibid., p. 39.
4. Quoted in Kawatake Shigetoshi, *Tsuruya nanboku shū*, p. 32, translated in Donald Keene, *Dawn to the West*, p. 458.
5. Matsudaira Sadanobu was born in the twelfth month of 1758 (the eighth year of Hōreki). That month fell entirely within January 1759. I have followed Western chronology.
6. John Whitney Hall, *Tanuma Okitsugu*, p. 38.
7. The preceding biographical material is derived mainly from Fujita, *Matsudaira Sadanobu*, pp. 2–17. I should note, however, that not all historians condemn Tanuma Okitsugu's regime. He has been praised for the bold policies he adopted in his attempt to break through the economic stagnation, notably his currency reform. Tanuma also was interested in finding out in what ways knowledge of the West could help Japan. He offered his patronage to the European studies of Hiraga Gennai and even asked the Dutch on Deshima to send carpenters from Batavia to instruct Japanese workmen in building bigger ships. But these admirable

features of his regime were overshadowed by its reputation for corruption. For a brief survey of Tanuma's reign, see Donald Keene, *The Japanese Discovery of Europe*, pp. 101–102. For a much more detailed study, see Hall, *Tanuma Okitsugu*.

8. Fujita, *Matsudaira Sadanobu*, p. 18. Normally the post of chief (*rōjūshu*) was filled by one of the sitting *rōjū*, not by a newly appointed outsider.

9. Presumably he chose this term in imitation of the Kyōho Reforms proclaimed by his grandfather Tokugawa Yoshimune. The Kansei era lasted from 1789 to 1800, and the Kansei Reforms were proclaimed in 1790.

10. Yoshizawa Tadashi, *Watanabe Kazan*, p. 4.

11. Quoted in Fujita, *Matsudaira Sadanobu*, p. 28, translated in Donald Keene, *World Within Walls*, p. 521. There are minor variations in the wording of the last line of the *kyōka*.

12. These were the daimyos of Owari, Kii, and Mito, the descendants, respectively, of the ninth, tenth, and eleventh sons of Tokugawa Ieyasu.

13. The incident, described later, is known as the *songō senge* (imperial command concerning the honorific title).

14. Kōkaku was a posthumous title; he was the son of Prince Kan'in Sukehito and was first known as Morohito, later as Tomohito. See Fujita, *Matsudaira Sadanobu*, p. 135.

15. The first example (1221) took place during the Jōkyū rebellion, and the second (1447) was shortly before the Ōnin War.

16. The account of the controversy over the *songō* (honorific title) is drawn mainly from Fujita, *Matsudaira Sadanobu*, pp. 136–150. See also Herschel Webb, *The Japanese Imperial Institution in the Tokugawa Period*, pp. 123–125.

17. For his words, see Fujita, *Matsudaira Sadanobu*, pp. 140–141.

18. Donald Keene, *Emperor of Japan*, p. 384.

19. In the eleventh month of 1787, Emperor Kōkaku sent a poem to the shogun Tokugawa Ienari, reproaching him for the bakufu's failure to do anything to relieve the suffering: "tamikusa ni / tsuyu no nasake o / kakeyokashi / yoyo no mamori no / kuni no tsukasa wa" (Bestow at least a particle of kindness on the people, you who are charged with defending the country). See Tsuji Tatsuya, *Tennō to shōgun*, p. 315. This *waka* gained wide circulation in Kyōto because it embodied the hope of people of the city that the court would induce the bakufu to help them (p. 316). Assuming that Kōkaku actually wrote the poem, this was the first time an emperor had attempted to intervene in the running of the country by the Tokugawa bakufu (p. 322).

20. For details, see Tsuji, *Tennō*, p. 341.

21. Quoted in Fujita, *Matsudaira Sadanobu*, p. 149.

22. This was the figure at the time of the 1743 census and probably had not changed much. See Satō Shōsuke, *Watanabe Kazan*, p. 6.

23. For descriptions of the four visits (in his sixteenth, twenty-sixth, thirty-fifth, and forty-first years) and for his final stay when he was sent into exile in Tahara in his forty-eighth year, see Hibino Hideo, *Watanabe Kazan*, pp. 134–135.

24. He composed many *tanka* (short poems) and *haiku*, some of which have been preserved.

25. Suganuma Teizō, *Watanabe Kazan: Hito to geijutsu*, p. 12. Kazan was only eight years old when his great-uncle, Hirayama Bunkyō, died in 1801 in his seventieth year. Kazan could not have learned more than the essentials of painting from him. But perhaps this experience (if it occurred) encouraged his inborn artistic talent.

26. An editor draws a line between true diaries and other works that Kazan called "diaries," but were actually travel accounts, in *Watanabe Kazan shū*, vol. 2, p. 333.

27. *Gūgadō nikki*, in *Watanabe Kazan shū*, vol. 1, p. 6.

28. Hibino, *Watanabe Kazan*, p. 40.

29. Quoted in Satō Shōsuke, "Keiseika Kazan to kagakusha Chōei," p. 45. The original text, in a daily schedule that Kazan drew up for himself in 1828, is in Matsuoka Daisen, *Zenrakudō kiden*, quoted in *Watanabe Kazan shū*, vol. 2, p. 333.

30. Ozawa Kōichi, *Watanabe Kazan kenkyū*, p. 104. Ozawa points out that Bunchō came to be known as the doyen of the *nanga* (*bunjinga*) school in eastern Japan, but he cannot be categorized as a "pure" *nanga* painter. Not only did he study Kanō-style painting with Katō Bunrei (1706–1782), but he went to Nagasaki, where he studied under the Chinese painter Zhang Jiugu. While in Nagasaki, he met Shiba Kōkan, who happened to be there on his travels, and the two men became friendly. This may explain the influence of Western art in some of Bunchō's works.

31. Tsukiyama Terumoto, *Watanabe Kazan no gyakugansaku kō*, p. 39. Having seen the original manuscript, Tsukiyama wrote that Kazan had written *shunga* in each instance.

32. Kazan, *Gūgadō nikki*, entry for the twenty-ninth day of the twelfth month (January 28, 1816), pp. 27–28. The grandfather's name was Kawamura Hikozaemon.

33. This title was given to the work, probably after Kazan's death, by his disciple Tsubaki Chinzan.

34. *Watanabe Kazan shū,* vol. 1, p. 43. He passed the same verdict on a Ming painting of a beautiful woman. Five months later, he attended an exhibition of paintings by Zhao Zhongmu, a Yuan-dynasty painter, and pronounced them "unmistakably fake" (p. 67).

35. *Watanabe Kazan shū,* vol. 1, p. 39.

36. Satō, *Watanabe Kazan,* p. 21.

37. This free version of a part of the inscription owes much to the Japanese translation in Suganuma, *Watanabe Kazan: Hito to geijutsu,* p. 228. See also Hibino, *Watanabe Kazan,* plate 2 and p. 177. The painting dates, however, from 1838, not from his samisen-playing years.

3. *Genre Paintings and Early Portraits*

1. The meaning of the title, as explained by Kurahara Korehito, was that the work was intended to present the full range of Kazan's painting to date, from copies made of old works to depictions of events from his own life (*Watanabe Kazan,* p. 88).

2. For a *yomikudashi* of the *kanbun* text, see Ōta Zentarō, *Watanabe Kazan,* pp. 14–15. Ōta gives the entire text and pictures of the work. A translation of the essays into Japanese is in *Issō hyakutai zufu kaisetsu,* the pamphlet accompanying the 1995 reprint of *Issō hyakutai.*

3. A woodblock edition of the work was made by Kazan's second son, Watanabe Shōka, who published it in 1879. Subsequent editions of *Issō hyakutai* have been reproduced photographically from Kazan's original, not from Shōka's woodblocks.

4. It is now generally believed that the essays were not composed in the order in which they appear in the work.

5. The first mention of Kazan in Takizawa Bakin's letters is dated Bunsei, first year, second month, thirtieth day (April 5, 1818). Bakin does not mention Kazan by name but describes "a close friend of my son, a samurai, who is studying painting in the same school and who also is friendly with *rangakusha.*" Bakin was pleased to have a *rangakusha* acquaintance: he intended to ask Kazan to use Dutch lenses to make a "photograph" (*shashin*) of a silkworm. See Shibata Mitsuhiko and Kanda Masayuki, eds., *Bakin shokan shūsei,* vol. 1, p. 27. Bakin describes Kazan as a painter in the Chinese style who is studying in the same atelier with his son in *Kyokutei ikō,* p. 365.

6. Iwasa Matabei (1578–1650), Hishikawa Moronobu (seventeenth century), and Miyagawa Chōshun (1628–1752). All three artists, although known

for their genre paintings, had studied the classical traditions of the Tosa and Kanō schools.

7. Miyake Tomonobu, "Kazan sensei ryakuden," p. 318.

8. Jack Hillier, *The Art of Hokusai in Book Illustration*, p. 97.

9. Ibid., p. 98.

10. Kishi Ganku (1749?–1838) first studied Kanō painting, then worked in the style of Shen Nanpin, and still later was influenced by the Maruyama and Shijō schools. He was a famous painter of animals, notably tigers.

11. Text and paraphrase in Suzuki Susumu, "*Issō hyakutai* zufu kaisetsu," p. 3.

12. Yoshizawa Tadashi, "Watanabe Kazan hitsu *Issō hyakutai* zu ni tsuite," p. 423. In his earlier book, Yoshizawa went no further than to state that "perhaps the *manga* influenced *Issō hyakutai*" (*Watanabe Kazan*, p. 23).

13. Kurahara, *Watanabe Kazan*, p. 88. The painting of Duanmu by Hayashi Hansui is reproduced on p. 89. His pioneering article on the identity of Hayashi appeared in 1969.

14. The Kazan-kai (Kazan Society) in Tahara reproduced the entire work in collotype in 1964, and it has been reprinted several times since, along with the helpful explanation by Suzuki Susumu.

15. For the year in which he began to study with Satō Issai, the chronology in *Watanabe Kazan shū*, vol. 7, p. 104, gives 1811, but this date is contradicted by the account of why he was unable to study with Issai in 1819 because of an unaccommodating gatekeeper. A Kazan expert suggested to me that Kazan attended Issai's daytime lectures from 1811 but that his domain did not permit him to go out at night, possibly because it was feared that he and his friends might actually intend to participate in the immoral pleasures to which young samurai were susceptible (letter from Bessho Kōichi, March 2005).

16. Miyajima Shin'ichi stresses this point in *Shōzōga*, esp. pp. 7–9, 20.

17. This may be an overstatement. Kanehara Hiroyuki calls attention to the portrait of Sugita Genpaku by Ishikawa Tairō (1765–1817) as an example of portraiture that used Western realism even to depict the faint wrinkles on Genpaku's face ("Kazan no jinbutsu shōzōga," p. 103). (The dates for Tairō, long a matter of conjecture, are from Katagiri Kazuo, "Yōfū gaka Ishikawa Tairō to Edo no rangaku-kai.") In discussing Tairō's profile portrait of Hippocrates, Calvin L. French found similarities that "inevitably call to mind the Zen portrait tradition as represented by Bunsei's portrait of *Yuima*" (*Through Closed Doors*, p. 162). Other scholars have noted resemblances to eighteenth-century Chinese portraits. But

none of these works possesses the intensity and precision of Kazan's portrait of Issai.

18. Several versions of the portrait, including the third, fourth, fifth, and sixth, long disappeared, have resurfaced in recent years, but the first version is still missing. Versions 3 to 7 are reproduced in Kyōto kokuritsu hakubutsukan, ed., *Nihon no shōzō*, p. 189.

19. Kazan mentioned in the second entry of *Gūgadō nikki*, his 1815 diary, that he had "seen" a barbarian book (*bansho*), an indication that his interest in the West had at least germinated by that time (*Watanabe Kazan shū*, vol. 1, p. 6). It is possible that Kazan had seen eighteenth-century Chinese portraits, but he does not mention any, and their realism is flat and undramatic.

20. The drawing is reproduced in *Kazan meisaku shū*, illustration 82. Jeanne d'Arc looks like a seventeenth-century lady of good family; only the sword in her right hand suggests her martial exploits.

21. The copy, dated 1832, is reproduced in Suzuki Susumu and Ozaki Masaaki, *Watanabe Kazan*, illustration 72. Kazan wrote in *katakana* above Edward Bright's portrait an approximation of the Dutch pronunciation of the name: *buriguto*.

22. His portrait is dated 1831. Doubts about the date were expressed by Yoshizawa, who favored 1840 (*Watanabe Kazan*, p. 193), the year that is now generally accepted. Among the many Japanese portraits of Hippocrates, one painted by Ishikawa Tairō in 1799 is credited with having started the vogue for these portraits. Painting Hippocrates may have been the way that Japanese men of science expressed their yearning for scientific information from abroad.

23. Miyajima, *Shōzōga*, p. 10. The absence of background in *ukiyoe* prints influenced Manet and later Impressionist artists.

24. Suganuma Teizō relates his discovery of an anonymous manuscript about Tachihara Suiken which states that Kazan attended Suiken's funeral and at that time was asked by Tachihara Kyōsho to paint his father's portrait (*Watanabe Kazan: Hito to geijutsu*, p. 210). The portrait was destroyed during the 1923 earthquake. A similar version of the portrait is in the Metropolitan Museum of Art. It is dated 1838 and, according to the information on the box, was painted by Kazan at the request of Nakajima Kaemon, a Tahara samurai. He was the judge who was kind to Kazan during his trial, suggesting that the painting was later than 1838.

25. Kazan's portrait of Fujiwara Seika and several preliminary sketches are reproduced in Suganuma Teizō, *Watanabe Kazan*, p. 42.

26. Four versions of the portrait are reproduced in Hibino Hideo, *Watanabe Kazan*, pp. 150–151; a fifth is in Suganuma, *Watanabe Kazan*, p. 43, where the account of Kazan's weeping as he painted also can be found. For a brief account of the filial piety that Kazan showed at the time of his father's death, see Miyake, "Kazan sensei ryakuden," p. 315.

27. Quoted in Okado Kazuyuki, "Watanabe Kazan," p. 20. The camera obscura was first described to Japanese readers by Ōtsuki Gentaku in *Oranda benwaku*, originally published in 1799.

28. Okado, "Watanabe Kazan," p. 20. Many copies were made of the portrait of Ōzora Buzaemon. That in the Cleveland Museum of Art is probably one of the two originals. Kazan used the same techniques in making the portrait of Bakin's son Kinrei in his coffin. See Bakin, *Kyokutei ikō*, p. 126.

29. Okado, "Watanabe Kazan," p. 24.

4. *Travels and Career*

1. Donald Keene, *Travelers of a Hundred Ages*, pp. 325–327.

2. Some of the sketches made on the journey are reproduced in *Watanabe Kazan to sono shiyō ten*, p. 41.

3. Yoshizawa Tadashi, *Watanabe Kazan*, p. 25.

4. *Shisōroku* was a more polished version of the same account. The *shi* in the title indicates that Kazan was sent on a "mission," but its nature is not disclosed. Probably it was to help prepare Kitsusaburō, the younger brother of the ailing daimyo of Tahara, to succeed him. When Kitsusaburō became daimyo in 1823, he took the name Miyake Yasuteru. See *Watanabe Kazan shū*, vol. 1, p. 101.

5. I am making a distinction between *nikki* (a diary) and *kikō* (a travel account), although Kazan himself did not clearly distinguish between the two. Kazan's later travel accounts are written mainly in Japanese, but *Yūsōki* and the revised version, *Shisōroku*, are in *kanbun*.

6. An excellent introduction to Kazan's travel accounts is in Haga Tōru, *Watanabe Kazan*.

7. *Shisōroku*, in *Watanabe Kazan shū*, vol. 1, p. 131. Uraga and the Miura Peninsula are at the entrance to Edo Bay. No doubt Kazan feared that American ships might intrude into the bay, as in fact happened in 1853. *Yūsōki* (p. 114) does not contain the shout of joy.

8. The four provinces he visited were Kazusa, Shimōsa, Hitachi, and Musashi. The area corresponds roughly to the present Chiba, Tochigi, Saitama, and Tōkyō prefectures.

9. Haga gives the dimensions as thirteen centimeters in height and between twenty and forty centimeters in width (*Watanabe Kazan*, p. 39). I have consulted the special issue of *Kobijutsu* (no. 48, June 1975) devoted to *Shishū shinkei*, which gives photographs of all thirty landscapes, some in color, with a little information. Unfortunately, neither the photographs nor the pages are numbered, and this makes it difficult to give references. The standard edition of Kazan's works (*Watanabe Kazan shū*) gives, without explanation, fuzzy photographs of twelve of the illustrations.

10. Haga, *Watanabe Kazan*, p. 58. Based on an entry of 1840 in a diary kept by Kazan, some scholars believe that he colored in the sketches at that time, but Haga was convinced that the entry referred to only minor touches. The coloring of the whole is so fresh and vivid that he could not imagine Kazan adding it fifteen years later.

11. Haga suggested that the older girl might be a *kamuro*, a kind of maid to a courtesan (*Watanabe Kazan*, p. 84).

12. See the fuller description in Haga, *Watanabe Kazan*, p. 84.

13. For example, his flower-and-bird *Meika jūyū* (*The Ten Celebrated Flowers*) of 1826, reproduced in Suzuki Susumu and Ozaki Masaaki, *Watanabe Kazan*, plate 27. Ozaki, although expressing admiration for the work (classed as an Important Work of Art), noted certain weaknesses that Kazan may have derived from the Qing painter Yun Nantian, one of the major *bunjinga* painters of the period (p. 133). It is not an exciting work.

14. *Kikyō nichiroku*, in *Watanabe Kazan shū*, vol. 1, pp. 182–187. The illustrations, though, have been omitted.

15. The preceding recounting of the machinations of the Tahara Domain leaders is derived from Satō Shōsuke, *Watanabe Kazan*, p. 41.

16. *Watanabe Kazan shū*, vol. 7, p. 125. His new rank was *goyōjin chūgoshō shihai*.

17. This proverbial saying is used to mean that one does not know one's own limitations. Han was a master craftsman, but a rival, not realizing this, boastfully swung his axe outside Han's gate.

18. Quoted in Satō, *Watanabe Kazan*, p. 42.

19. Ibid., pp. 42–43. The original poem is written in *kanbun*, as is the letter. Plum blossoms were often used as a symbol for the scholar.

20. One was lost in a fire, but a photograph survives. The two full-length portraits are reproduced in Suganuma Teizō, *Watanabe Kazan: Hito to geijutsu*, pp. 72–73.

21. The sketches are murkily reproduced in *Watanabe Kazan shū*, vol. 1, pp. 212–247.

22. A *sōshaban* is a kind of herald who took part in ceremonies at the shogun's palace.
23. Kazan wrote a letter in 1832 in which he frankly discussed Miyake Yasunao's faults (*Watanabe Kazan shū*, vol. 3, pp. 39–43). He was (1) impetuous, (2) self-centered, and (3) vain.
24. Kazan, *Zenrakudō nichiroku*, in Suzuki Seisetsu, ed., *Kazan zenshū*, p. 295.
25. *Watanabe Kazan shū*, vol. 1, p. 299. See also Satō, *Watanabe Kazan*, p. 55.
26. Kawasumi Matsujirō, a *toshiyori* (elder) of Tahara Domain.
27. Kazan, *Zenrakudō nichiroku*, p. 264. See also Sato, *Watanabe Kazan*, p. 52.
28. Letter to Suzuki Shunsan, in *Watanabe Kazan shū*, vol. 3, pp. 107–108. The letter lacks a date and an addressee, but there is reason to believe that it was written in 1833. See also Satō, *Watanabe Kazan*, p. 53.

5. *The Early 1830s*

1. An *uchideshi* is a student who lives in the teacher's house and is thus provided with food and shelter.
2. For a brief account of Yoshida Chōshuku's accomplishments, see Imaizumi Genkichi, *Rangaku no ie Katsuragawa no hitobito*, vol. 2, pp. 481–484.
3. I have derived the preceding biographical material on Takano Chōei mainly from Takano Chōun, *Takano Chōei den*, pp. 62–77.
4. Takano quotes the letters that Chōei wrote to his father relating his concern in *Takano*, pp. 88, 150.
5. Numata Jirō, *Yōgakushi denrai no rekishi*, p. 136. After Holland was occupied by France, the British (the enemies of France) retaliated by sending a fleet to seize Java from the Dutch. The British also intended to take Deshima, but the island survived the threat and for a time was the only place in the world where the Dutch flag flew. Java was returned to the Dutch in 1817 as the result of a treaty between England and Holland signed in 1814.
6. Satō Shōsuke, *Takano Chōei*, p. 27.
7. Takano, *Takano*, pp. 158–159.
8. Ibid., p. 170.
9. Miyake Tomonobu, "Kazan sensei ryakuden," p. 322.
10. Ibid. See also Satō Shōsuke, *Yōgakushi no kenkyū*, p. 163.
11. Haga Tōru, *Watanabe Kazan*, p. 103.
12. The meaning of the title is something like "Excursion to Sagami Diary." *Yūsō nikki*, in *Watanabe Kazan shū*, vol. 1, pp. 320–347. See also Takumi

Hideo, *Nihon no kindai bijutsu to bakumatsu*, pp. 64–89. The contents are effectively related in Haga, *Watanabe Kazan*, pp. 98–149.

13. Haga, *Watanabe Kazan*, p. 115. I have benefited from Haga's excellent account of Kazan and Takagi Goan's journey.

14. The sixteen sketches that Kazan made during the journey are reproduced, very much reduced in size, in Takumi, *Nihon no kindai bijutsu to bakumatsu*, pp. 90–93.

15. Kazan, *Yūsō nikki*, pp. 327–328.

16. Ibid., p. 329.

17. Ibid., p. 330. The residence of Tahara Domain, where O-gin had served as a concubine to the former daimyo, was situated in Kōji-machi.

18. Kazan later learned from O-gin's husband that he had gone to visit an aunt who was seriously ill (*Yūsō nikki*, p. 338).

19. Kazan, *Yūsō nikki*, p. 331.

20. The sketch is reproduced in Haga, *Watanabe Kazan*, p. 131.

21. Kazan did not indicate who talked about the future and the past (whether O-gin, the old man, Kazan, or all three) or who wept. I have been obliged by English usage to supply subjects for the verbs.

22. She had four children, the youngest still an infant. O-gin died in 1862, long after Kazan.

23. Kazan, *Yūsō nikki*, p. 337.

24. Ibid., pp. 337–338.

25. Ibid., p. 332. He refers to two guests, Uchidaya and Megusuriya, by the names of their shops.

26. The sketch is reproduced in Haga, *Watanabe Kazan*, p. 141.

27. Kazan, *Yūsō nikki*, p. 339.

28. Ibid., pp. 334–335.

29. Ibid., pp. 336–337.

30. The portrait sketch is reproduced in ibid., p. 335. The man's name was actually Ishii Hikohachi; Surugaya was the name of his shop. He was the headman (*nanushi*) of Sakai Village.

6. *Foreign Influence and Major Portraits*

1. Watanabe Kazan, "Gekizetsu wakumon jo," in Satō Shōsuke, ed., *Watanabe Kazan, Takano Choei, Sakuma Shozen*, p. 78.

2. The meeting of Kazan and Yoshida Chōshuku is mentioned in *Gūgadō nikki*, entry for the nineteenth day of the first month of 1815 (February

27, 1815) (*Watanabe Kazan shū*, vol. 1, p. 7). Chōshuku appears as Yoshida Kukoku in the diary. Kazan met Chōshuku ten times in 1815.

3. He is actually labeled Watanabe Nobori, the name Kazan most often used for himself. Nobori was a dialectical pronunciation of Noboru; it is hard to be sure which pronunciation was intended. The shaven-headed samurai to his right is labeled Kōno Ryōan, probably the Kone Roan mentioned in *Japans Dagh Register*, pp. 48–49. Two other Japanese in the picture are identified as the son of Naruse Hayato and his retainer. See Suganuma Teizō, *Watanabe Kazan: Hito to geijutsu*, p. 211. The interpreters on this occasion were probably Iwase Yajūrō, his son Yashichirō, and Nomura Hachizō. Both Iwase Yajūrō and Iwase Yashichirō feature prominently in Katagiri Kazuo, *Oranda tsūshi no kenkyō*.

 This seems to have been a gathering of "second-tier" participants, both Japanese and Dutch, The "first tier" was represented on the Japanese side by Katsuragawa Hoken (1797–1844), a major scholar of Dutch learning, and, on the Dutch side, by the celebrated Philipp Franz von Siebold. See Imaizumi Genkichi, *Rangaku no ie Katsuragawa no hitobito*, vol. 2, p. 220.

4. The account of Heinrich Bürger in Imaizumi, *Rangaku no ie*, vol. 2, pp. 226–227, is laudatory throughout, and Bürger's serious interest in Japan is suggested by the chronicle of Japan he compiled. See Itazawa Takeo, *Shiboruto*, p. 163. He was certainly well educated in the sciences, but most Japanese who wrote about him had something unpleasant to say about his character. We are told that Bürger had a child by a prostitute named Tsune, the elder sister of Siebold's mistress Taki. According to what Kazan heard, Bürger had an English wife, but, according to Numata Jirō and others, he also had a Dutch wife. Satō Shōsuke discounted most of the rumors in *Watanabe Kazan*, pp. 161–163.

5. Eliza Morrison, *Memoirs of the Life and Labours of Robert Morrison, D.D. by His Widow*, vol. 1, p. 412.

6. Ibid.

7. Sugimoto Tsutomu, *Koseki San'ei den*, p. 337. This copy of the dictionary finally found its way into the hands of Koseki San'ei, who quoted it nine times (p. 339).

8. Watanabe Kazan, "Shinkiron," in Satō Shōsuke, ed., *Kazan, Chōei ronshū*, p. 35.

9. Better known as Kondō Morishige (1771–1829), Kondō Seisai was a geographer, a bibliographer, and an explorer of the Kurile Islands. A brief biography is given in Nichiran gakkai, ed., *Yōgakushi jiten*, pp. 284–285.

10. *Watanabe Kazan shū*, vol. 1, pp. 251–252.

11. Sidotti prepared himself for a stay in Japan by studying Japanese for four years with a Japanese resident of the Philippines. Before landing in Japan (from a Filipino ship), he disguised himself as a samurai, wearing Japanese attire and carrying two swords. Despite the disguise, he was immediately detected as a foreigner and arrested. He was sent to Edo, where the Confucian philosopher Arai Hakuseki interrogated him in 1709/1710. He died in captivity.

12. Katsuragawa Hoken, a high-ranking bakufu physician, studied *rangaku* with Ōtsuki Gentaku.

13. *Watanabe Kazan shū*, vol. 1, p. 257.

14. Ibid., p. 258.

15. The Dutch translation, *De Natuurlijke Historie der Insecten*, was published in 1764–1768.

16. *Watanabe Kazan shū*, vol. 1, p. 259.

17. Kazan's knowledge of Dutch and of the West in general is the subject of Iwasaki Katsumi, "Kazan to yōgaku."

18. *Watanabe Kazan shū*, vol. 3, p. 283. See also Satō Shōsuke, "Keiseika Kazan to kagakusha Chōei," p. 60. Murakami Sadahira (1808–1872) was a Tahara Domain samurai and a close friend of Kazan's, who became a specialist in Western-style gunnery. I have translated *gochō* as "corporal," its modern meaning, but at the time it meant merely the leader of five soldiers.

19. Miyake Tomonobu, "Kazan sensei ryakuden," p. 320.

20. I have been unable to trace this man. Perhaps Miyake Tomonobu, thinking of Hatazaki Kanae, inadvertently created a new name.

21. Miyake, "Kazan sensei ryakuden," pp. 319–320.

22. Shibata Mitsuhiko and Kanda Masayuki, eds., *Bakin shokan shūsei*, vol. 1, p. 27. Takizawa Bakin does not give Kazan's name, but the person (*jin*) he mentions was undoubtedly Kazan.

23. The original Dutch painting, by Willem Frederik van Royen (1654–1723), was presented in 1729 to Shogun Yoshimune. It was copied by Ishikawa Tairō and his brother Mōkō (Taketaka) in 1796 and later by Tani Bunchō. These two copies are reproduced in Ono Tadashige, *Edo no yōgakka*, illustrations 84 and 86. Bunchō's painting is in Calvin L. French, *Through Closed Doors*, p. xxii. French suggested that Bunchō may have copied the Ishikawas' copy rather than the original (p. 165). It is more than seven feet high.

24. The pioneering (unsigned) study of the portrait compared different stages of the portrait of Satō Issai (*Kokka* 484 [1931]: 81–82). The author

believed that the version reproduced in the same issue of *Kokka* was the best of the many painted over the years and that the portrait of Issai was Kazan's finest. Yoshizawa Tadashi, however, was sure that "no one could fail to recognize the progress" from the portrait of Issai to Kazan's later portraits (*Watanabe Kazan*, p. 100).

25. Two sketches are reproduced in *Tsubaki Chinzan ten*, p. 86; they also are in Satō Shōsuke, ed., *Watanabe Kazan, Takano Chōei*, p. 47. Ozawa Kōichi, who wrote this section of the Tsubaki Chinzan catalogue, believes that the sketches date to 1844 or thereabouts. Taka, who was presumably in her late thirties, looks older. Her suffering, especially while her husband languished in prison, may have aged her. Kazan sketched his two sons (Yoshizawa, *Watanabe Kazan*, pp. 110–111), but not his daughter. Kazan was not a misogynist—he certainly revered his mother—but the absence of any portraits of his wife and daughter is disappointing. It probably was due to Confucian prejudices against women rather than from lack of affection.

26. Takizawa Bakin's description of how he came to ask Kazan to paint the portrait is in *Kyokutei ikō*, p. 126. Kazan could not come at once because of urgent domain business. Kinrei lived from 1797 to 1835.

27. Bakin, *Kyokutei ikō*, p. 126.

28. For an illustrated account of the portraits of emperors of the Tokugawa period (and Emperor Meiji), see Kuroda Hideo, *Ō no shintai, ō no shōzō*, pp. 276–322.

29. Moto had married Iwamoto Mohei; Kō was his mother. After her husband's death, she herself managed the family business (silk wholesalers).

30. The Dutch word *dapper* means "brave," rather than "smartly dressed." A letter from Katsuragawa Hoken to "Dapperu sama," probably written in 1827, was signed Botanicus. See Itō Tasaburō, "Takami Senseki to rangaku," in *Kinseishi no kenkyū*, vol. 2, p. 308.

31. Itō, "Takami Senseki," p. 303.

32. Ibid., p. 307.

33. For a discussion of the resemblances (and lack of resemblances) between the two portraits, see Hibino Hideo, *Watanabe Kazan*, p. 172.

34. The three calligraphers were Ichikawa Beian (1779–1858), Maki Ryōko (1777–1843), and Nukina Kaioku (1778–1863). For an account of Beian, see John M. Rosenfield, *Extraordinary Persons*, vol. 3, pp. 28–29.

35. Miyake, "Kazan sensei ryakuden," p. 319.

36. Hatazaki Kanae (1807–1842) began his career as a servant on Deshima and is said to have picked up Dutch from Siebold. He was imprisoned on the charge of having stolen the cloak with the crest of the Tokugawa family that was discovered in the possession of the *opperhoofd* Johan Willem de Sturler. He escaped and, changing his name, found employment as a teacher of *rangaku* in Mito Domain. His knowledge of Dutch was reputed to rank with that of Chōei and San'ei. When he was again arrested in 1837, Kazan traveled in the snow to Shinagawa to say goodbye. Events of Hatazaki's life are related in Itō, *Kinseishi no kenkyū*, vol. 2, pp. 283–297.

37. Miyake, "Kazan sensei ryakuden," p. 319.

7. *The Meeting of East and West*

1. This information is derived from Sakai Shizu, "Nagasaki rankanchō Johann Erdewin Niemann ni tsuite," which gives the years of Niemann's movements and promotions after leaving Holland in 1818 on p. 1.

2. Niemann's position on July 23, 1833, was given as *ambtenaar* (official). See Katagiri Kazuo, *Oranda tsūji no kenkyū*, p. 64.

3. Kazan used the Dutch term *algemene aardrijkskunde*.

4. The text says seven *shaku*, three *sun*, which is slightly more than seven feet, three inches.

5. Watanabe Kazan, "Gekizetsu shōki," in Satō Shōsuke, ed., *Kazan, Choei ronshū*, p. 10.

6. Almost every *nenpyō* I have looked at has some variation on the statement that Kazan had engaged in a question-and-answer session with Niemann (*Oranda no shisetsu kapitan Niemann to mondō suru*).

7. This passage occurs toward the end of the preface to Watanabe Kazan, "Gekizetsu wakumon," in Satō, *Kazan, Chōei ronshū*, pp. 16–17. A translation into modern Japanese is in Satō Shōsuke, ed., *Watanabe Kazan, Takano Chōei*, p. 98.

8. Kazan, "Gekizetsu wakumon," pp. 13–14.

9. Kazan, "Gekizetsu shōki," p. 11.

10. Ibid. The "general" refers to the head of the East India Company, a title that was retained after the Dutch government took over the company.

11. Kazan, "Gekizetsu shōki," p. 12. See also Satō Shōsuke, *Watanabe Kazan*, p. 127.

12. Kazan, "Gekizetsu wakumon," p. 25.

13. Ibid., p. 26.

14. Satō, *Watanabe Kazan*, p. 132.
15. Kazan, "Gekizetsu wakumon," p. 18.
16. Ibid., p. 26.
17. Ibid., pp. 31–32.
18. By the "kingdom of God," theology is probably meant. The "kingdom of man" probably refers to the sciences. The third kind of learning, *kunst*, usually means "art," but a Japanese might have equated it with *gei*, which at present means "art," but in Kazan's time would have meant "technical skill."
19. Kazan, "Gekizetsu wakumon," p. 20.
20. Especially in "Shinkiron" (Exercising Restraint over Auguries), written later that year. See also Satō, *Watanabe Kazan*, pp. 126–127. Remembering Niemann's remarks about the size of the escort accompanying important people, Kazan pointed out in the later work that the king of France had only twenty-five people escorting him. Echoing Niemann, Kazan declared that the large numbers in a Japanese procession were solely for show and served no useful purpose.
21. Miyake Tomonobu, "Kazan sensei ryakuden," p. 321. Other accounts state that Koseki San'ei thought that his frail body would not be able to endure prison life or, alternatively, that he feared that the punishment he would receive for his crime would extend to his whole family if he did not commit suicide. San'ei's real reason cannot now be ascertained, but Tomonobu may have been correct.
22. Iwasaki Katsumi, who studied the books that Kazan had owned and that now are in the National Library, was sure that Kazan had borrowed a Chinese translation of the Old Testament from Tomonobu and had asked San'ei for pronunciations ("Kazan to yōgaku"). This opinion was supported by Itō Tasaburō, who claimed that the Old Testament was one of forty-six books that Hatazaki Kanae had left with Kazan. But Iwasaki Tesshi argued that Itō had misread the characters on the library deposit slip and that the book in question was not the Old Testament. Besides, Robert Morrison did not use the term *kyūyaku* in his translation of the Old Testament. See Satō, *Watanabe Kazan*, pp. 91–92. In any case, if San'ei was in fact translating a Christian text, it was more likely the New Testament than the Old Testament.
23. Yoshizawa Tadashi, *Watanabe Kazan*, pp. 89–90.
24. The title of the painting, *Kōshozu*, means literally "picture of [someone] correcting a manuscript." This was an allusion to a Chinese story of a

female entertainer who was literarily talented and corrected manuscripts in her spare time. Here, it is simply an elegant way of saying "picture of a geisha." The geisha's name is not given on the painting, but scholars feel reasonably sure of the identification.

25. Hibino Hideo, *Watanabe Kazan*, p. 177.
26. For a partial translation, see chapter 2. A complete translation of the inscription into Japanese is in Suganuma Teizō, *Watanabe Kazan*, p. 228.
27. Hirai Kensai (1802–1856) became a master forger of Kazan's works. See Tsukiyama Terumoto, *Watanabe Kazan no gyakugansaku kō*, pp. 78–83. Reproductions of works by Kensai are in *Kanzō meihin sen*, vol. 1, pp. 98, 104–107.
28. A translation of the inscription into modern Japanese is in *Kazan meisaku shū*, p. 127.

8. *Danger from Overseas*

1. Satō Shōsuke, *Watanabe Kazan*, p. 79.
2. A translation of the letter is in Donald Keene, *The Japanese Discovery of Europe*, p. 34.
3. Kudō Heisuke, *Aka Ezo fūsetsu kō*, p. 218.
4. Ibid., p. 217.
5. John Whitney Hall, *Tanuma Okitsugu*, p. 103.
6. A translation of Satō Genrokurō's *Ezo shūi* into modern Japanese is Inoue Takaaki, *Aka Ezo fūsetsu kō*, which includes the original illustrations.
7. It is noteworthy that Hayashi Shihei, like Kudō Heisuke and various Japanese before him, considered Ezo to be a foreign country. See Hall, *Tanuma Okitsugu*, p. 166.
 Sangoku tsūran zusetsu was the first Japanese book translated into a European language, by Julius Klaproth into French in 1832. For more on Klaproth, see P. F. Kornicki, "Julius Klaproth and His Works."
8. Hayashi Shihei, *Kaikoku heidan*, p. 7, translated in Keene, *Japanese Discovery of Europe*, pp. 39–40.
9. Hara Zen, ed., *Sentetsu sōdan*, Kanbun sōsho (Tōkyō: Yūhōdō, 1929), pp. 124–125, translated in Ryusaku Tsunoda, Wm. Theodore de Bary, and Donald Keene, eds., *Sources of Japanese Tradition*, pp. 369–370.
10. In 1792 the ship *Ekaterina*, commanded by Lieutenant Adam Laxman, arrived in Nemuro with three Japanese castaways aboard and a request to open trade. Following a precedent set in 1725, when a Cambodian ship had arrived and made a similar request, Matsudaira Sadanobu informed

Laxman that he would have to negotiate in Nagasaki, the only port open to foreign ships. Laxman was given a document permitting him to enter the port of Nagasaki. Interpreting this document as an authorization of trade in Nagasaki, Rezanov asked in 1804 for additional ports to be opened. See Kagawa Takayuki, *Kuzureyuku sakoku*, p. 213.

11. Shiba Kōkan, *Shunparō hikki*, p. 62.

12. Kagawa, *Kuzureyuku sakoku*, pp. 213–214.

13. Satō Shōsuke, *Yōgakushi no kenkyū*, p. 155.

14. The name Bonin comes from the Japanese *bunin*, meaning "uninhabited." The Japanese have usually called the islands Ogasawara after Ogasawara Sadayori, who supposedly discovered them in 1593. In 1675 the bakufu, referring to them as the Bunin Islands, declared that they belonged to Japan. They remained uninhabited until 1830.

15. W. G. Beasley, *Great Britain and the Opening of Japan*, p. 19.

16. Quoted in ibid., p. 15.

17. Also known as Karl Friederich Augustus Gützlaff (1803–1851), Charles Gutzlaff was born a German but took British citizenship. At this time, he worked as an interpreter of Chinese for the British trade commissioners in Macao.

18. Satō, *Watanabe Kazan*, p. 148. Satō believed that the report originated in the October 5, 1837, edition of the *Singapore Free Press*.

19. Kazan named a man called Wolff as the source of this rumor in "Gaikoku jijō shō" (Conditions in Foreign Countries, 1839), in Satō Shōsuke, ed., *Kazan, Chōei ronshū*, p. 73. Wolff is identified as J. W. Wolff, a member of the Deshima trading station who arrived in Japan in 1837, in Satō Shōsuke, ed., *Watanabe Kazan, Takano Chōei, Sakuma Shōzan*, p. 31.

20. Satō, *Watanabe Kazan*, p. 153. The official was the *daikan* Hagura Yōkyū.

21. Satō, *Watanabe Kazan*, p. 147. In the sixth month of 1838, when the annual Dutch ship arrived in Nagasaki, it brought secret documents concerning the *Morrison*. The outgoing and incoming *opperhoofd*, Johannes Niemann and Edouard Grandisson, presented these documents to the Nagasaki magistrate. The reports described the travels of the two groups of castaways to Macao and declared that the purpose of returning them was to ask for trade. They also mentioned that the *Morrison* had been hit by Japanese gunfire the year before.

22. Watanabe Kazan, "Shinkiron," in Satō, *Kazan, Chōei ronshū*, p. 34.

23. Kazan could also have heard of Robert Morrison's dictionary from Takano Chōei. Chōei had studied in Nagasaki with the interpreter

Yoshio Gonnosuke, who owned a section of Morrison's dictionary. See Satō, *Watanabe Kazan*, p. 158.

24. This seems to be Kazan's evaluation of Haga Ichisaburō!

25. Kazan, "Shinkiron," p. 34. See also Satō, *Watanabe Kazan, Takano Chōei, Sakuma Shōzan*, p. 66. Kazan made similar statements about Morrison in other writings.

26. Admiral Ivan Fyodorovich Krusenstern (1770–1846) was the captain of the *Nadezhda*, the ship aboard which Ambassador Rezanov traveled to Nagasaki. He wrote a book describing his travels between 1803 and 1806, notably to Japan, Kamchatka, and Alaska. The work was translated into many languages, including Dutch. The English translation, *Voyage Round the World*, was published in London in 1813.

27. Admiral Vasilij Mikhajlovich Golovnin (1776–1831) was captured by the Japanese in 1811 while surveying the southern Kurile Islands. He was kept in confinement until 1813 by way of taking revenge for the depredations committed in the Kuriles and on Sakhalin by Russian marines under the command of Nikolai Khvostov and Gariil Davydov. Golovnin wrote an account of his imprisonment. The English translation, which gave his name as Golownin, is *Narrative of My Captivity in Japan, During the Years 1811, 1812, 1813*.

28. Kazan, "Shinkiron," p. 36.

29. The distinction being made by Kazan is between secular and religious authority. The word *shi*, translated here as "bishop" in order to suggest superior status within the priesthood, is more commonly used for "teacher."

30. These opinions obviously reflect what Niemann told the Japanese about the Dutch educational system. See Kazan, "Shinkiron," p. 37. See also Satō, *Watanabe Kazan, Takano Chōei, Sakuma Shōzan*, p. 69.

31. Chikamatsu Monzaemon, "The Uprooted Pine," in Donald Keene, trans., *Major Plays of Chikamatsu*, p. 332.

32. As his source of information on the sinister plans of Russia, Kazan mentioned a statement made by Midshipman F. F. Mur, who was captured together with Golovnin in the Kuriles. Mur was eager to collaborate with his Japanese captors, according to Golownin, *Narrative*, p. 253. Golovnin also mentioned that interpreters had told him that "the Dutch boasted of having succeeded in imbuing the Japanese with an irreconcilable hatred towards the Russians" (p. 241).

33. Kazan, "Shinkiron," p. 40.

9. *The Road to Prison*

1. This anecdote, together with the claim that it marked the beginning of the persecution of Kazan and his friends known as Bansha no goku, appears in Akai Tōkai, "Dakkō hiji," p. 291. Akai Tōkai (1787–1862) was a Confucian scholar of the Hayashi school and a member of Kazan's "salon."

2. Takano Chōun, *Takano Chōei den*, p. 402. The statement is in Takano Chōei's essay "Tori no nakune" (The Singing of Birds).

3. One member of the Polish army who managed to escape from Kamchatka was Baron Moritz von Benyowsky. See chapter 8.

4. Satō Shōsuke, *Watanabe Kazan*, p. 168. For the statement in Kazan's "Saikō seiyō jijō sho" that the Russian government had promised Polish prisoners who performed outstanding work in the pacification of the "Ezo region" that they would be permitted to send for their wives, see Satō Shōsuke, ed., *Kazan, Chōei ronshū*, pp. 87–88.

5. Two works of geography that Kazan owned are discussed in Kaikoku hyakunen bunka jigyōkai, ed., *Sakoku jidai nihonjin no kaigai chishiki*, pp. 106, 112–113. One (*Shin'yaku yochi zusetsu*) was copied in his hand, but the translator is not known. The other, *Shin'yaku chishi*, was translated by Koseki San'ei in 1836, possibly at Kazan's request.

 Two Dutch works of geography figured prominently in Kazan's writings. One was P. J. Prinsen, *Geographische oefingen, of leerboek der aardrijkskunde* (1817). The translation of this work intended for the general reader was familiarly known to *rangakusha* as *Ryakushi*. J. van Wijk Roelandszoon, *Algemeen aardrijkskundig woordenboek* (1821–1826), was more specialized. Kazan wrote that he had acquired Roelandszoon's work with the help of San'ei and that he had it translated by Chōei. Another work that Kazan frequently quoted was Gerrit Nieuwenhuis, *Algemeen woordenboek van kunsten en wetenschappen* (8 vols., 1820–1829).

 For more details, see Satō Shōsuke, *Yōgakushi no kenkyū*, pp. 179–189. For mention of Dutch works translated by San'ei, see Grant K. Goodman, *Japan and the Dutch*, p. 161.

6. This and the preceding quote are from Kazan, "Saikō seiyō jijō sho," pp. 86–87.

7. Ibid., p. 88. I also consulted the translation into modern Japanese in Satō Shōsuke, ed., *Watanabe Kazan, Takano Chōei*, p. 125.

8. Kazan, "Saikō seiyō jijō sho," p. 89.

9. Honda Toshiaki, *Seiiki monogatari*, translated in Donald Keene, *The Japanese Discovery of Europe*, p. 211. When Honda spoke of profit, he may have been thinking of such practices as the head of a school (*iemoto*) charging a high fee in return for deigning to show a pupil one section of a scroll of secret teachings.

10. Egawa Hidetatsu, more commonly known as Tarōzaemon, was the *daikan* (chief magistrate) of Nirayama in Izu. The reverberatory furnace he built for manufacturing heavy artillery still stands.

11. A *metsuke* was a high-ranking officer charged with watching over other senior officials to make sure they did not deviate from approved behavior. On occasion, a *metsuke* might denounce senior officials to the shogun. A *honmaru* (keep of the castle) *metsuke* was one of the bakufu's highest-ranking officials. For an account of Torii Yōzō's actions as a *metsuke*, see Kitajima Masamoto, *Mizuno Tadakuni*, p. 239. See also Matsuoka Hideo, *Torii Yōzō*, p. 62.

12. Kitajima, *Mizuno Tadakuni*, p. 239.

13. Matsuoka, *Torii Yōzō*, p. 65.

14. Watanabe Kazan, "Shokoku kenchi sōzu," in Satō, *Kazan, Chōei ronshū*, p. 55.

15. Matsuoka, *Torii Yōzō*, p. 67.

16. Its full title, seldom used, is *Bojutsu yume monogatari* (*Tale of a Dream in 1838*). A translation by D. C. Greene is in *Transactions of the Asiatic Society of Japan* 40, no. 3 (1913).

17. Correcting *Yume monogatari*, Kazan wrote: "Although the country lies between 50 and 60 degrees of latitude, the climate is mild. The country produces wheat, barley, apples, and pears. The English also make a good deal of beer and pear wine, which they export.... A Dutchman said that the reason why the population is small is that they send so many people abroad" ("Kazan shuchū *Bojutsu monogatari*," in Satō, *Kazan, Chōei ronshū*, p. 200).

18. I have used the text of *Bojutsu yume monogatari* in Satō Shōsuke, ed., *Watanabe Kazan, Takano Chōei, Sakuma Shōzan*, pp. 165–169.

19. Quoted in Satō, *Watanabe Kazan*, pp. 222–223.

20. Satō, *Watanabe Kazan*, p. 230.

21. Matsuoka, *Torii Yōzō*, pp. 67–68. The priests' petition to go to the Bonin Islands was refused.

22. For these and other charges brought by Torii against Kazan, see Satō Shōsuke, *Yōgakushi kenkyū josetsu*, pp. 285–287; and Satō, *Watanabe Kazan*, pp. 231–234.

23. This explanation of how Hanai Koichi happened to see "Gekizetsu shōki" and "Gekizetsu wakumon," manuscripts that Kazan had shown to no one else, was given by Kazan in "Kita machibugyōsho kōsho," his deposition made at the North Magistrate's Office (*Watanabe Kazan shū*, vol. 4, pp. 305–306).

24. This was the *kita machibugyōsho*, or "North Magistrate's Office." North and south "town magistrates" alternately presided over cases.

25. Watanabe Kazan, "Kyakuzaroku," in Suzuki Seisetsu, ed., *Kazan zenshū*, p. 678. The informant was Odagiri Yōsuke, a secretary of Mizuno Tadakuni. He warned Kazan on June 16, 1839.

26. Letter to Suzuki Shunsan, in *Watanabe Kazan shū*, vol. 4, p. 35.

27. For the names of those arrested and those merely suspected, see Haga Noboru, *Bansha no goku*, pp. 170–174.

28. Letter to Tsubaki Chinzan, June 30, 1839, in *Watanabe Kazan shū*, vol. 4, p. 25.

29. Letter, July 3, 1839, in *Watanabe Kazan shū*, vol. 4, p. 27.

30. Letter to Tsubaki Chinzan, in *Watanabe Kazan shū*, vol. 4, p. 31.

31. The letter was sent to Kodera Ichirōemon, a *yōnin* (secretarial assistant) of Tahara Domain with whom Kazan had been close since boyhood. Kazan's family stayed with Kodera while he was in prison.

32. Letter to Kodera, in *Watanabe Kazan shū*, vol. 4, p. 39. Mention of a "hot-spring cure" is, of course, ironic. In hopes of reassuring his mother, Kazan says that apart from the crowded conditions in his cell, prison life is actually enjoyable, like a vacation at a hot-spring resort.

33. Letter to Tsubaki Chinzan, in *Watanabe Kazan shū*, vol. 4, p. 47. *Waraji* were straw sandals worn mainly while traveling.

34. Haga, *Bansha no goku*, p. 178.

35. Ibid., p. 167. Chōei was imprisoned, but in 1844 managed to escape, taking advantage of a fire in the prison. He wandered around the country for the next six years, helped by people wherever he went. In 1850, surrounded by bakufu police, he committed suicide.

36. This was considerably better than the conditions under which non-samurai were incarcerated. According to Kazan, six men would have to share the same *jō*. See Satō, *Watanabe Kazan*, p. 268.

37. Satō, *Watanabe Kazan*, p. 268. See also Haga, *Bansha no goku*, pp. 180–181.

38. Letter to Tsubaki Chinzan, June 19, 1839, in *Watanabe Kazan shū*, vol. 4, p. 25.

39. Letter to Tsubaki Chinzan, May 31, 1840, in *Watanabe Kazan shū*, vol. 4, p. 107.

40. The poem is included in a letter to Tsubaki Chinzan, September 25, 1839, in *Watanabe Kazan shū*, vol. 4, p. 59.

10. *The Trial*

1. Quoted in Satō Shōsuke, *Watanabe Kazan*, p. 245.
2. Satō, *Watanabe Kazan*, pp. 246–277. The *metsuke* in question was probably Torii Yōzō.
3. Satō, *Watanabe Kazan*, p. 247. Satō pointed out that although Kazan said he had written "Gaikoku jijō sho" and, later, "Shinkiron" in order to express opposition to the *uchiharai* edict as incompatible with the mercy expected of a shogun, neither work in fact discusses the *uchiharai* edict, and the order of composition of the two works was the opposite of Kazan's testimony.
4. "Kita machibugyōsho kōsho" (oral statement to the North Magistrate's Office), in *Watanabe Kazan shū*, vol. 4, pp. 299–307.
5. For Hatazaki Kanae, see chapter 6, note 36.
6. Letters to secretary of Egawa Hidetatsu, in *Watanabe Kazan shū*, vol. 4, pp. 61–64.
7. For many years, the manuscript of "Gaikoku jijō sho" was kept secret by the Egawa family in Izu Nirayama and was not available to scholars. Soon after the end of World War II in 1945, Satō Shōsuke was given permission by the head of the family to examine the work. See Satō, *Yōgakushi no kenkyū*, 177.
8. *Watanabe Kazan shū*, vol. 4, p. 62.
9. Akai Tōkai, "Dakkō hiji," p. 290. See also Satō, *Watanabe Kazan*, p. 265.
10. Satō, *Watanabe Kazan*, p. 266.
11. He was not a blood relation of Tsubaki Chinzan but was the father of the woman who married Chinzan's eldest son. See Ozawa Kōichi, "Teisetsu Tsubaki Chinzan," in *Tsubaki Chinzan ten*, p. 81.
12. Ozawa, "Teisetsu Tsubaki Chinzan," pp. 279–280.
13. Shibata Mitsuhiko and Kanda Masayuki, eds., *Bakin shokan shūsei*, vol. 5, p. 115. Despite these disclaimers, in his diary entry of August 12, 1837 (on hearing of the death of Kazan's younger brother Gorō), Takizawa Bakin described Kazan as an "old friend" (*kyūyū*) and mentioned with admiration the great care that Kazan had lavished on giving Gorō an excellent education (*Bakin nikki*, vol. 4, p. 299). He also described with admiration Kazan's insistence on examining Bakin's son in his coffin in order to be sure that his portrait was faithful to the original: "I was

struck with admiration, thinking one really must have friends" (*Kyokutei iko*, pp. 125–126).

14. *Nochi no tame no ki* is a miscellany by Bakin. The main subject is the illness and death of his son. Kazan figures in the work because he painted Kinrei's portrait. The afterword is dated the twentieth day of the sixth month (1835).

15. Shibata and Kanda, *Bakin shokan shūsei*, vol. 5, p. 117.

16. Ibid., p. 121.

17. Tokuda Takeshi admits that Bakin was "slightly" cold to Kazan after his arrest, but argues that Bakin, in his portrayal of a man unjustly accused of a crime in the novel *Kinsesetsu bishōnen roku*, covertly showed sympathy for Kazan (*Kinsei kindai shōsetsu to Chūgoku hakuwa bungaku*, pp. 259–264).

18. So stated by the journalist Fujita Mokichi (1852–1892), in *Bunmei tōzen shi* (1884), quoted in Satō Shōsuke, *Yōgakushi kenkyū josetsu*, p. 133.

19. Quoted in Hibino Hideo, *Watanabe Kazan*, p. 196. According to Bakin, however, the prison was pleasantly cool in summer, and the daimyo of Tahara frequently sent Kazan summer kimonos. See Shibata and Kanda, *Bakin shokan shūsei*, vol. 5, pp. 120–121.

20. Letter to Matsuzaki Kōdō, in *Watanabe Kazan shū*, vol. 4, p. 65.

21. Satō, *Watanabe Kazan*, p. 279.

22. Letter to Matsuzaki Kōdō, twelfth day of the first month (February 14, 1840), in *Watanabe Kazan shū*, vol. 4, pp. 65–66. Kazan says nothing about his own health but voices concern about Kōdō's. The letter concludes with Kazan's prayer that Kōdō will be careful what he eats and drinks.

23. One sketch is reproduced in Hibino, *Watanabe Kazan*, p. 129.

24. Kenkō, the author of *Tsurezuregusa*, related in section 5 this anecdote about Minamoto no Akimoto (1000–1047).

25. Letter to Ichiki Heizō, in *Watanabe Kazan shū*, vol. 4, pp. 68–69.

26. Letter to Fujimura Muneyoshi, April 21, 1840.

27. Letter to Matsuzaki Kōdō, in *Watanabe Kazan shū*, vol. 4, p. 86.

28. In 1709/1710, Arai Hakuseki (1657–1725), a Confucian adviser to two shoguns, interviewed the Italian Jesuit priest Giovanni Battista Sidotti, who had been captured after he secretly entered the country. Hakuseki's account of the interview, *Seiyō kibun* (*Things Heard About the West*), includes his evaluations of foreign learning and religion. The passage to which Kazan alludes is in Miyazaki Michio, ed., *Seiyō kibun*, pp. 16–17. For more on the interview, see Grant K. Goodman, *Japan and the Dutch*, pp. 45–47.

29. Letter to Tsubaki Chinzan, twenty-ninth day of the fifth month (June 28, 1840), in Satō Shōsuke, ed., *Kazan, Chōei ronshū*, p. 123. See also *Watanabe Kazan shū*, vol. 4, pp. 112–113.

30. *Watanabe Kazan shū*, vol. 4, p. 95.

31. Letter to Ichiki Heizō, in *Watanabe Kazan shū*, vol. 4, p. 94. Ichiki, a painting disciple of Kazan's, was the secretary (*yōnin*) of the magistrate of Uraga.

32. Letter to Tsubaki Chinzan, in Satō, *Kazan, Chōei ronshū*, p. 132.

33. *Watanabe Kazan shū*, vol. 4, p. 96.

34. Letter to Tsubaki Chinzan, November 26, 1840, in *Watanabe Kazan shū*, vol. 4, p. 161. See also Satō, *Kazan, Chōei ronshū*, p. 131.

35. Two hundred *hiki* was worth half of 1 *ryō*, or 2 *bu* in gold. Kazan mentions later in the letter that his debts totaled a little less than 200 *ryō*.

36. Letter to Tsubaki Chinzan, in Satō, *Kazan, Chōei ronshū*, p. 116. See also *Watanabe Kazan shū*, vol. 4, p. 107.

37. Letter to Chinzan, in *Watanabe Kazan shū*, vol. 4, p. 162.

38. Tang Zuxi was a Northern Song poet. The collection of anecdotes about poetry, *Jade Path Through Crane Forest*, was compiled by Luo Dajing.

39. A quotation from Tao Yuanming's poem "Return Home." A. R. Davis translated the words as "yesterday was wrong" (*T'ao Yüan-ming*, vol. 1, p. 192), but "yesterday's mistakes" better fits Kazan's context.

40. The three pleasures were peace in the family, nobility of aspirations, and an outstanding education.

41. Letter to Chinzan, in *Watanabe Kazan shū*, vol. 4, p. 157.

42. *Fan Shihuji* is a collection of poetry and prose by Fan Chengda (1126–1193), otherwise known as Fan Shihu. Fan was acclaimed as one of the Four Masters of Southern Song poetry, but he is best known today for the accounts of his travels. See Richard E. Strassberg, *Inscribed Landscapes*, pp. 213–218.

43. Wuzhen was a painter of the Yuan dynasty (1280–1354), known especially for his landscapes.

44. *Watanabe Kazan shū* identifies the man (whom the editor calls "Ryokka" rather than "Gōroku") as Miyake Ōkei (1794–1857), who was interested in selling Kazan's paintings.

45. Watanabe Kazan, "Kaiji gohenji," in Satō, *Kazan, Chōei ronshū*, p. 128. Several variant readings that may represent later decipherments of Kazan's handwriting are provided in *Watanabe Kazan shū*, vol. 4, p. 157.

11. *Kazan the Painter*

1. Laurance P. Roberts, *A Dictionary of Japanese Artists*, p. 74. *Kachōga* are "flower-and-bird paintings." *Nanga* is another name for *bunjinga*, the paintings of literary men, an ideal of Chinese painters adopted by the Japanese. The "landscapes" in the quotation may refer to the illustrations in Kazan's diaries.

2. In this connection, Kazan wrote to Tsubaki Chinzan, "Many sketches and copies were mislaid because I was so occupied with domain business. Some got lost at the time of the recent disturbance [his arrest in the previous year], others were thrown away as wastepaper. Many were used as weather stripping for furniture. There also is a large trunk that I left as it was without verifying the contents. The other day I discovered portrait sketches I had made of my grandmother and my parents. As soon as I have a chance to put them all together, I will send them to you" (*Watanabe Kazan shū*, vol. 4, p. 159). The portrait of his grandmother is one of many known works by Kazan that have disappeared.

3. The publication by the Tahara Municipal Museum of works by Kazan in its collection that had not previously been reproduced (*Kanzō meihin sen*, vol. 2) indicates how many are still generally unknown.

4. The term *qiyun*, one of the Six Principles of the fifth-century Xie He, is found also in the expanded form *qi yun sheng dong*, which Max Loehr rendered as "animation through spirit-consonance" (*The Great Painters of China*, p. 14). For other translations, see Michael Sullivan, *The Birth of Landscape Painting in China*, p. 106. Although often used in Chinese aesthetics, the term is enigmatic, but it seems to point to the necessity for artists to infuse their art with the spirit of nature. The term in the Japanese pronunciation *kiin* is discussed later.

5. Kobayashi Tadashi, "Nihon bunjinga no honryō to Seikadō korekushon," p. 7.

6. More commonly known as Yun Shouping (1633–1690), Yun Nantian was an important painter of the Qing dynasty known for his flower paintings. His depictions of flowers "suggests the scientific exactitude of a botanist's print" (Wen C. Fong and James C.V. Watt, *Possessing the Past*, p. 491). Kazan and his pupils also favored exactitude in their paintings.

7. Chinzan was not the only disciple to send questions on art to Kazan. Takagi Goan, his companion on one journey, sent his drawing of a sea lion and asked about portraiture. Kazan's reply insisted on likeness as

the touchstone of portraiture and gave specific advice on coloring (letter to Goan, in *Watanabe Kazan shū*, vol. 4, pp. 245–246).

8. An allusion to Mencius (3:4:13). After the death of Confucius, several of his disciples, believing that You Ruo resembled their late master, wished to render him the same observances that they had rendered to Confucius, but Zeng Zi, another disciple, disagreed. See James Legge, trans., *The Four Books*, p. 635. Kazan's quotation from Mencius is approximate. The quotation was intended to demonstrate that just as mere physical similarity did not make You Ruo really like Confucius, surface virtues like *fūin* and *fūshu* should not be considered touchstones of artistic quality.

9. A quotation from the *Shiji*. See Burton Watson, trans., *Records of the Grand Historian*, vol. 1, p. 151. Zai Wo was unusually eloquent, and Zi Yu was unusually ugly. Confucius was disappointed in Zai Wo despite his eloquence (*Analects*, 5:9), but Zi Yu, despite his ugliness, was not an evil man.

 Kazan insists that people should not be judged on the basis of their outward appearance or manner of speech, the equivalents of *fūin* and *fūshi*.

10. A reference to the *Analects*, 19:16. See Arthur Waley, trans., *The Analects of Confucius*, p. 227. Kazan is telling Chinzan not to pay attention to the pronouncements of pretentious "authorities."

11. For Lin Liang (ca. 1418–1480) and Lü Ji (active ca. 1475–1503), see Fong and Watt, *Possessing the Past*, pp. 358–360.

12. For Yun Nantian and Wen Zhengming (1470–1559), see Fong and Watt, *Possessing the Past*, pp. 489–491, 389–394.

13. Letter to Tsubaki Chinzan, in *Watanabe Kazan shū*, vol. 4, pp. 115–116.

14. An allusion to the *Zhuangzi*, vol. 6, in which Yan Hui tells Confucius that he has forgotten everything. See Burton Watson, trans., *The Complete Works of Chuang Tzu*, p. 90. This chapter of the *Zhuangzi* deals with the necessity of transcending good and evil, life and death, existence and annihilation.

15. Letter to Chinzan, in *Watanabe Kazan shū*, vol. 4, pp. 117–118.

16. It usually has been dated the third day of the eleventh month of Tenpō 11 (November 26, 1840), but the editors of *Watanabe Kazan shū* believe that the date is uncertain (vol. 4, p. 119).

17. Kazan probably had in mind notable scenes in China that, painted realistically, had the effect of familiarizing people with geography. This realism contrasts with the typical ink paintings of anonymous mountains swathed in clouds.

18. Letter to Tsubaki Chinzan, in *Watanabe Kazan shū*, vol. 4, pp. 121–122.

19. Kuwagata Keisai's view from above the Japanese islands is reproduced in Hibino Hideo, *Watanabe Kazan*, p. 230. Colored reproductions of Keisai's panoramas are in *Kuwagata Keisai*; all the important places in Japan can be identified. Hokusai also made bird's-eye views of Japan.

20. Kazan used a term from the *Yijing* (*The Book of Changes*) to designate such a lot.

21. Letter to Fukuda Hankō, in *Watanabe Kazan shū*, vol. 4, pp. 208–209. See also Kazan's letter to Chinzan, third day of the eleventh month (ibid., p. 160), in which he wrote, "Obviously, a born loser is bound to lose. Just as it says in the diagram for impasse in *The Classic of Changes*, 'This one suffers Impasse in the buttocks here at the root of the tree, in the brambles and he enters a secluded valley.' I am in a similar situation" (Richard John Lynn, trans., *The Classic of Changes*, p. 430).

22. In an earlier version of the painting, now in the Tahara Municipal Museum, the distant hills are even less clear. See *Kanzō meihin sen*, vol. 1, p. 51.

23. Ozaki Masaaki, "Sakuhin kaisetsu," in Suzuki Susumu and Ozaki Masaaki, *Watanabe Kazan*, p. 134.

24. A companion painting, showing men cultivating fields, was modeled on a work by Jiao Bingjian, but the source painting for *The Singing Loom* has not yet been identified.

25. Burton Watson, trans., *Meng Ch'iu*, p. 67.

26. The first draft of this painting clearly shows Kazan's efforts to achieve proper perspective.

27. Letter to Tsubaki Chinzan, in *Watanabe Kazan shū*, vol. 4, p. 223.

28. Kōno Motoaki, "Kazan to Edo kaiga," pp. 84–88.

29. For a selection of critical evaluations, see Hibino, *Watanabe Kazan*, pp. 236–237.

30. Letter to Tsubaki Chinzan, in *Watanabe Kazan shū*, vol. 4, p. 222.

31. Hibino, *Watanabe Kazan*, p. 237.

32. Arthur Waley, trans., *The Book of Songs*, p. 322. This is poem 219 in the Mao numbering.

33. Hibino, *Watanabe Kazan*, p. 257.

12. *The Last Year*

1. According to the Western calendar, it was January 23, 1841.

2. A reference to Ju Boyu, a minister of the ancient kingdom of Wei, who decided that for sixty years he had called right what he now called

wrong. The same statement was also attributed to Confucius. See Burton Watson, trans., *The Complete Works of Chuang Tzu*, p. 305.

3. The poem is in Chinese, but I have consulted the Japanese transcription in Hibino Hideo, *Watanabe Kazan*, p. 233. The "useless tree" is mentioned by Zhuangzi. Not only is the wood of such poor quality that it cannot be used, but the leaves give off a bad smell. That is why it survives, untouched by woodcutters, while useful trees are felled. See Watson, *Chuang Tzu*, p. 209.

4. Miyake Tomonobu, "Kazan sensei ryakuden," p. 324. The "sinister member of the shogunate" has not been identified.

5. For a good account of Miyake Tosa-no-kami Yasunao, see Sugiura Minpei, *Kazan tansaku*, pp. 182–186.

6. Kyokutei Bakin, *Chōsakudō zakki shō*, p. 475. Bakin learned of these events from a bakufu official, supposing that although the news was second-hand, it was trustworthy. Yasunao was appointed as *sōshaban* on the eighth day of the twelfth month (January 19, 1842).

7. Miyake Ryokka figures prominently in Kazan's letter to Fukuda Hankō, twelfth day of the ninth month (October 27, 1841), in *Watanabe Kazan shū*, vol. 4, p. 229. Kazan had a poor opinion of Ryokka's judgment and blamed him for his current distress.

8. Letter to Tsubaki Chinzan, in Satō Shōsuke, ed., *Kazan, Chōei ronshū*, p. 133.

9. Letter to Hankō, in *Watanabe Kazan shū*, vol. 4, p. 229. See also Hibino, *Watanabe Kazan*, pp. 199, 272.

10. Letter to Hankō, in *Watanabe Kazan shū*, vol. 4, p. 229.

11. Satō Shōsuke, *Watanabe Kazan*, pp. 317–318.

12. Ibid., p. 316.

13. Quoted in ibid., pp. 319–321.

14. We know, however, from a letter that Kazan sent to Hankō that he had delivered ten completed paintings to Ryokka in the ninth month. See Satō, *Watanabe Kazan*, p. 325. Kazan seems to have altered the facts, even in this suicide note, perhaps to mitigate the offense of having sold the paintings.

15. Letter to Tsubaki Chinzan, in *Watanabe Kazan shū*, vol. 4, p. 233. Suganuma Teizō gives an extremely free translation into modern Japanese of part of the letter in *Teihon Watanabe Kazan zenshū*, vol. 1, p. 69.

16. Satō Shōsuke, *Yōgakushi kenkyū josetsu*, pp. 169–170.

17. Satō, *Watanabe Kazan*, pp. 328–330.

18. *Watanabe Kazan shū*, vol. 4, p. 234.

19. Satō, *Watanabe Kazan*, p. 327. See also Ozawa Kōichi, *Watanabe Kazan Nobori*, p. 112.

20. Letter to Watanabe Sukuemon, in *Watanabe Kazan shū*, vol. 4, p. 236.

21. See the introduction.

22. Tachihara Kyōsho, a close friend of Kazan's, died in the fifth month of 1840 at the age of fifty-five.

23. Letter to Tsubaki Chinzan, in *Watanabe Kazan shū*, vol. 4, p. 161.

24. Letter to Watanabe Tatsu, in *Watanabe Kazan shū*, vol. 4, p. 238. The letter consists of broken phrases spread out over six lines, perhaps to make it easier for his son to read.

25. The ages are given according to traditional Japanese calculation; by Western count, they all would be a year or so younger.

26. In his letter of the tenth day of the tenth month to Murakami Sadahira (1808–1872), a samurai of Tahara Domain, Kazan asked him to look after his mother, wife, and children. He also gave the names of three other Tahara samurai whom he wished to thank for their support. The letter concludes with the words "eternal farewell" (*eiketsu*) (*Watanabe Kazan shū*, vol. 4, p. 235). In the remaining letter written immediately before his suicide, addressed to a disciple named Kaneko Kenshirō, Kazan asked him to show affection to his mother, wife, and children (p. 234)

27. Quoted in Ozawa, *Watanabe Kazan Nobori*, p. 117. Ozawa gave six different accounts of Kazan's death (pp. 117–124). The one quoted here was by Doi Rei, at one time the mayor of Tahara. Each account is somewhat different, but all agree on the mother's reactions. One is by a maidservant who, at the age of eighty-seven, recalled events of sixty-eight years earlier.

28. It was not until 1868, when Kazan was officially pardoned, that a tombstone was permitted to be erected over his grave.

29. Matsuzaki Kōdō, *Kōdō nichireki*, vol. 6, p. 165. The entry, for the twenty-seventh day of the twelfth month, is surprisingly brief and noncommittal, considering that Kōdō's great affection for Kazan had impelled him to write the letter to Mizuno Tadakuni that saved Kazan's life.

30. Suma, the wife of Kazan's younger son, Kanō. See Ozawa Kōichi, *Watanabe Kazan kenkyū*, p. 263.

31. Matsuoka Jirō escorted Kazan to exile in Tahara. He made up for his rigorous treatment of the unfortunate prisoner by marrying Kazan's daughter and, later, by editing Kazan's diary *Zenrakudō kiden*.

32. The known facts about Tatsu's life are in Ozawa, *Watanabe Kazan kenkyū*, pp. 270–273.

33. For a detailed account of Kanō's life, see Ozawa, *Watanabe Kazan kenkyū*, pp. 273–283.
34. Sugiura, *Kazan tansaku*, p. 182. In the preceding pages of his book, Sugiura describes how one after another of Kazan's friends and enemies died either before or shortly after the Meiji Restoration, until only Yasunao was left.
35. The text of the pardon, issued in the first month of the fourth year of Keiō (1868), is in Sugiura, *Kazan tansaku*, pp. 172–173.
36. Satō, *Watanabe Kazan*, p. 331. The plot contains the remains of Kazan, his mother, his wife, Kanō, and Kanō's wife.
37. The portrait is reproduced in Nihon rekishigakkai, ed., *Shōzō senshū*, p. 317.
38. This painting is in the Honolulu Academy of Arts.
39. Suzuki Seisetsu, ed., *Kazan zenshū*. The second volume was added in 1915, and the two volumes were combined and supplemented in 1941.
40. Suzuki, *Kazan zenshū*, vol. 1, p. 1.
41. Jack R. Hillier, *Japanese Drawings of the 18th and 19th Centuries*, p. 108.

Bibliography

Abiko, Bonnie. "Persecuted Patriot: Watanabe Kazan and the Tokugawa Bakufu." *Monumenta Nipponica* 44 (1989): 199–219.

Akai Tōkai. "Dakkō hiji." In Ikuchi Mokusei, *Kazan sōtai roku*. Tōkyō: Hōsendō, 1943.

Andō Gorō. *Nihon kindai kyōiku shisō no kenkyū.* Tōkyō: Gakugai tosho, 1972.

Arisaka Takamichi. *Nihon yōgakushi no kenkyū.* Vol. 2. Ōsaka: Sōgensha, 1972.

Bakin nikki. 4 vols. Tōkyō: Chūō kōron sha, 1973.

Beasley, W. G. *Great Britain and the Opening of Japan, 1834–1858.* 1951. Reprint, London: Routledge, 1995.

Bessho Kōichi. *Watanabe Kazan.* Nagoya: Arumu, 2004.

Bujin to bunjin to no aida de: Watanabe Kazan ten. Utsunomiya: Tochigi kenritsu bijutsukan, 1984.

Cortazzi, Hugh. *Isles of Gold: Antique Maps of Japan.* New York: Weatherhill, 1983.

Davis, A. R. *T'ao Yüan-ming (A.D. 365–427): His Works and Their Meaning.* Cambridge: Cambridge University Press, 1983.

Fong, Wen C., and James C. Y. Watt. *Possessing the Past: Treasures from the National Palace Museum, Taipei.* New York: Metropolitan Museum of Art, 1996.

French, Calvin L. *Shiba Kōkan: Artist, Innovator, and Pioneer in the Westernization of Japan.* New York: Weatherhill, 1974.

French, Calvin L. *Through Closed Doors: Western Influence on Japanese Art, 1639–1853.* Rochester, Mich.: Oakland University Press, 1977.

Fujimori Seikichi. *Watanabe Kazan: Hito to geijutsu.* Tōkyō: Shunjūsha, 1962.

Fujita Satoru. *Matsudaira Sadanobu.* Chūkō shinsho series. Tōkyō: Chūō kōron sha, 1993.

Fujita Satoru. *Tenpō no kaikaku.* Tōkyō: Yoshikawa kōbunkan, 1989.

Golownin, Vasilij Mikhajlovich. *Narrative of My Captivity in Japan, During the Years 1811, 1812, 1813.* London: Colburn, 1819.

Goodman, Grant K. *Japan and the Dutch, 1600–1853.* Richmond: Curzon Press, 2000.

Haga Noboru. *Bansha no goku.* Tōkyō: Shūei shuppan, 1970.

Haga Tōru. *Watanabe Kazan: Yasashii tabibito.* Asahi sensho series. Tōkyō: Asahi shinbun, 1986.

Haga Tōru. "Yōfū bunjinga no sekai." *Chōmen* 50 (1972).

Hall, John Whitney. *Tanuma Okitsugu, 1719–1788: Forerunner of Modern Japan.* Cambridge, Mass.: Harvard University Press, 1955.

Hankai Jirō. *Koseki San'ei.* Tōkyō: Ōshisha, 1987.

Hayashi Shihei. *Kaikoku heidan.* Iwanami bunko series. Tōkyō: Iwanami shoten, 1939.

Hayashiya Tatsusaburō, ed. *Bakumatsu bunka no kenkyū.* Tōkyō: Iwanami shoten, 1978.

Hesselink, Reinier H. "A Dutch New Year at the Shirandō Academy: 1 January 1795." *Monumenta Nipponica* 50 (1995): 189–234.

Hibino Hideo. *Watanabe Kazan.* Tōkyō: Perikansha, 1994.

Hillier, Jack. *The Art of Hokusai in Book Illustration.* Berkeley: University of California Press, 1980.

Hillier, Jack R. *Japanese Drawings of the 18th and 19th Centuries: Catalogue.* Washington, D.C.: International Exhibitions Foundation, 1980.

Hosono, Masanobu. *Nagasaki Prints and Early Copperplates.* Translated by Lloyd R. Craighill. Tōkyō: Kōdansha International, 1978.

Imaizumi Genkichi. *Rangaku no ie Katsuragawa no hitobito.* 3 vols. Tōkyō: Shinozaki shorin, 1965.

Inoue Takaaki. *Aka Ezo fūsetsu kō.* Tōkyō: Kyōikusha, 1979.

Ishii Hakutei. *Nihon ni okeru yōfūga no enkaku.* Tōkyō: Iwanami shoten, 1932.

Ishikawa Jun. *Watanabe Kazan.* Tōkyō: Mikasa shobō, 1941.

Ishiyama Teiichi. "'Dr. Heinrich Bürger' no shōgai ni tsuite." *Hōsei shigaku* 22 (1970).

Issō hyakutai. Aichi-ken, Tahara-machi: Kazan kai, 1964.

Itazawa Takeo. *Nichiran bunka kōshōshi no kenkyū.* Tōkyō: Yoshikawa kōbunkan, 1959.

Itazawa Takeo. *Shiboruto.* Jinbutsu sōsho series. Tōkyō: Yoshikawa kōbunkan, 1960.

Itō Tasaburō. *Kinseishi no kenkyū.* Vol. 2. Tōkyō: Yoshikawa kōbunkan, 1982.

Iwasaki Katsumi. "Kazan to yōgaku" (1–6). *Shomotsu tenbō* 20, no. 3 (1942).

Japans Dagh Register. 1826. Reprint, Tōkyō: Nichiran kōshōshi kenkyūkai, 1988.

Kaempfer, Engelbert. *Kaempfer's Japan: Tokugawa Culture Observed.* Edited, translated, and annotated by Beatrice M. Bodart-Bailey. Honolulu: University of Hawai'i Press, 1999.

Kagawa Takayuki. *Kuzureyuku sakoku.* Nihon no rekishi series. Tōkyō: Shūeisha, 1992.

Kaikoku hyakunen bunka jigyōkai, ed. *Sakoku jidai nihonjin no kaigai chishiki.* Tōkyō: Kangensha, 1953.

Kanehara Hiroyuki. "Kazan no jinbutsu shōzōga." In Tokoha bijutsukan, ed., *Teihon Watanabe Kazan zenshū,* vol. 3. Matsumoto: Kyōdo shuppan, 1991.

Kanzō meihin sen. Vol. 1. Tahara: Tahara-machi hakubutsukan, 1994.

Kanzō meihin sen. Vol. 2. Tahara: Tahara-shi hakubutsukan, 2005.

Katagiri Kazuo. *Oranda tsūji no kenkyū.* Tōkyō: Yoshikawa kōbunkan, 1985.

Katagiri Kazuo. *Oranda yado ebi-ya no kenkyū.* 2 vols. Kyōto: Shibunkaku, 1998.

Katagiri Kazuo. "Yōfū gaka Ishikawa Tairō to Edo no rangaku-kai." *Museum,* February 1970.

Kawakatsu Heita, ed. *"Sakoku" o hiraku.* Tōkyō: Dōbunkan, 2000.

Kawatake Shigetoshi. *Tsuruya nanboku shū.* Tōkyō: Chiheisha, 1948.

Kazan meisaku shū. Tahara: Tahara-machi kyōiku iinkai, 1985.

Keene, Donald. *Dawn to the West: Japanese Literature of the Modern Era.* New York: Holt, Rinehart and Winston, 1984.

Keene, Donald. *Emperor of Japan: Meiji and His World, 1852–1912.* New York: Columbia University Press, 2002.

Keene, Donald. *The Japanese Discovery of Europe, 1720–1830.* Stanford, Calif.: Stanford University Press, 1969.

Keene, Donald. *Landscapes and Portraits: Appreciations of Japanese Culture.* Tōkyō: Kodansha International, 1971.

Keene, Donald. *Travelers of a Hundred Ages.* New York: Holt, 1989.

Keene, Donald. *World Within Walls: Japanese Literature of the Pre-Modern Era, 1600–1867.* New York: Holt, Rinehart and Winston, 1976.

Keene, Donald, trans. *Major Plays of Chikamatsu.* New York: Columbia University Press, 1961.

King, F. H. H. "Les Premiers Étudiants britanniques de chinois (1753–1834)." *France-Asie,* n.s., 17, pt. 169, September–October 1961.

Kitajima Masamoto. *Mizuno Tadakuni.* Tōkyō: Yoshikawa kōbunkan, 1969.

Kobayashi Tadashi. "Nihon bunjinga no honryō to Seikadō korekushon." In *Nihon no bunjingaten,* vol. 2. Tōkyō: Seikadō bijutsukan, 1996.

Kobijutsu, no. 48, June 1975.

Kobori Keiichirō. *Sakoku no shisō.* Chūkō shinsho series. Tōkyō: Chūō kōron sha, 1974.

Koga Jūnirō. *Nagasaki kaiga zenshi.* Tōkyō: Hokkō shobō, 1944.

Kōno Motoaki. "Kazan to Edo kaiga." In Tokoha bijutsukan, ed., *Teihon Watanabe Kazan zenshū,* vol. 3. Matsumoto: Kyōdo shuppan, 1991.

Kornicki, P. F. "Julius Klaproth and His Works." *Monumenta Nipponica* 55 (2000): 579–591.

Kouwenhoven, Arlette, and Matthi Forrer. *Siebold and Japan: His Life and Work.* Leiden: Hōtei, 2000.

Kudō Heisuke. *Aka Ezo fūsetsu kō.* Hokumon sōsho series 1. Tōkyō: Hokkō shobō, 1943.

Kurahara Korehito. *Watanabe Kazan.* Tōkyō: Shin Nihon shuppan, 1973.

Kuroda Hideo. *Ō no shintai, ō no shōzō.* Tōkyō: Heibonsha, 1993.

Kuwagata Keisai. Tsuyama: Tsuyama-shi kyōiku iinkai, 2004.

Kyokutei Bakin. *Chōsakudō zakki shō.* In *Kyokutei ikō.* Tōkyō: Kokusho kankōkai, 1911.

Kyōto kokuritsu hakubutsukan. *Nihon no shōzō.* Tōkyō: Chūō kōron sha, 1978.

Legge, James, trans. *The Four Books: Confucian Analects, The Great Learning, The Doctrine of the Mean, and the Works of Mencius.* New York: Paragon, 1966.

Leims, Thomas F. *Die Enstehung des Kabuki.* Leiden: Brill, 1990.

Loehr, Max. *The Great Painters of China.* New York: Harper & Row, 1980.

Lynn, Richard John, trans. *The Classic of Changes: A New Translation of the I Ching as Interpreted by Wang Bi.* New York: Columbia University Press, 1994.

Matsuoka Hideo. *Torii Yōzō.* Chūkō shinsho series. Tōkyō: Chūō kōron sha, 1991.

Matsuzaki Kōdō. *Kōdō nichireki.* Edited by Yamada Taku. 6 vols. Tōyō bunko series. Tōkyō: Heibonsha, 1983.

Minamoto Ryōen. *Tokugawa gōri shisō no keifu.* Tōkyō: Chūō kōron sha, 1972.

Miyajima Shin'ichi. *Shōzōga.* Tōkyō: Yoshikawa kōbunkan, 1994.

Miyake Tomonobu. "Kazan sensei ryakuden." In Suzuki Seisetsu, ed., *Kazan zenshū.* Tōkyō: Kazan sōsho shuppankai, 1941.

Miyazaki Michio, ed. *Seiyō kibun.* Tōyō bunko series. Tōkyō: Heibonsha, 1968.

Mori Senzō. *Watanabe Kazan.* Chūkō bunko series. Tōkyō: Chūō kōron sha, 1978.

Morrison, Eliza. *Memoirs of the Life and Labours of Robert Morrison, D.D. by His Widow.* 2 vols. London: Longman, 1839.

Nakamura Yasuhiro. "Satō Issai." In Minamoto Ryōen, ed., *Edo no jugaku.* Kyōto: Shibunkaku, 1988.

Naruse Fujio. *Satake Shosan.* Kyōto: Minerva shobō, 2004.

Naruse Fujio. *Shosan, Naotake.* Tōkyō: Sansaisha, 1969.

Nichiran gakkai, ed. *Yōgakushi jiten.* Tōkyō: Yūshōdō, 1984.

Nihon rekishigakukai, ed. *Shōzō senshū.* Tōkyō: Yoshikawa kōbunkan, 1962.

Numata Jirō. "Hainrihi byuruga no denki." In *Rangaku shiryō kenkyūkai, Kenkyū hōkoku,* no. 233 (1970).

Numata Jirō. *Yōgaku denrai no rekishi.* Tōkyō: Shibundō, 1964.

Okado Kazuyuki. "Watanabe Kazan: Ōzora Buzaemon zō." *Kokka* 1249 (1999).

Okamura Chibiki. *Kōmō bunka shiwa.* Tōkyō: Sōgensha, 1953.

Ono Tadashige. *Edo no yōgakka.* Tōkyō: Sansaisha, 1968.

Ōoka Makoto. *Eiketsu kaku no gotoku ni sōrō.* Tōkyō: Kyōbundō, 1990.

Ōta Zentarō. *Watanabe Kazan.* Toyohashi: Kazan sōsho shuppankai, 1940.

Ōtomo Kazuo. *Edo bakufu to jōhō kanri.* Kyōto: Rinsen, 2003.

Ōtsuki Gentaku. *Oranda benwaku.* Bunmei genryū sōsho series 1. Tōkyō: Kokusho kankōkai, 1913.

Ōtsuki Gentaku. *Rangaku kaitei.* Bunmei genryū sōsho series 1. Tōkyō: Kokusho kankōkai, 1913.

Ozawa Kōichi. *Watanabe Kazan kenkyū.* Tōkyō: Nihon tosho sentaa, 1998.

Ozawa Kōichi. *Watanabe Kazan Nobori.* Tahara: Tahara-machi kyōiku iinkai, 1976.

Ozawa Kōichi, ed. *Kazan shokan shū.* Tōkyō: Kokusho kankōkai, 1982.

Rai Kiichi. *Jugaku, kokugaku, yōgaku.* Nihon no kinsei series. Tōkyō: Chūō kōron sha, 1993.

Roberts, Laurance P. *A Dictionary of Japanese Artists: Painting, Sculpture, Ceramics, Prints, Lacquer.* Tōkyō: Weatherhill, 1976.

Rosenfield, John M., with Fumiko Cranston. *Extraordinary Persons: Works by Eccentric, Nonconformist Japanese Artists of the Early Modern Era (1580–1868) in the Collection of Kimiko and John Powers.* 3 vols. Cambridge, Mass.: Harvard University Art Museums, 1999.

Sakai Shizu. "Nagasaki rankanchō Johann Erdewin Niemann ni tsuite." In *Rangaku shiryō kenkyūkai, Kenkyū hōkoku,* no. 226 (1969).

Sansom, George B. *The Western World and Japan, a Study in the Interaction of European and Asiatic Cultures.* London: Cresset, 1950.

Satō Genrokurō. *Ezo shūi.* Hokumon sōsho series 1. Tōkyō: Hokkō shobō, 1943.

Satō Shōsuke. "Keiseika Kazan to kagakusha Chōei." In Satō Shōsuke, ed., *Watanabe Kazan, Takano Chōei, Sakuma Shōzan, Yokoi Shōnan, Hashimoto Sanai.* Nihon shisō taikei series. Tōkyō: Iwanami shoten, 1971.

Satō Shōsuke. *Takano Chōei.* Iwanami shinsho series. Tōkyō: Iwanami shoten, 1997.

Satō Shōsuke. *Watanabe Kazan*. Jinbutsu sōsho series. Tōkyō: Yoshikawa kōbunkan, 1986.

Satō Shōsuke. *Yōgakushi kenkyū josetsu*. Tōkyō: Iwanami shoten, 1964.

Satō Shōsuke. *Yōgakushi no kenkyū*. Tōkyō: Chūō kōron sha, 1980.

Satō Shōsuke, ed. *Kazan, Chōei ronshū*. Iwanami bunko series. Tōkyō: Iwanami shoten, 1978.

Satō Shōsuke, ed. *Watanabe Kazan, Takano Chōei*. Nihon no meicho series. Tōkyō: Chūō kōron sha, 1972.

Satō Shōsuke, ed. *Watanabe Kazan, Takano Chōei, Sakuma Shōzan, Yokoi Shōnan, Hashimoto Sanai*. Nihon shisō taikei series. Tōkyō: Iwanami shoten, 1971.

Shiba Kōkan. *Shunparō hikki*. Nihon zuihitsu taisei series. Tōkyō: Yoshikawa kōbunkan, 1975.

Shibata Mitsuhiko and Kanda Masayuki, eds. *Bakin shokan shūsei*. Tōkyō: Yagi shoten, 2002–2004.

Stanley-Baker, Joan. *The Transmission of Chinese Idealist Painting to Japan: Notes on the Early Phase (1661–1799)*. Ann Arbor: Center for Japanese Studies, University of Michigan, 1992.

Steenis-Kruseman, M. J. van. "Contribution to the History of Botany and Exploration in Malaysia." *Blumea* 11, no. 2 (1962).

Strassberg, Richard E. *Inscribed Landscapes: Travel Writing from Imperial China*. Berkeley: University of California Press, 1994.

Suganuma Teizō. *Kazan no kenkyū*. Tōkyō: Zaō kankōkai, 1947.

Suganuma Teizō. *Watanabe Kazan*. Nihon no bijutsu series. Tōkyō: Shibundō, 1979.

Suganuma Teizō. *Watanabe Kazan: Hito to geijutsu*. Tōkyō: Shunjūsha, 1962.

Sugimoto Tsutomu. *Edo no oranda-ryū ishi*. Tōkyō: Waseda daigaku, 2002.

Sugimoto Tsutomu. *Koseki San'ei den*. Tōkyō: Keibundō, 1970.

Sugita Genpaku. *Rangaku kotohajime*. Iwanami bunko series. Tōkyō: Iwanami shoten, 1939.

Sugiura Minpei. *Ishin zen'ya no bungaku*. Iwanami shinsho series. Tōkyō: Iwanami shoten, 1967.

Sugiura Minpei. *Kazan tansaku*. Tōkyō: Kawade, 1972.

Sugiura Minpei and Bessho Kōichi. *Edo-ki no kaimei shisō*. Tōkyō: Shakai hyōron sha, 1990.

Sullivan, Michael. *The Birth of Landscape Painting in China*. Berkeley: University of California Press, 1962.

Sullivan, Michael. *The Meeting of Eastern and Western Art*. Berkeley: University of California Press, 1989.

Suzuki Seisetsu, ed. *Kazan zenshū*. 2 vols. in 1. Tōkyō: Kazan sōsho shuppankai, 1941.

Suzuki Susumu. *"Issō hyakutai* zufu kaisetsu." In *Issō hyakutai*. Aichi-ken, Tahara-machi: Kazan kai, 1964.

Suzuki Susumu. "Kazan no shōzōga o megutte." *Museum*, April 1956.

Suzuki Susumu and Ozaki Masaaki. *Watanabe Kazan*. In *Nihon bijutsu kaiga zenshū*. Tōkyō: Shūeisha, 1980.

Takano Chōun. *Takano Chōei den*. Tōkyō: Iwanami shoten, 1943.

Takizawa Bakin. *Kyokutei Bakin shū*. Kindai Nihon bungaku taisei series. Tōkyō: Kokumin tosho, 1927.

Takizawa Bakin. *Kyokutei ikō*. Tōkyō: Kokusho kankōkai, 1911.

Takumi Hideo. *Nihon no kindai bijutsu to bakumatsu*. Tōkyō: Chūsekisha, 1994.

Thunberg, Carl Peter. *Travels in Europe, Africa and Asia, Made Between the Years 1770 and 1779*. 4 vols. London: Rivington, 1795.

Tokoha bijutsukan, ed. *Teihon Watanabe Kazan zenshū*. 3 vols. Matsumoto: Kyōdo shuppan, 1991.

Tokuda Takeshi. *Kinsei kindai shōsetsu to Chūgoku hakuwa bungaku*. Tōkyō: Kyūko shoten, 2004.

Tozawa Yukio. *Oranda-ryū Go-ten'i Katsuragawa-ke no sekai*. Tōkyō: Tsukiji shokan, 1994.

Tsubaki Chinzan ten. Tahara: Tahara-machi hakubutsukan, 1994.

Tsuji Tatsuya. *Tennō to shōgun*. Nihon no kinsei series. Tōkyō: Chūō kōron sha, 1991.

Tsukiyama Terumoto. *Watanabe Kazan no gyakugansaku kō*. Tōkyō: Kawade shobō, 1996.

Tsunoda, Ryusaku, Wm. Theodore de Bary, and Donald Keene, eds. *Sources of Japanese Tradition*. New York: Columbia University Press, 1958.

Tsurumi Shunsuke. *Takano Chōei*. Tōkyō: Asahi shinbun, 1975.

Ueno, Masuzo. "A Japanese Portrait of Heinrich Bürger." *Zoologische Mededelingen* 49, no. 10 (1975).

Ueno Masuzō. "Hainrihi Byurugeru." *Seibutsu no kagaku* 7 (1975).

Waley, Arthur, trans. *The Analects of Confucius*. London: Allen & Unwin, 1938.

Waley, Arthur, trans. *The Book of Songs*. Boston: Houghton Mifflin, 1937.

Watanabe Kazan. Shinchō Nihon bijutsu bunko series. Tōkyō: Shinchōsha, 1997.

Watanabe Kazan, Tsubaki Chinzan ga egaku jinbutsuga. Tahara: Tahara-shi hakubutsukan, 2005.

Watanabe Kazan ga tsukaeta shukun tachi. Tahara: Tahara-machi hakubutsukan, 2001.

Watanabe Kazan shū. 7 vols. Tōkyō: Nihon tosho sentaa, 1999.

Watanabe Kazan to sono shiyū ten. Tahara: Tahara-machi hakubutsukan, 1993.

Watson, Burton, trans. *The Complete Works of Chuang Tzu*. New York: Columbia University Press, 1964.

Watson, Burton, trans. *Meng Ch'iu*. Tōkyō: Kodansha International, 1979.

Watson, Burton, trans. *Records of the Grand Historian of China*. 2 vols. New York: Columbia University Press, 1961.

Watson, Burton, trans. *Su Tung-p'o*. New York: Columbia University Press, 1965.

Watsuji Tetsurō. *Sakoku: Nihon no higeki*. Tōkyō: Chikuma, 1951.

Webb, Herschel. *The Japanese Imperial Institution in the Tokugawa Period*. New York: Columbia University Press, 1968.

Yamakawa Shōtarō. "Koseki San'ei to sono shokan." *Bunka*, nos. 1–5 (1938).

Yoshizawa Tadashi. *Watanabe Kazan*. Tōkyō: Tōkyō daigaku, 1956.

Yoshizawa Tadashi. "Watanabe Kazan hitsu *Issō hyakutai* zu ni tsuite." *Kokka* 812 (1959).

Zolbrod, Leon M. *Takizawa Bakin*. New York: Twayne, 1967.

Numbers in italics refer to pages on which illustrations appear.

Index

ASIA PERSPECTIVES

HISTORY, SOCIETY, AND CULTURE

A series of the Weatherhead East Asian Institute,
Columbia University, published by Columbia University Press

Carol Gluck, Editor

Comfort Women: Sexual Slavery in the Japanese Military
During World War II, by Yoshimi Yoshiaki,
tr. Suzanne O'Brien

The World Turned Upside Down: Medieval Japanese
Society, by Pierre François Souyri, tr. Käthe Roth

Yoshimasa and the Silver Pavilion: The Creation of the Soul
of Japan, by Donald Keene

Geisha, Harlot, Strangler, Star: The Story of a
Woman, Sex, and Moral Values in Modern Japan,
by William Johnston

Lhasa: Streets with Memories, by Robert Barnett